BIRDS *of* INSTAGRAM

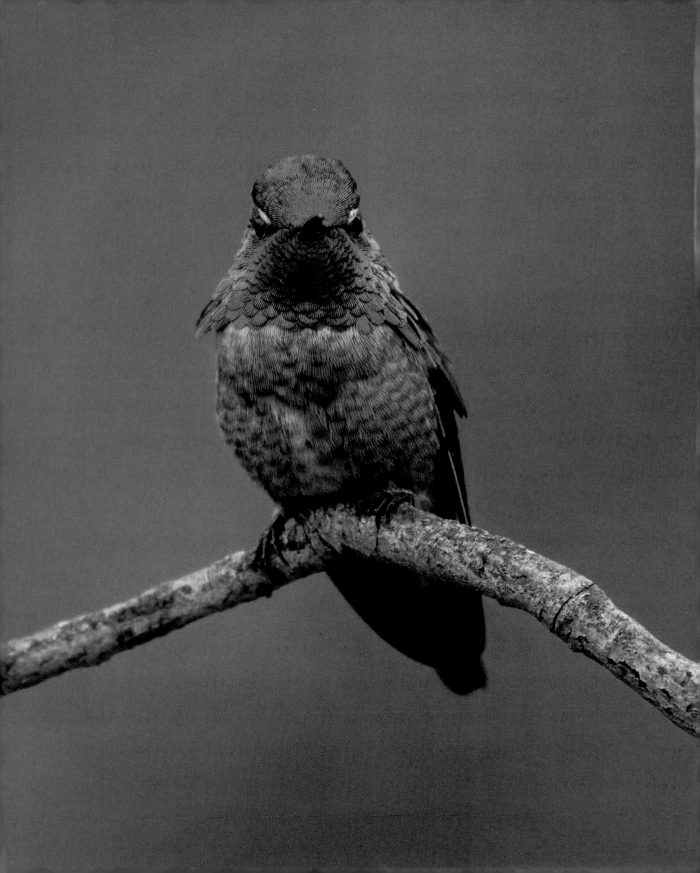

BIRDS *of* INSTAGRAM

Edited by **David Allen Sibley** & Chris Gatcum

 Extraordinary Images from Around the World

Abrams Image, New York

< Anna's Hummingbird
Calypte anna
Redding, California, USA
Nikon D500 with 200–500mm
lens, 1/160 sec. at f/5.6, ISO 4000
Elijah Gildea, @elijahs_photography

UniPress Books
www.unipressbooks.com

Commissioning Editor: Kate Shanahan
Project Manager: Natalia Price-Cabrera
Design & Art Direction: Paul Palmer-Edwards
Picture Research & Selection: Chris Gatcum

Library of Congress Control Number: 2020944974

ISBN: 978-1-4197-5170-7

Printed and bound in China
10 9 8 7 6 5 4 3 2 1

Abrams Image books are available at special discounts when purchased in quantity for premiums and promotions as well as fundraising or educational use. Special editions can also be created to specification. For details, contact specialsales@abramsbooks.com or the address below.

Abrams Image® is a registered trademark of Harry N. Abrams, Inc.

ABRAMS The Art of Books
195 Broadway, New York, NY 10007
abramsbooks.com

Introduction

David Allen Sibley

Birdwatchers often struggle to explain the appeal of their hobby, and give lots of different reasons as to why they watch birds. Fundamentally, though, I think it is all about establishing and nurturing a connection with the natural world. Until a few generations ago, people's lives were intertwined with the outside world, but we now live with air conditioning and other modern comforts, increasingly isolated from nature. However, research shows that immersing ourselves in the natural world is good for our mental health, and that time spent outdoors makes us happier, more focused, and more relaxed.

Birds can provide us with this much-needed connection, and through them we can get a sense of the vast, interconnected network that is Earth. We do not necessarily need to travel far to experience these benefits either—the effect is so universal that it can be achieved by looking at birds through a window, and even photographs of them can have a positive influence on our well-being. In observing this, things we learned about in middle school science—the water cycle, migration, the food chain, survival of the fittest, and so on—are elevated from abstract concepts to simple, intuitive realities. An interested observer watching chickadees at a backyard bird feeder will develop an understanding of how an ecosystem works and how each bird fits into the larger patterns.

In the more immediate sense, we can enjoy watching birds for their aesthetic appeal; their shapes are beautiful. The adaptations required for flight include the consolidation of weight into a central body mass, and a coat of feathers to streamline and smooth their contours. Birds travel a lot, and need to be able to move deftly through air, or water, or both. Some species with highly aerial lifestyles, such as swallows and falcons, are incredibly sleek and elegant, but even species with unusual (and perhaps even comical) features, such as penguins and herons, still project a sense of efficient grace.

The colors and patterns are beautiful too, as, like us, birds communicate primarily through sight and sound. This means that their coloration and the shapes they use for display have evolved over time for maximum visual impact. Apparently, the same things that the female Wood Duck finds beautiful in a male also appear beautiful to us, as you will see in some of the photographs contained within these pages.

Because birds express themselves using sight and sound, we can eavesdrop on their lives, and understand (or at least make up dialog for) some of their behavior. Many of the photographs in this book feature birds that seem to be showing emotions: adoring, arguing, frustrated, relaxed, and more. This is one of the things that makes birds so engaging.

Birds are also exciting. There is something magical about their comings and goings—the ability to fly is inspiring, and it makes them ephemeral and unpredictable. Some species travel the globe, migrating tens of thousands of miles every year,

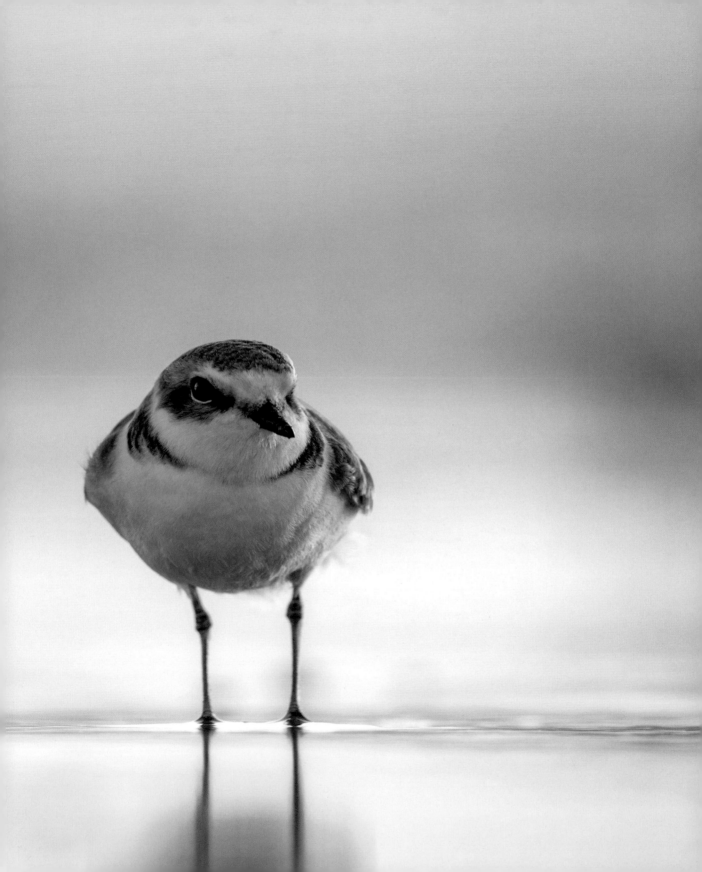

< Snowy Plover
Charadrius nivosus
Ormond Beach,
California, USA
Nikon D750 with 150–600mm
lens, 1/160 sec. at f/6.3, ISO 280
Alecia Smith, @alecia_birds

while others simply travel the neighborhood. But any bird can appear in front of you one second and disappear the next, and it is this unpredictability that makes even common birds exciting to see. Red-winged Blackbirds might be common in your area, and you might expect to see some whenever you go out, but if one is accommodating enough to perch in the open, close and well-lit, that is a rare treat and worth pausing to enjoy. A short walk through a city park, or simply looking out of your kitchen window, could reveal a different bird at any time.

Of course, the things birders tend to talk about are rare and dramatic sightings—those "once-in-a-lifetime" experiences. But these are, of course, rare. Most of the time our birdwatching efforts produce more routine sightings, such as a House Wren probing tangles of foliage, a Song Sparrow singing from the top of a thicket, a Ring-billed Gull flying overhead on its way to or from something more interesting, or a Red-tailed Hawk just sitting in a tree, watching. These sorts of "everyday" sightings could be considered unremarkable, as we can see them every day, but they are also pleasantly reassuring for the exact same reason—if the birds were gone there would be a an unnerving silence in our lives.

To see them anew we need to pause and simply watch. If we can open our senses to the everyday activities of a bird, another level opens up. There are moments of sublime beauty, peace, humor, and drama happening all the time. It is not so much

a question of getting to the right place at the right time—more often, the challenge is to recognize when we are already there. The photographers featured in this book have all shown that they are expert at anticipating those moments, and tripping the shutter before the moment has passed. This requires a deep understanding not only of the camera, but also of the birds, so you can make an educated guess about what your subject might do next and where to set up for the best angle and lighting. I salute the skill and dedication of these photographers, and cannot imagine the cumulative hours of work that went into the images that fill the pages of this book.

Beyond the technical skills and intuition needed to set up a successful shot, an eye for finding beauty in the ordinary is also needed when you want to capture a bird at its best. The birds in this book are, for the most part, just doing what they do—preening, resting, foraging, singing, interacting—and the camera has captured their beauty and grace in these unguarded moments. Each of the photographs in this book is, in essence, an informal portrait, but they come together to form a portfolio of "celebrities at work and at play." Just one fraction of a second offers a glimpse into the bird's world and into a much bigger story. Relax and enjoy their beauty, elegance, mystery, and charm.

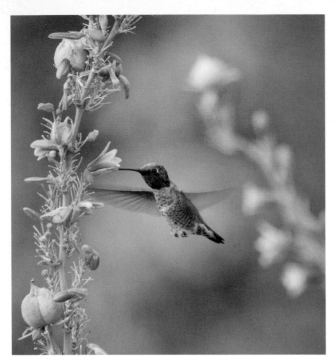
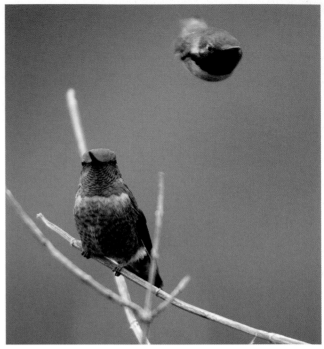

> **Violet Sabrewing**
> *Campylopterus hemileucurus*
> Vara Blanca, Heredia, Costa Rica
> *Nikon D500 with 70–200mm lens,*
> *1/1250 sec. at f/3.5, ISO 2000*
> Elijah Gildea, @elijahs_photography

∧ **Anna's Hummingbird**
⌐ *Calypte anna*
Redding, California, USA
Nikon D500 with 200–500mm lens,
1/250 sec. at f/6.3, ISO 800
Elijah Gildea, @elijahs_photography

"These Anna's Hummingbirds were
photographed in my backyard—I have
12 hummingbird feeders set up and
often have 50 or more birds present."

"The Violet Sabrewing is one of Costa
Rica's largest hummingbirds. This one
was photographed in the highlands of
Costa Rica where they come to feeders
at several lodges, providing plenty of
opportunities for great photographs."

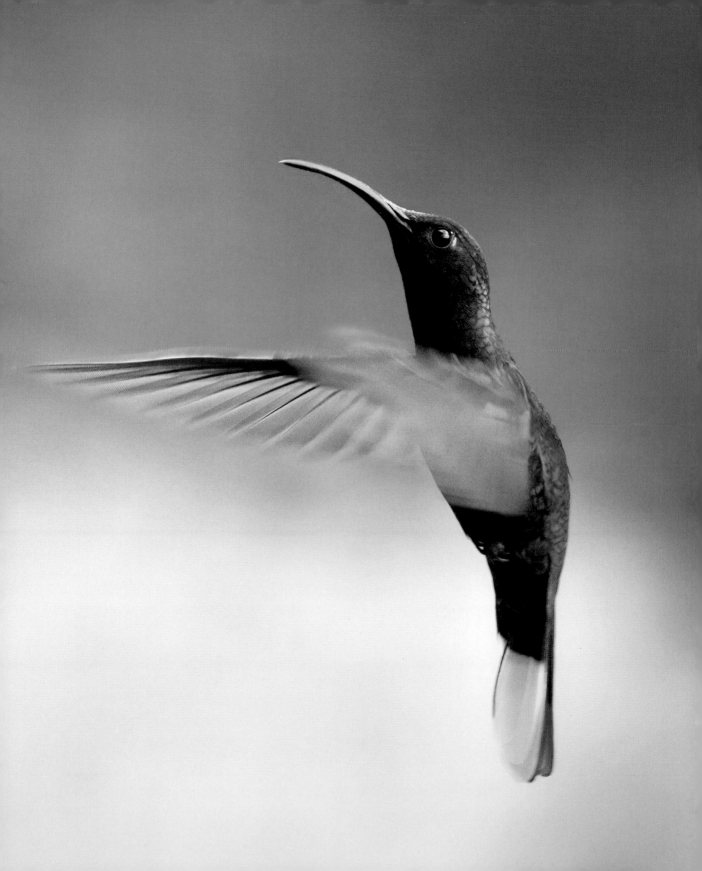

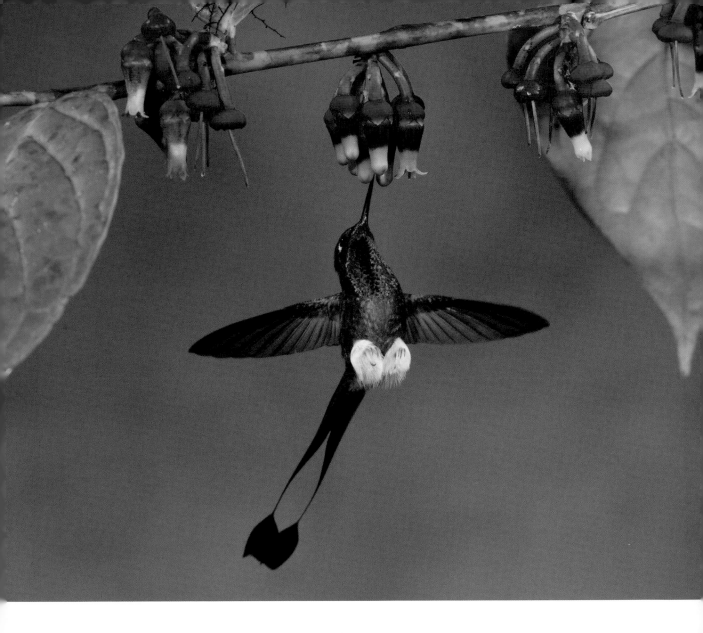

"The Booted Racket-Tail is one of the
world's most spectacular hummingbirds.
Here, a male bird feeds on a wildflower."

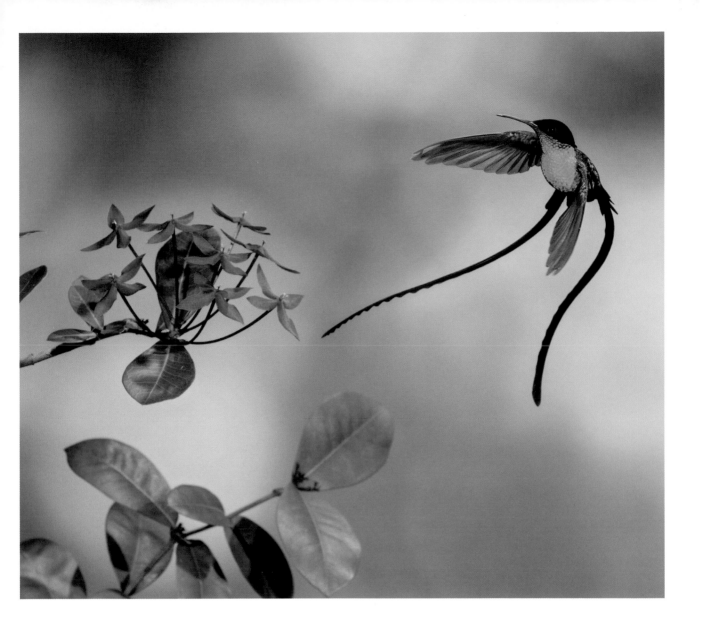

∧ **Streamertail (Black-billed morph)**
Trochilus polytmus
Eastern Jamaica
Canon EOS 7D MkII with 100–400mm
lens, 1/200 sec. at f/11, ISO 320
Glenn Bartley, @bartleys_photo_workshops

⌐ **Booted Racket-Tail**
Ocreatus underwoodii
Tandayapa Valley, Ecuador
Canon EOS 7D with 300mm lens,
1/250 sec. at f/9, ISO 200
Glenn Bartley, @bartleys_photo_workshops

"These little showstoppers are endemic to eastern Jamaica, so I was very excited when I had the chance to see and photograph them. Check out his incredible emerald iridescence and those streamers, which can be up to seven inches (18cm) long!"

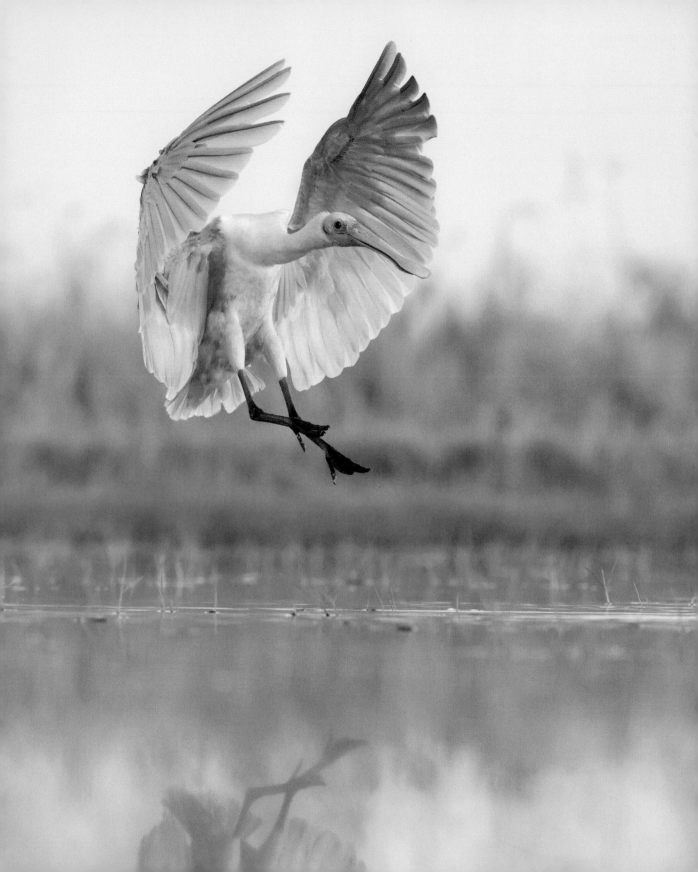

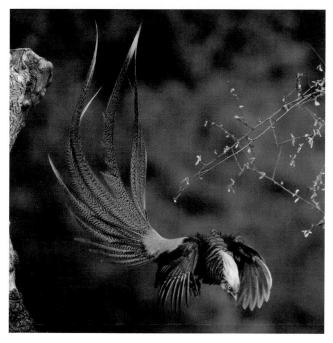

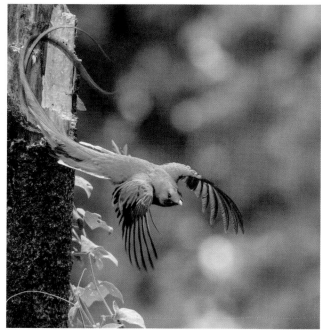

∧ Golden Pheasant
Chrysolophus pictus
Yunnan province, China
Sony α9 with 400mm lens, 1/2000 sec.
at f/4, ISO 10,000
Oleg Alexeyev, @oleg_alexeyev_photo

‹ Roseate Spoonbill
Platalea ajaja
Sarasota, Florida, USA
Nikon D850 with 500mm lens,
1/2500 sec. at f/5.6, ISO 2500
Peter Brannon, @peter.brannon

⌐ Resplendent Quetzal
Pharomachrus mocinno
Savegre Valley, Costa Rica
Canon EOS 7D MkII with 600mm lens,
1/1250 sec. at f/4.5, ISO 3200
Glenn Bartley, @bartleys_photo_workshops

› Snowy Egret
Egretta thula
Tampa, Florida, USA
Nikon D850 with 500mm lens,
1/4000 sec. at f/6.3, ISO 500
Peter Brannon, @peter.brannon

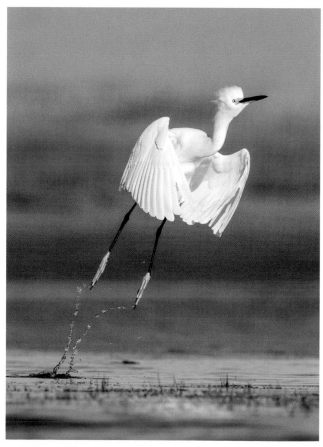

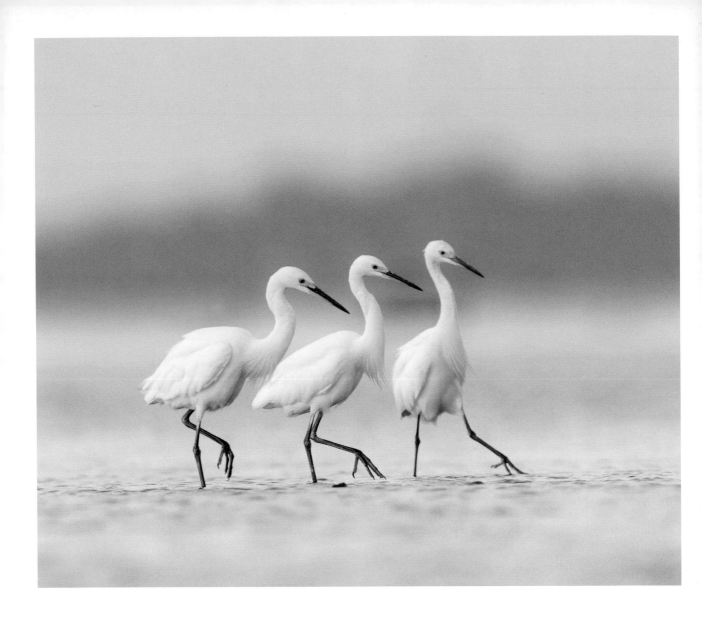

"Mass feeding occurs around the estuary when fish are in abundance, with egrets competing with other birds for fish."

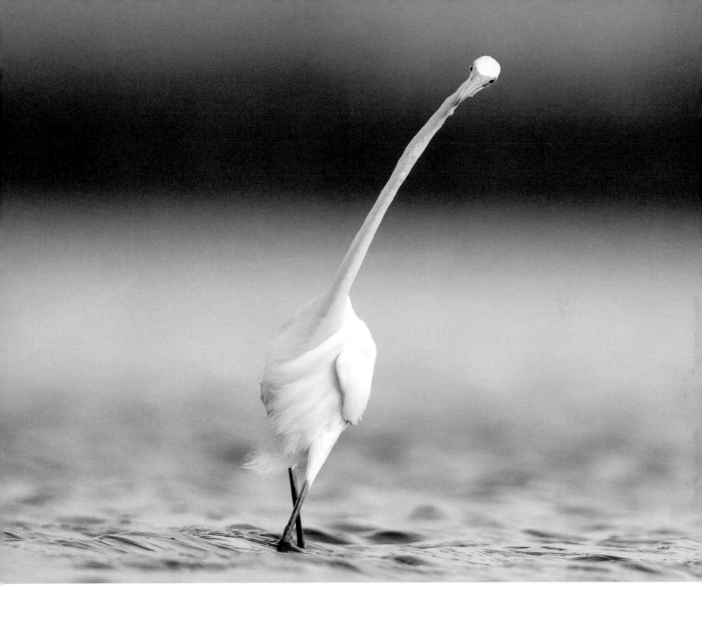

∧ **Great Egret**
Ardea alba
Mandurah, Australia
*Canon EOS 1D X MkII with 600mm lens and
1.4x teleconverter, 1/640 sec. at f/5.6, ISO 8000*
Georgina Steytler, @georgina_steytler

⌐ **Little Egret**
Egretta garzetta
Mandurah, Australia
*Canon EOS 1D X MkII with 600mm lens and
1 4x teleconverter, 1/500 sec. at f/7.1, ISO 4000*
Shelley Pearson, @shelley_pearson_

"It was a very windy evening and this
Great Egret was battling to keep his
head up!"

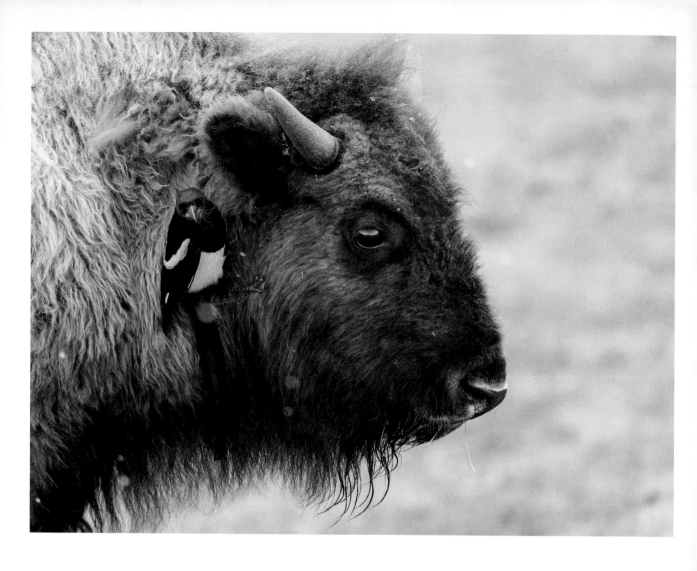

"I came across a herd of bison and started photographing them. All of a sudden, this magpie came down to one of the younger bison and started plucking the hair fibers from its cheek."

∧ **Black-billed Magpie & American bison**
Pica hudsonia & Bison bison
Yellowstone National Park, USA
Canon EOS 1D MkIV with 500mm lens and 1.4x teleconverter, 1/200 sec. at f/5.6, ISO 800
Ben Knoot, @benknoot

❯ **Eurasian Magpie & Red deer**
Pica pica & Cervus elaphus
Bristol, UK
Canon EOS 5D MkII with 100–400mm lens, 1/160 sec. at f/5.6, ISO 500
Mark Eastment, @markeastmentphotography

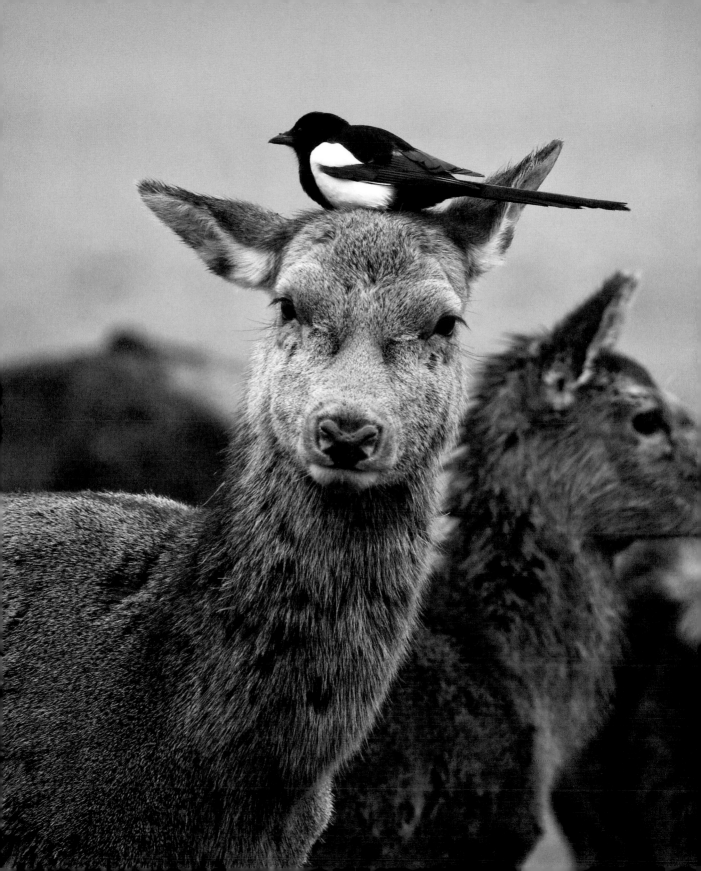

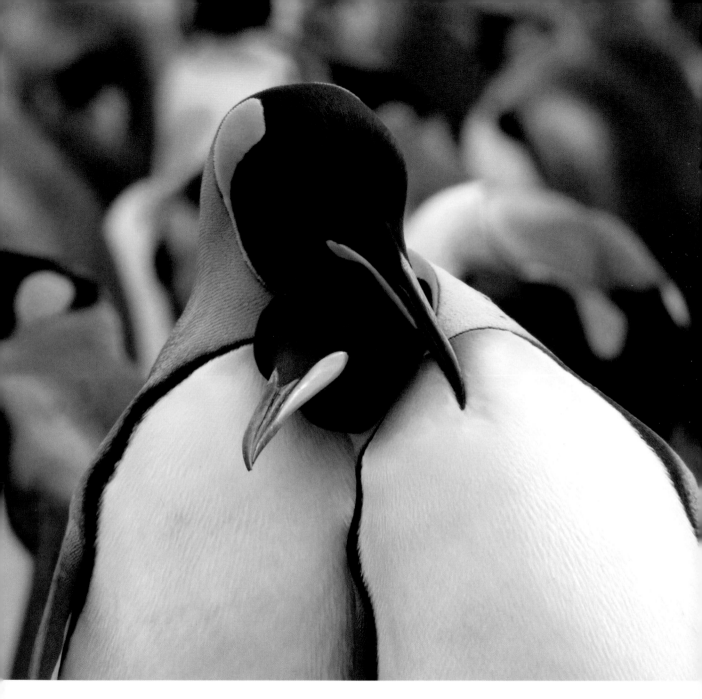

"I'm very fond of penguins, and have made three trips to Antarctica to photograph them. I've seen many penguin species, and the larger ones (such as the King Penguin) have an almost human way of embracing each other as a part of their courting display. This particular photo is very popular on Instagram, inspiring people to caption it with whatever comes to mind when they look at this scene."

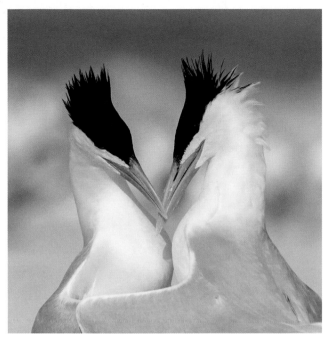

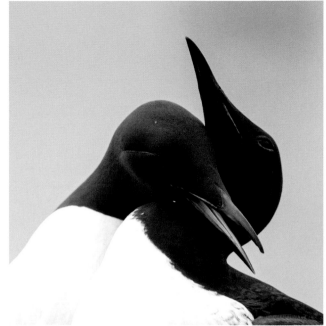

∧ Royal Tern
Thalasseus maximus
Tampa, Florida, USA
Nikon D600 with 300mm lens,
1/2000 sec. at f/7.1, ISO 280
Peter Brannon, @peter.brannon

< King Penguin
Aptenodytes patagonicus
Volunteer Point, Falkland Islands
Nikon D800 with 70–200mm lens,
1/1000 sec. at f/10, ISO 1000
Franka Slothouber, @frankaslothouber

⌐ Common Murre
Uria aalge
Hornøya, Norway
Canon EOS 1D X with 600mm lens and 1.4x
teleconverter, 1/1250 sec. at f/5.6, ISO 1600
Kimmo Lahikainen, @_lahki_birds_

> Northern Gannet
Morus bassanus
Grassholm Island, UK
Canon EOS 1D X with 70–200mm
lens, 1/3200 sec. at f/8, ISO 400
Drew Buckley, @drewbphotography

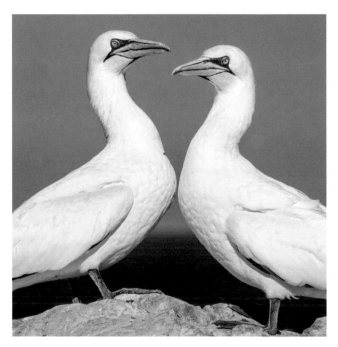

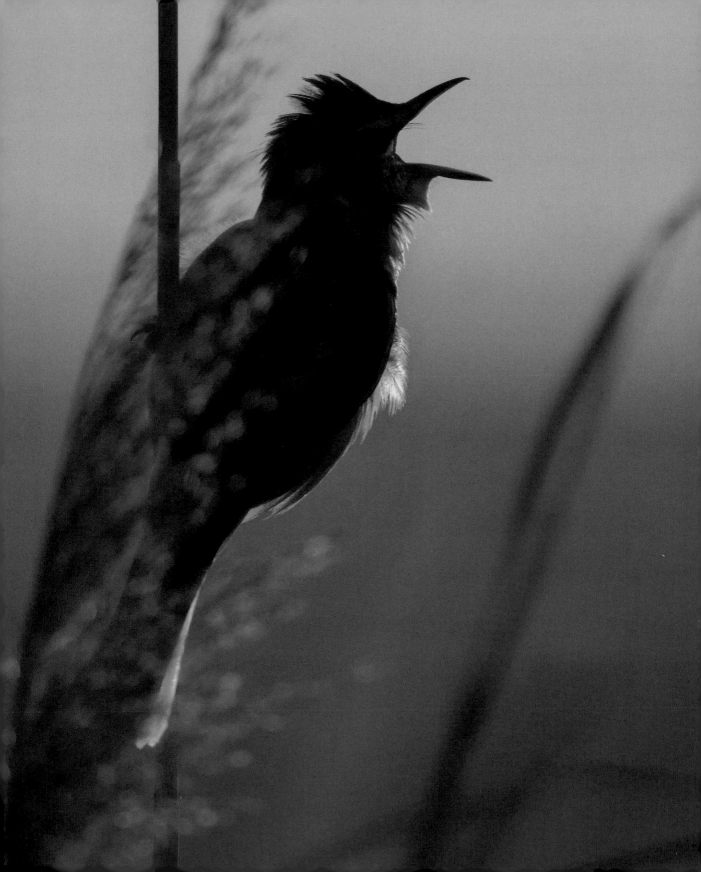

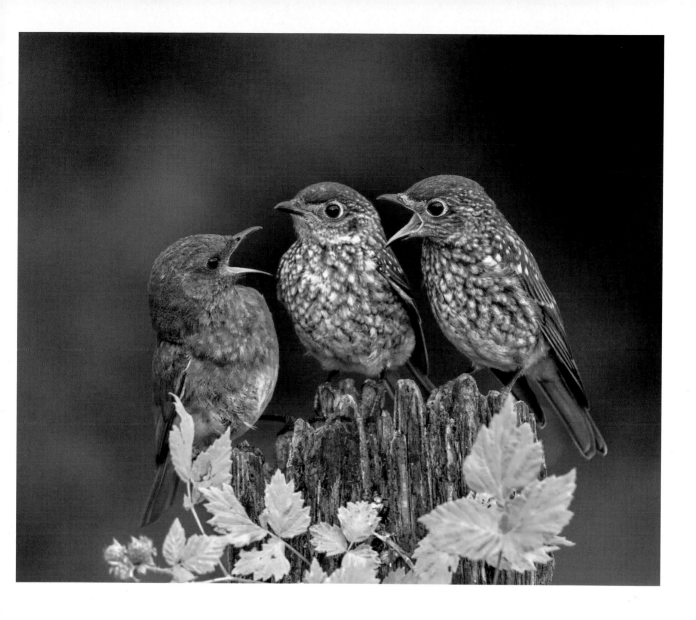

"I came across this Great Reed Warbler singing in the morning hours. This shot was taken from inside my car, using a beanbag to support the lens."

∧ **Eastern Bluebird**
Sialia sialis
St. Catharines, Ontario, Canada
Nikon D7200 with 300mm lens and 1.4x teleconverter, 1/200 sec. at f/7.1, ISO 640
Robert. S. Parker, @robert.s.parker

‹ **Great Reed Warbler**
Acrocephalus arundinaceus
Lake Neusiedl, Austria
Nikon D2X with 500mm lens and 1.4x teleconverter, 1/1000 sec. at f/5.6, ISO 500
Robert Kreinz, @rkreinz

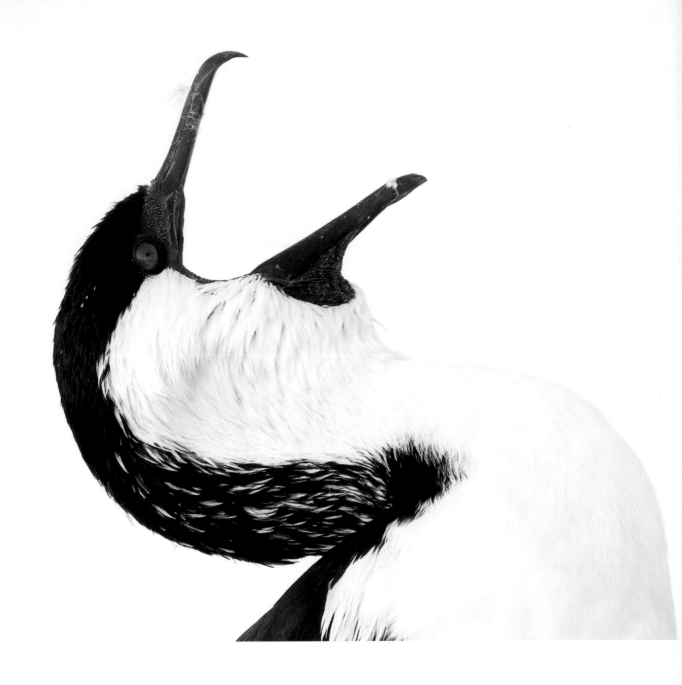

"Cormorants are often overlooked as photographic subjects, but they are one of my favorites because they are so full of personality. I bent down for this shot to get the white sky behind the bird's head, rather than blue water."

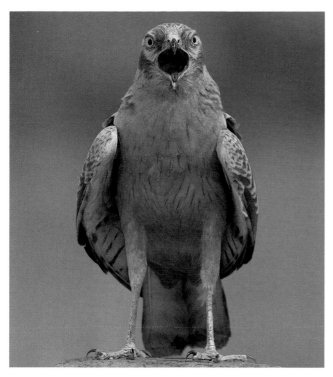

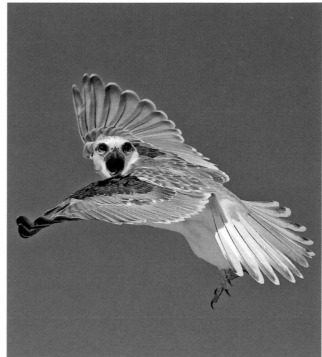

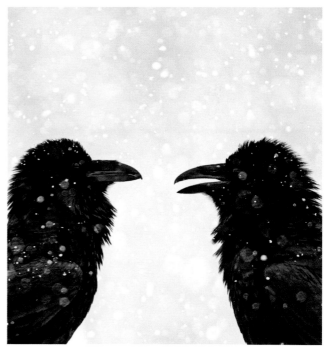

⌃ Montagu's Harrier
Circus pygargus
Pune, Maharashtra, India
Nikon D7200 with 200–500mm
lens, 1/500 sec. at f/8, ISO 200
Digvijay Chaugle, @_birdboy_

‹ Black-faced Cormorant
Phalacrocorax fuscescens
Kingscote, Kangaroo Island, Australia
Canon EOS 1D X with 100–400mm lens and
1.4x teleconverter, 1/1000 sec. at f/8, ISO 3200
Georgina Steytler, @georgina_steytler

⌐ Black-shouldered Kite
Elanus axillaris
Toodyay, Australia
Canon EOS 1D X with 500mm
lens, 1/4000 sec. at f/8, ISO 1250
Georgina Steytler, @georgina_steytler

› Common Raven
Corvus corax
Kuusamo, Finland
Canon EOS 1D MkIII with 500mm
lens, 1/1250 sec. at f/4, ISO 800
Kimmo Lahikainen, @_lahki_birds_

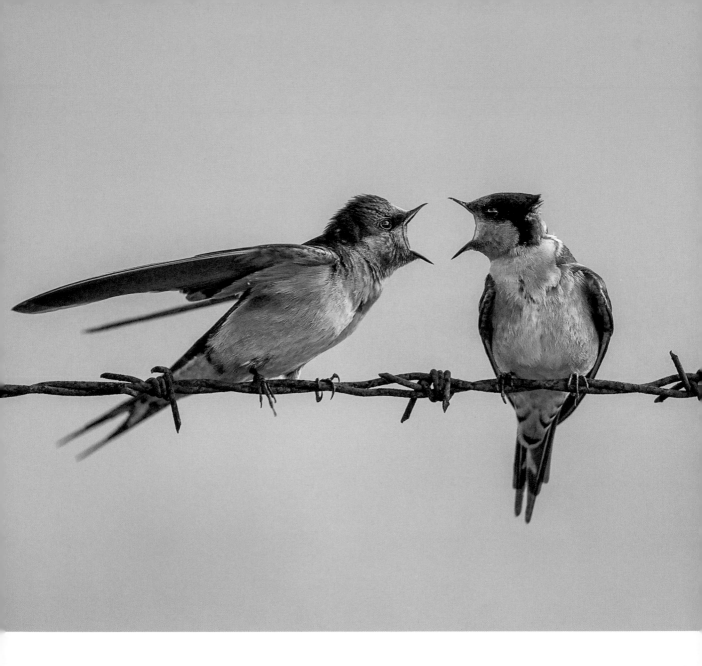

"I was driving home in my car after photographing at a lake, when I spotted these birds on the fence line. A car makes a great mobile bird blind, and as long as I stayed inside I knew the birds would not move. I took this image through the passenger side, resting my long lens on the window. Using high speed continuous shutter mode I was able to capture the moment the birds had a minor disagreement!"

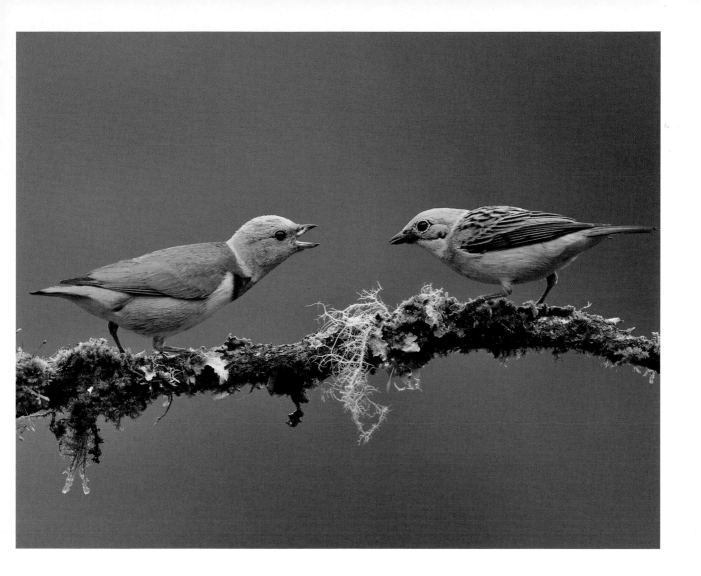

∧ **Golden-browed Chlorophonia &
Silver-throated Tanager**
*Chlorophonia callophrys
& Tangara icterocephala*
Near Los Quetzales National Park,
Costa Rica
*Nikon D850 with 500mm lens and 1.4x
teleconverter, 1/800 sec. at f/5.6, ISO 500*
John Crawley, @jc_wings

⌐ **Welcome Swallow**
Hirundo neoxena
Lake McLarty, Australia
*Canon EOS 1Ds MkIII with 500mm lens and
1.4x teleconverter, 1/500 sec. at f/7.1, ISO 320*
Georgina Steytler, @georgina_steytler

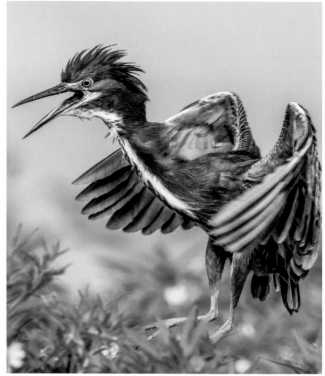

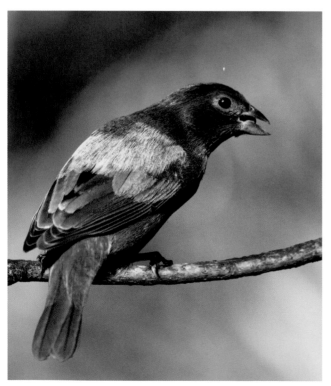

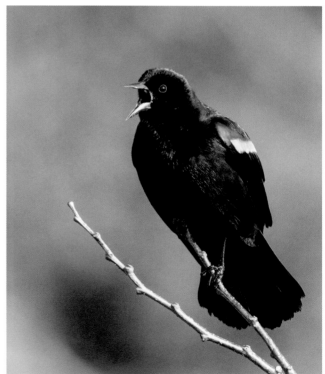

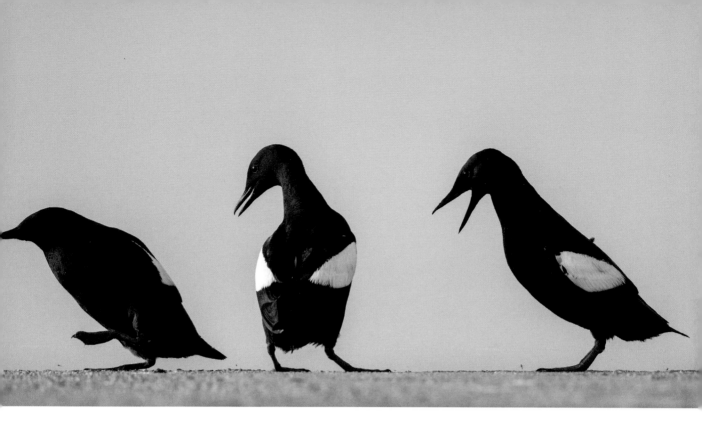

┌┌ **Indigo Bunting**
Passerina cyanea
Niagara, Ontario, Canada
Nikon D500 with 500mm lens,
1/320 sec. at f/6.3, ISO 800
Robert S. Parker, @robert.s.parker

┌ **Green Heron**
Butorides virescens
Wellington, Florida, USA
Nikon D850 with 500mm lens,
1/2500 sec. at f/8, ISO 500
Greg Christoph, @gregxoph

˄ **Black Guillemot**
Cepphus grylle
Norrskär, Finland
Canon EOS 1D X with 600mm
lens and 1.4x teleconverter,
1/3200 sec. at f/5.6, ISO 1600
Kimmo Lahikainen, @_lahki_birds_

‹‹ **Painted Bunting**
Passerina ciris
West Palm Beach,
Florida, USA
Nikon D850 with 500mm lens
and 1.4x teleconverter, 1/800
sec. at f/6.3, ISO 200
Greg Christoph, @gregxoph

‹ **Red-winged Blackbird**
Agelaius phoeniceus
Boynton Beach, Florida, USA
Nikon D750 with 500mm lens,
1/1600 sec. at f/8, ISO 1800
Greg Christoph, @gregxoph

"Norrskär is a lighthouse island in
the Gulf of Bothnia. Fearless Black
Guillemots nest on the island's
breakwater."

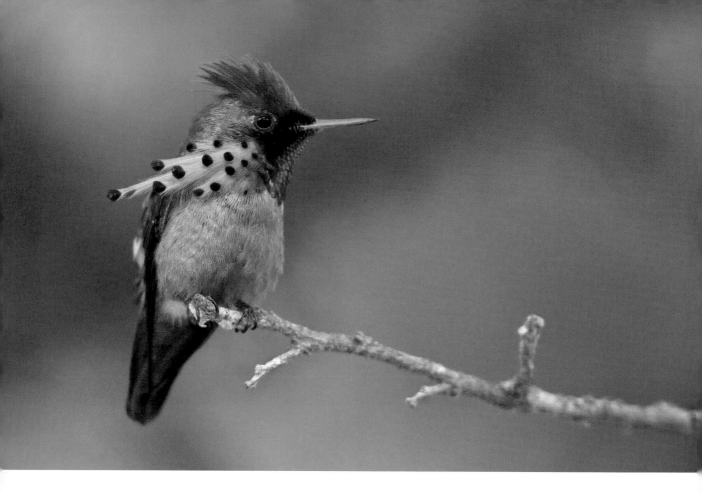

⌃ Tufted Coquette
Lophornis ornatus
Asa Wright Nature Center, Trinidad
Canon EOS 7D with 500mm lens and 1.4x teleconverter, 1/200 sec. at f/5.6, ISO 800
Glenn Bartley, @bartleys_photo_workshops

⌐ Long-tailed Sylph
Aglaiocercus kingii
San Isidro, Ecuador
Nikon D5 with 500mm lens, 1/2000 sec. at f/7.1, ISO 10,000
John Crawley, @jc_wings

⌐ Indian Paradise-Flycatcher
Terpsiphone paradisi
Nagarhole National Park, Karnataka, India
Nikon D750 with 200–500mm lens, 1/400 sec. at f/5.6, ISO 1000
Pradeep Purushothaman, @pradeep.wildlens

> Rainbow Bee-Eater
Merops ornatus
Ballina, New South Wales, Australia
Nikon D800E with 300mm lens, 1/800 sec. at f/6.3, ISO 500
Scott Rolph, @aussiebirdphotography

>> Van Hasselt's Sunbird
Leptocoma brasiliana
Bukit Batok, Singapore
Nikon D500 with 400mm lens, 1/200 sec. at f/5.6, ISO 720
Vincent Chiang, @vincent_ckx

"A tiny, male Tufted Coquette. Although it weighs in at less than one tenth of an ounce (2.3g) this ball of feathers is definitely one of the most spectacular hummingbirds there is!"

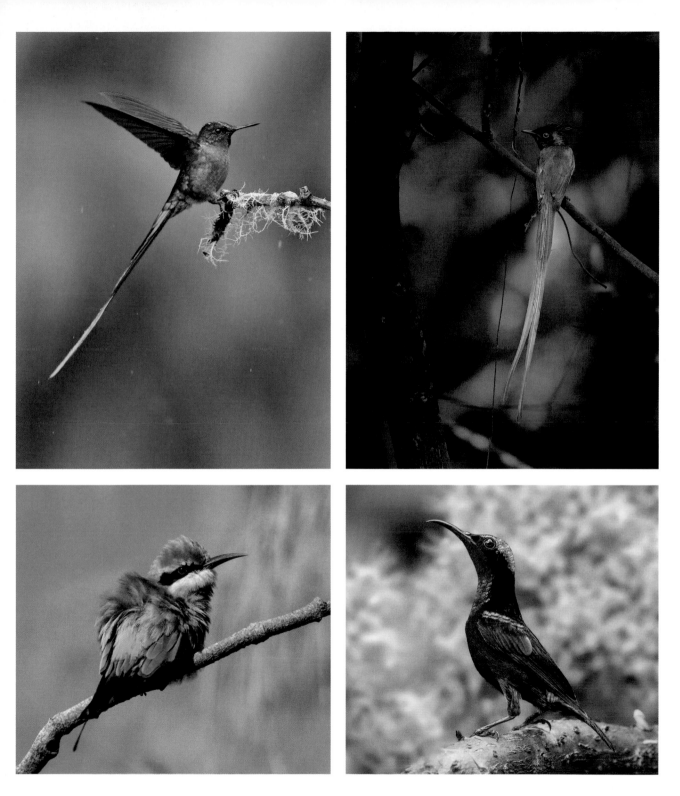

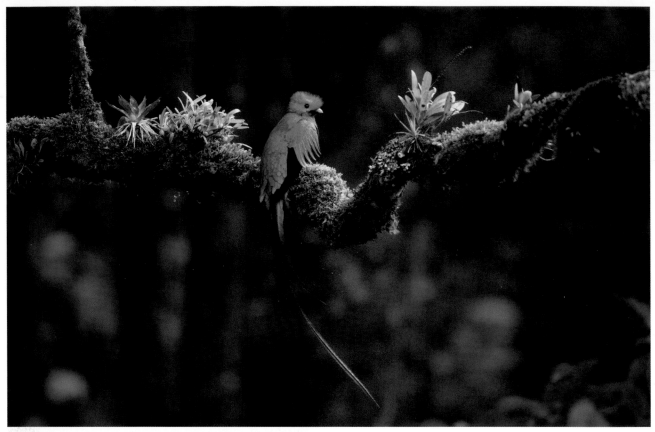

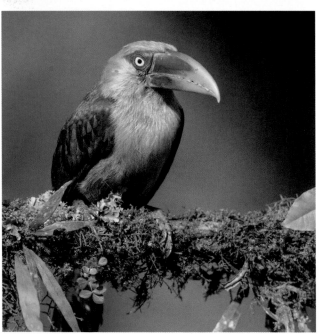

∧ **Resplendent Quetzal**
Pharomachrus mocinno
Talamanca Mountains, Costa Rica
Canon EOS 5D MkIII with 500mm lens and
1.4x teleconverter, 1/320 sec. at f/5.6, ISO 1600
Jess Findlay, @jessfindlay

‹ **Saffron Toucanet**
Pteroglossus bailloni
Atlantic Rainforest, Brazil
Canon EOS 7D with 600mm lens,
1/2000 sec. at f/4.5, ISO 400
Glenn Bartley, @bartleys_photo_workshops

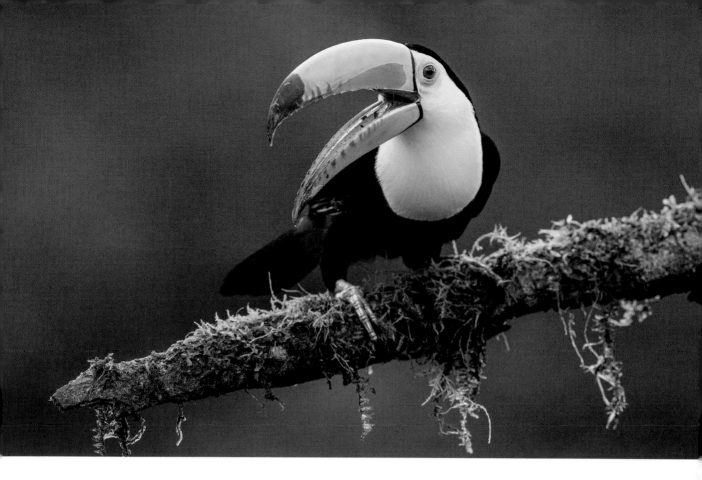

⌃ Keel-billed Toucan
Ramphastos sulfuratus
Costa Rica
*Canon EOS 1D X MkII with 400mm
lens, 1/640 sec. at f/5.6, ISO 1000*
Praveen Siddannavar, @praveensiddannavar

"Costa Rica has amazing biodiversity
and is a must-visit destination for
nature lovers. After just three days of
my trip I had already photographed
more than 50 bird species."

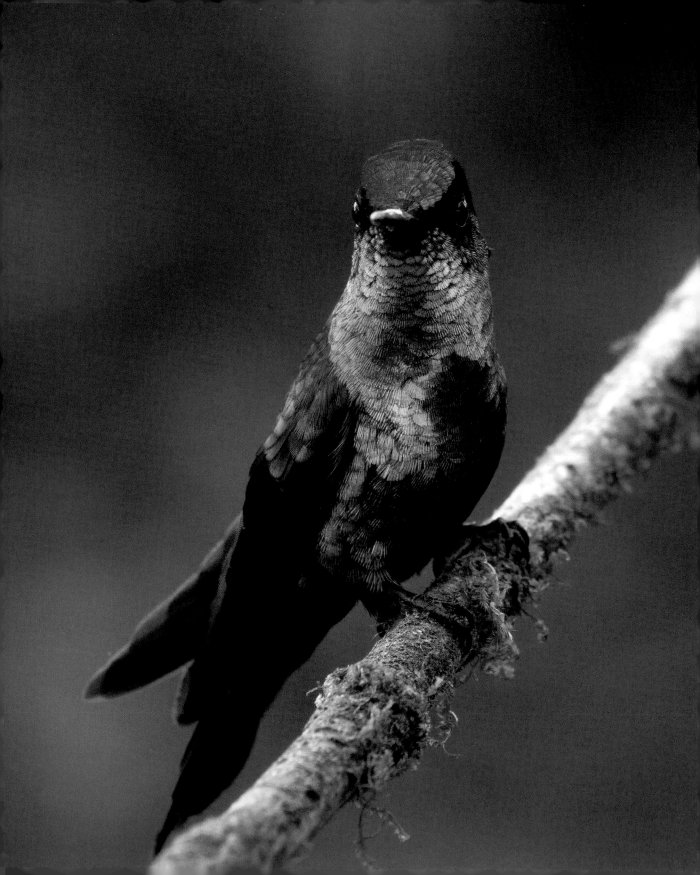

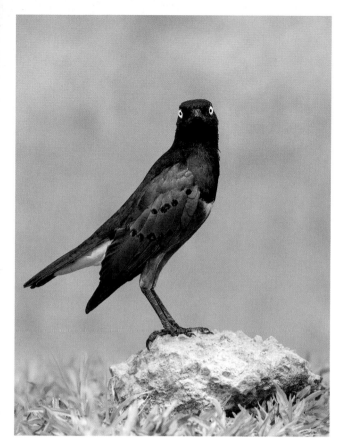

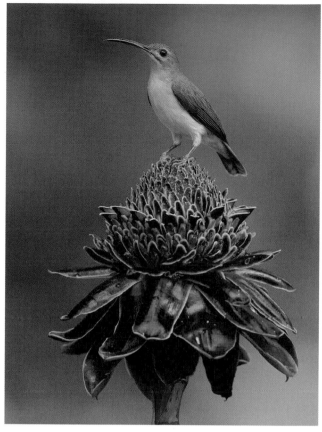

^ **Little Spiderhunter**
Arachnothera longirostra
Tattekad, Kerala, India
Canon EOS 1D X with 500mm lens,
1/500 sec. at f/4, ISO 800
Praveen Siddannavar, @praveensiddannavar

⌐ **Superb Starling**
Lamprotornis superbus
Pioneer Road, Singapore
Canon EOS 7D MkII with 100–400mm
lens, 1/500 sec. at f/5, ISO 200
Vincent Chiang, @vincent_ckx

< **Fiery-throated Hummingbird**
Panterpe insignis
La Trinidad, Dota, San José, Costa Rica
Nikon D500 with 200–500mm lens,
1/1250 sec. at f/7.1, ISO 2500
Elijah Gildea, @elijahs_photography

"The Fiery-throated Hummingbird is
found in the highlands of Costa Rica,
and is quite a common sight in the
montane forest canopy."

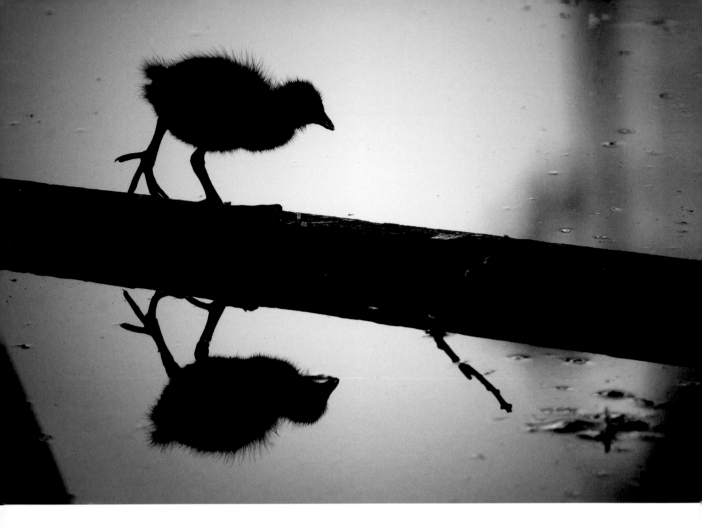

"I photographed this moorhen chick at dawn, walking around the base of the gibbon enclosure at a zoo. It was great watching it explore the water's edge, occasionally pecking at potential food. The light was not great, so it was hard to get a good shot, but when it walked along this wooden plank I saw the opportunity for a nice silhouette."

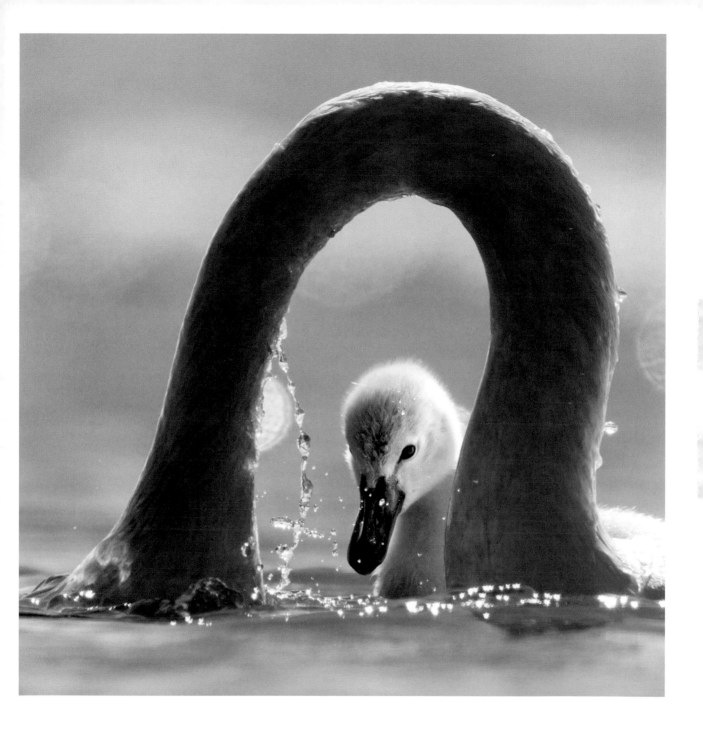

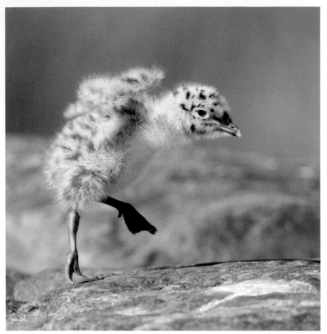 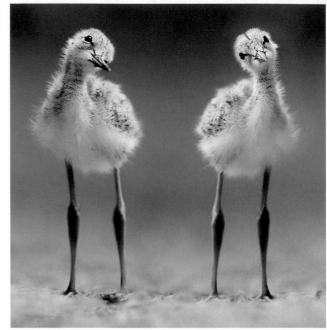

∧ **Mew Gull**
Larus canus
Vålö, Finland
*Canon EOS 5D MkIV with 600mm
lens and 1.4x teleconverter, 1/2500
sec. at f/6.3, ISO 400*
Kimmo Lahikainen, @_lahki_birds_

⌐ **Black-winged Stilt**
Himantopus himantopus
*Canon EOS 1D MkIII with 300mm
lens, 1/1500 sec. at f/2.8, ISO 500*
Stefano Ronchi, @stefanoronchi

〉 **Black Swan**
Cygnus atratus
Vogelpark Avifauna,
the Netherlands
*Nikon D5600 with 150–600mm
lens, 1/125 sec. at f/6, ISO 4500*
Femke van Willigen, @ajoebowan

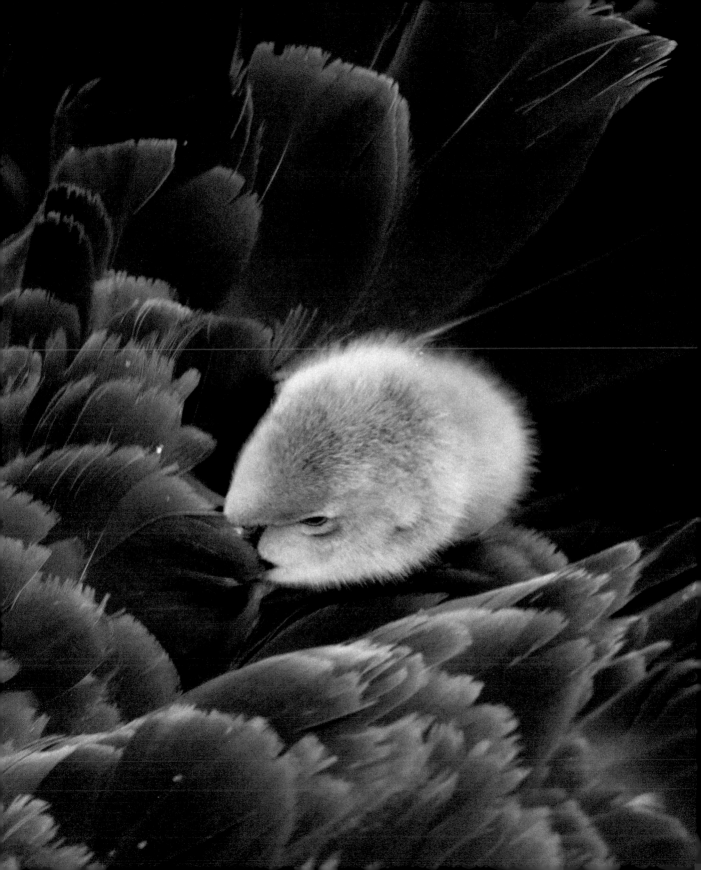

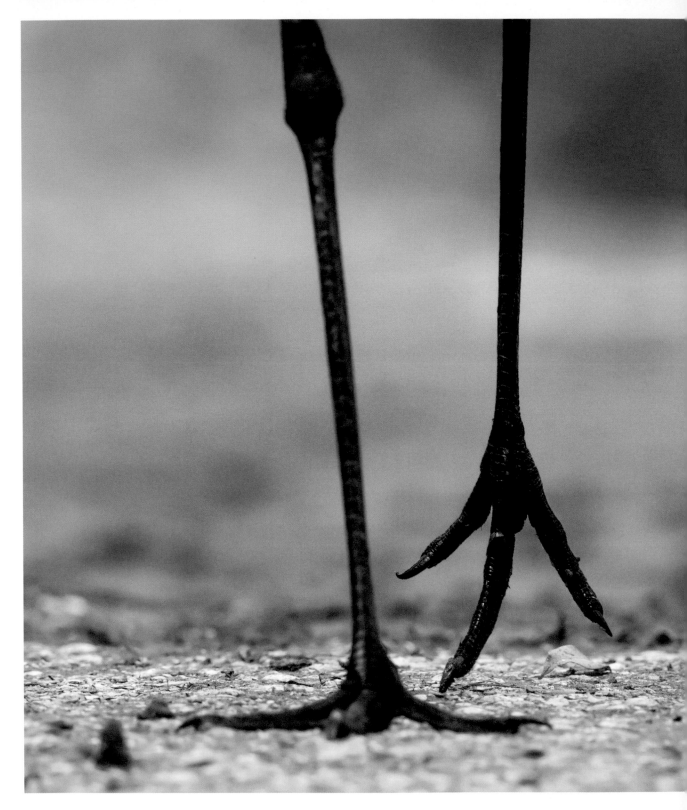

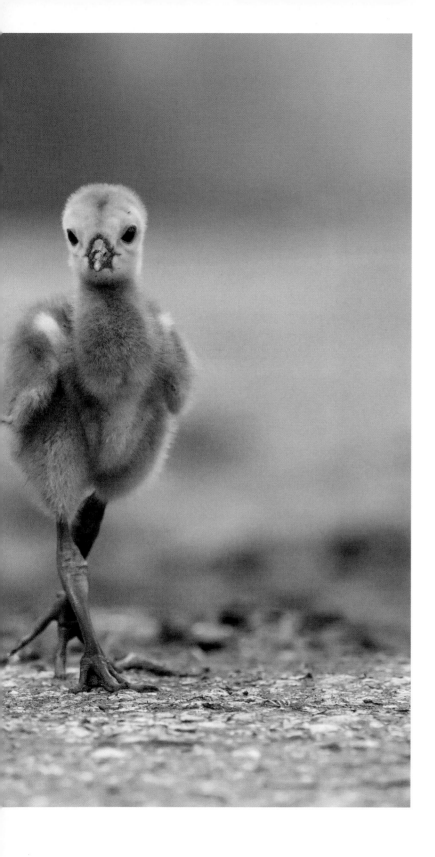

< Sandhill Crane
Antigone canadensis
Lakeland, Florida, USA
Nikon D500 with 500mm lens,
1/1600 sec. at f/5.6, ISO 1000
Peter Brannon, @peter.brannon

"I was exploring a nature
trail when I happened upon
a family of Sandhill Cranes
walking in my direction.
I moved to the side of the
trail, laid down on my belly,
and readied my camera.
The young colt followed
the mother around dutifully,
almost mimicking her
behavior. When I went
through my photos, this
one captured the moment
the best, with the little one
following perfectly in step."

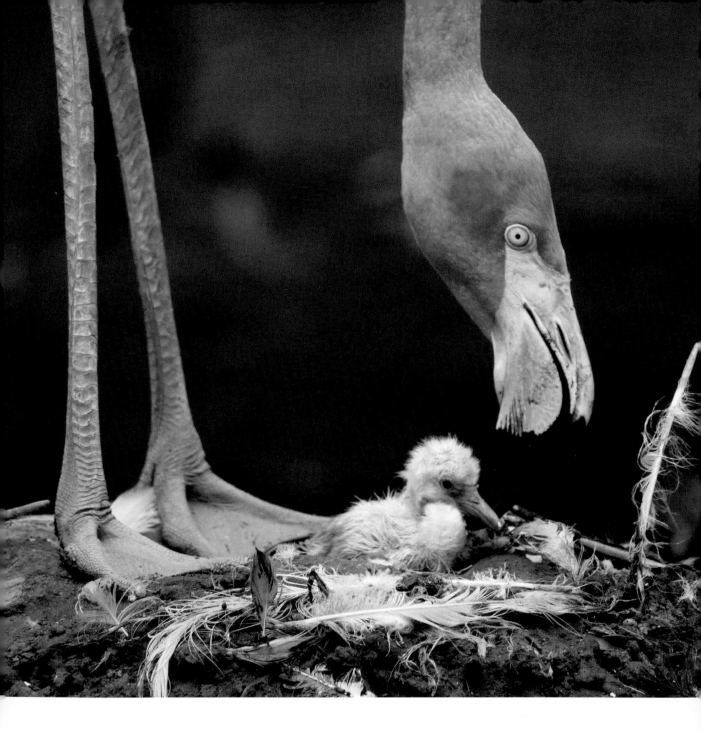

"This baby had hatched moments before I took this shot, and was still wet from the eggsack. Mom was already tenderly caring for it, making sure that her baby was okay."

American Flamingo
Phoenicopterus ruber
Vogelpark Avifauna,
the Netherlands
Nikon D5600 with 150–
600mm lens, 1/1600 sec.
at f/6.3, ISO 2000
Femke van Willigen,
@ajoebowan

American Flamingo
Phoenicopterus ruber
Vogelpark Avifauna,
the Netherlands
Nikon D5600 with 150–
600mm lens, 1/400 sec.
at f/6.3, ISO 400
Femke van Willigen,
@ajoebowan

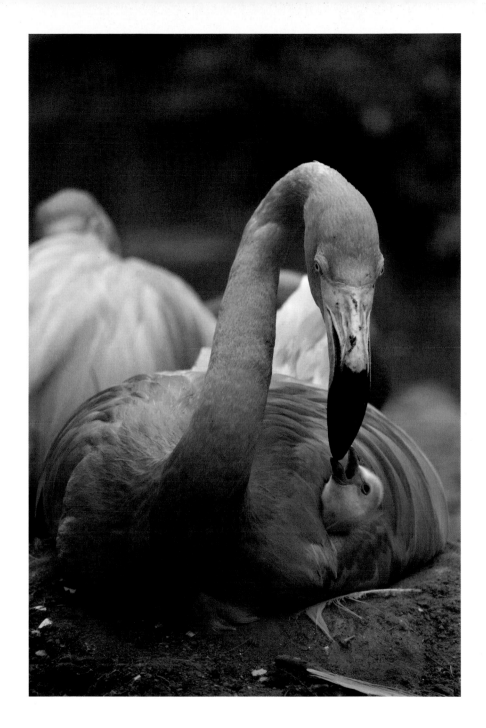

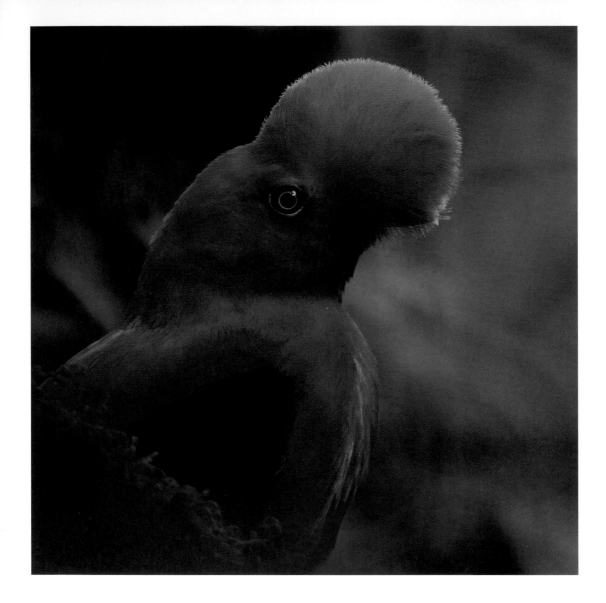

∧ **Andean Cock-Of-The-Rock**
Rupicola peruvianus
Jardín, Colombia
Nikon D500 with 200–500mm lens,
1/320 sec. at f/7.1, ISO 3200
Elijah Gildea, @elijahs_photography

〉 **King Vulture**
Sarcoramphus papa
San Carlos, Alajuela, Costa Rica
Nikon D500 with 200–500mm lens,
1/1600 sec. at f/6.3, ISO 1600
Elijah Gildea, @elijahs_photography

"I watched a bunch of males dance all day for a single lady—hilariously entertaining."

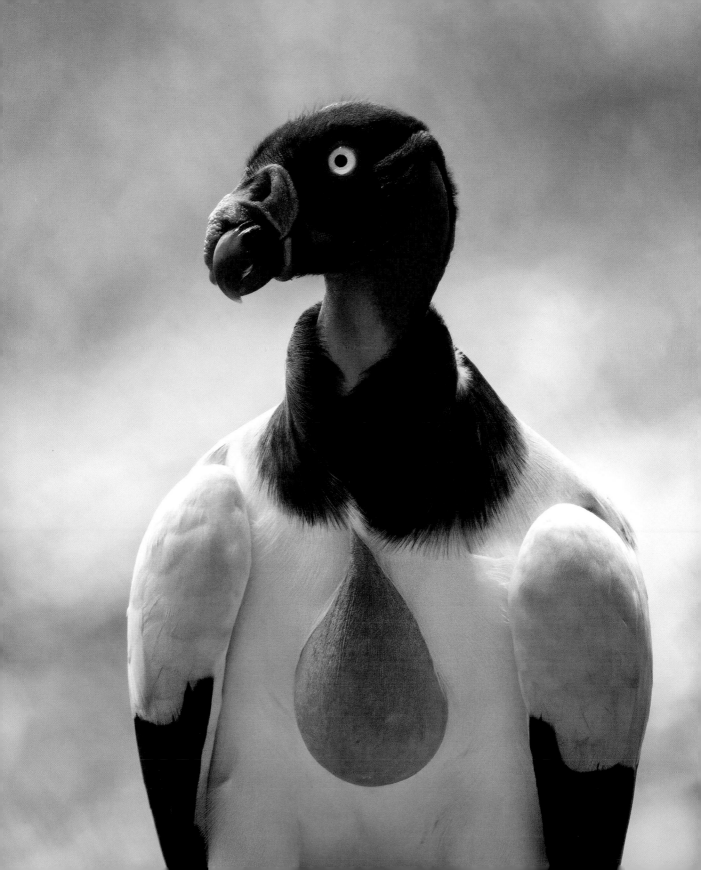

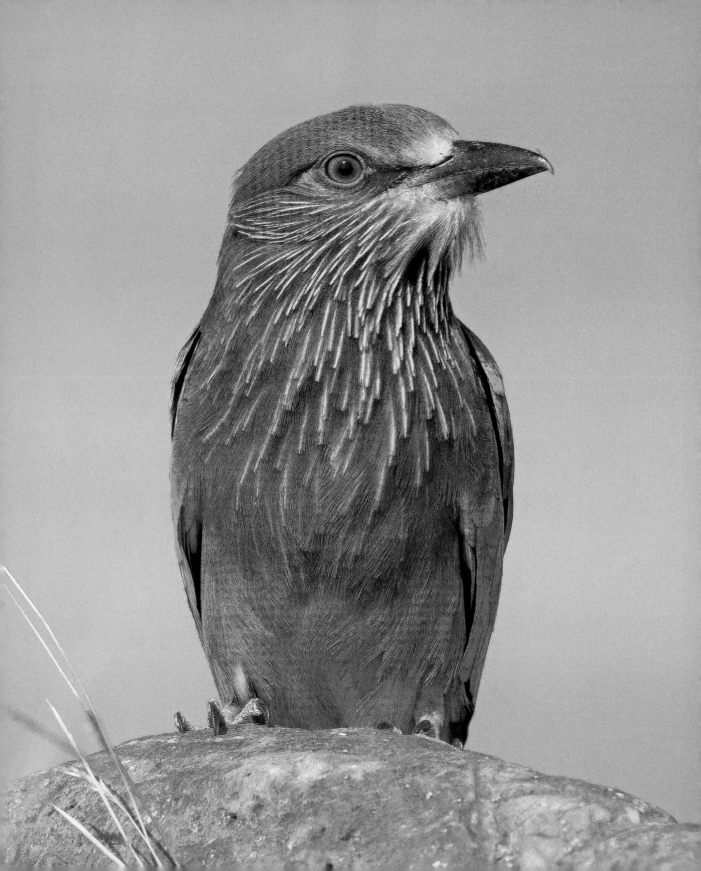

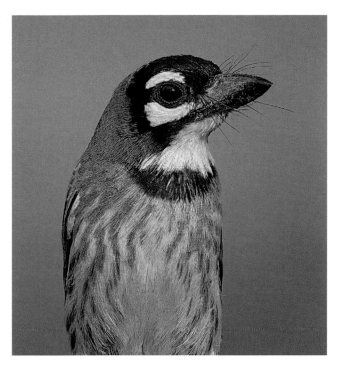

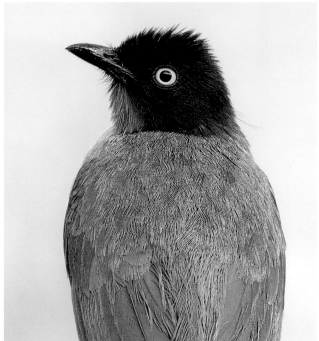

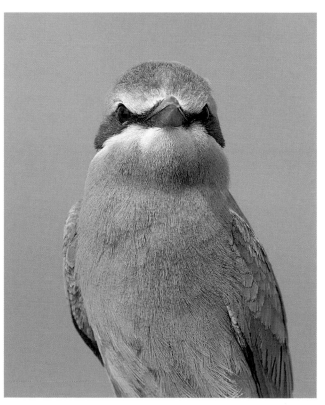

∧ **Coppersmith Barbet**
Psilopogon haemacephalus
Bengaluru, Karnataka, India
Nikon D7200 with 200–500mm
lens, 1/800 sec. at f/8, ISO 400
Digvijay Chaugle, @_birdboy_

‹ **Blue-cheeked Bee-Eater**
Merops persicus
Pune, Maharashtra, India
Nikon D7200 with 200–500mm
lens, 1/800 sec. at f/8, ISO 400
Digvijay Chaugle, @_birdboy_

¬ **Flame-throated Bulbul**
Rubigula gularis
Munnar, Kerala, India
Nikon D7200 with 200–500mm
lens, 1/100 sec. at f/8, ISO 400
Digvijay Chaugle, @_birdboy_

› **Indian Roller**
Coracias benghalensis
Pune, Maharashtra, India
Nikon D7200 with 200–500mm
lens, 1/640 sec. at f/8, ISO 200
Digvijay Chaugle, @_birdboy_

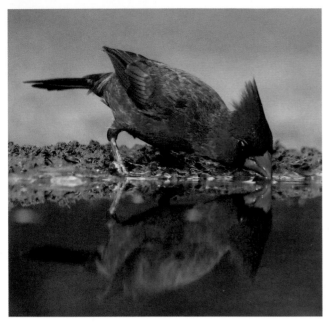

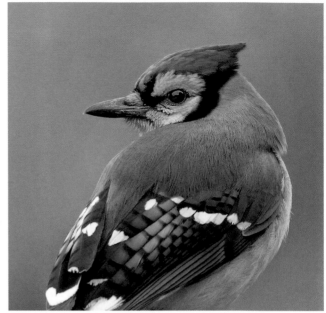

∧ **Northern Cardinal**
Cardinalis cardinalis
Santa Clara Wildlife Ranch, Texas, USA
Canon EOS 5D MkIV with 150–600mm lens,
1/1250 sec. at f/6.3, ISO 640
Eli Martinez, @sdmdiving

⌐ **Blue Jay**
Cyanocitta cristata
London, Ontario, Canada
Olympus OM-D E-M1 with 300mm
lens, 1/1000 sec. at f/5.6, ISO 640
Kevin Biskaborn, @kevinbiskaborn

> **Crested Barbet**
Trachyphonus vaillantii
Kruger National Park,
South Africa
Canon EOS 40D with 100–400mm
lens, 1/800 sec. at f/9, ISO 400
Heinrich Human, @heinrich_human

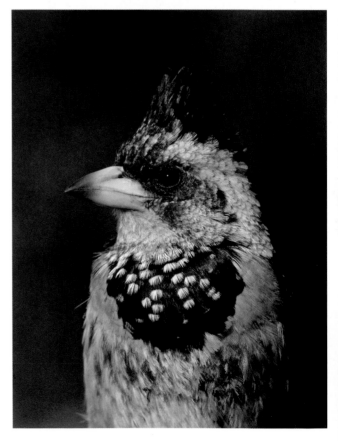

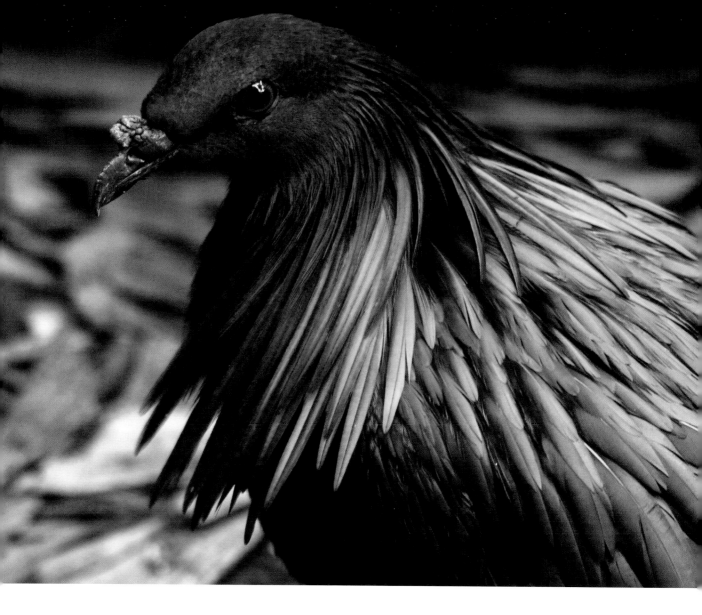

⌃ Nicobar Pigeon
Caloenas nicobarica
Vogelpark Avifauna,
the Netherlands
Nikon D5600 with 150–600mm
lens, 1/30 sec. at f/5.3, ISO 2000
Femke van Willigen, @ajoebowan

"The plumage of the Nicobar Pigeon is truly astonishing—it is full of color and its iridescence changes depending on how the light catches it."

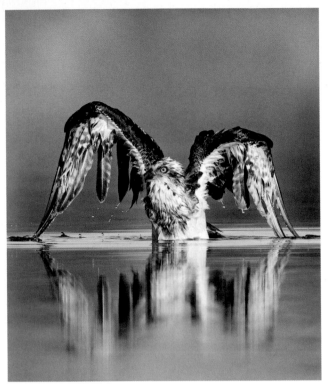

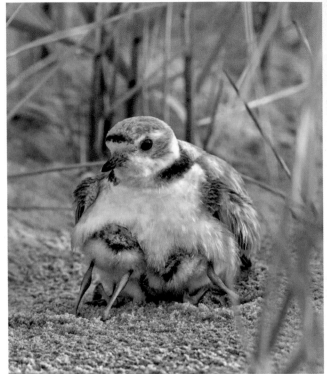

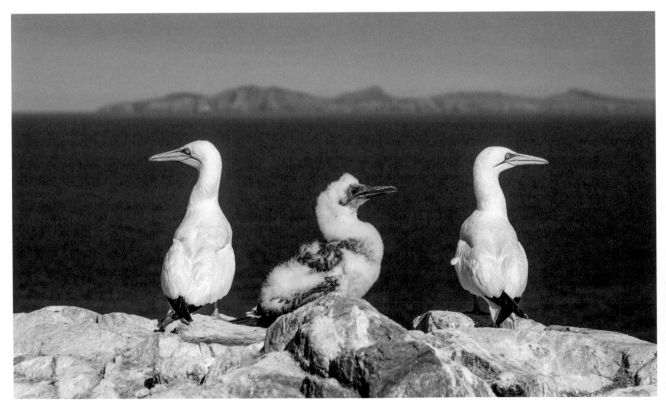

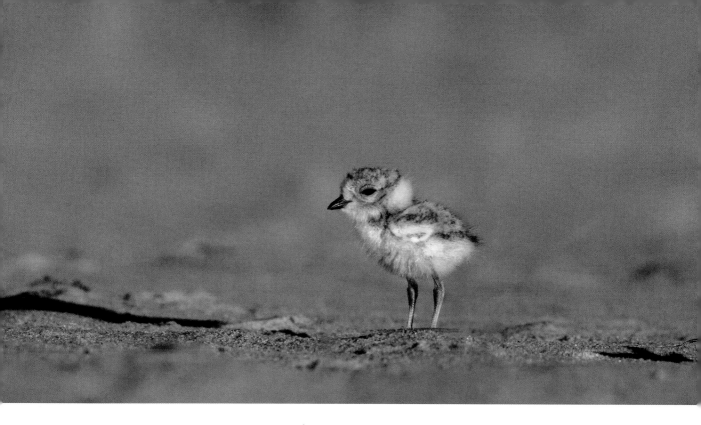

⌐⌐ Osprey
Pandion haliaetus
Mandurah, Australia
Canon EOS 1D X with 500mm lens and 1.4x teleconverter, 1/1600 sec. at f/7.1, ISO 800
Shelley Pearson, @shelley_pearson_

⌐ Piping Plover
Charadrius melodus
Nickerson Beach, Long Island,
New York, USA
Nikon D500 with 500mm lens and 1.7x teleconverter, 1/500 sec. at f/9, ISO 800
Robert S. Parker, @robert.s.parker

< Northern Gannet
Morus bassanus
Grassholm Island, UK
Canon EOS 1D X with 70–200mm lens, 1/1600 sec. at f/10, ISO 400
Drew Buckley, @drewbphotography

ʌ Piping Plover
Charadrius melodus
Nickerson Beach, Long
Island, New York, USA
Nikon D500 with 500mm lens and 1.4x teleconverter, 1/1600 sec. at f/8, ISO 500
Robert S. Parker, @robert.s.parker

"I had heard so much about the shorebirds of Nickerson Beach that I decided to embark on a long, eight-hour drive from my home in Ontario. I arrived at the beach just after 5am, as the sun was peeking over the horizon, and walked across the cool, deep sand to where the Piping Plovers were nesting. The light was magical and to my delight I saw this newly hatched chick scurrying over the sun-kissed sands. It was a moment I will never forget."

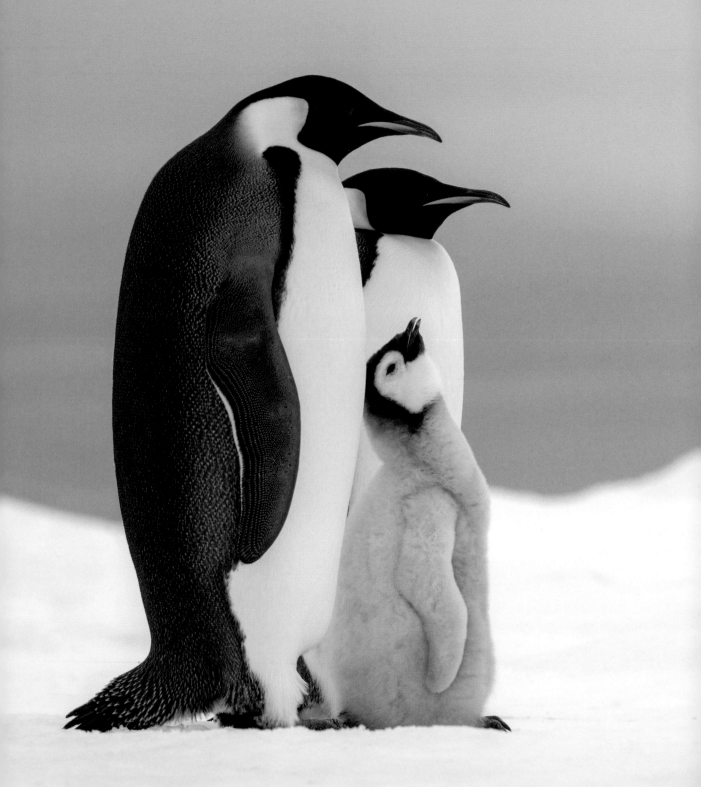

< **Emperor Penguin**
Aptenodytes forsteri
Snow Hill Island,
Antarctica
Nikon D850 with 70–200mm
lens, 1/1250 sec. at f/8, ISO 200
Franka Slothouber,
@frankaslothouber

> **Emperor Penguin**
Aptenodytes forsteri
Snow Hill Island,
Antarctica
Nikon D500 with 70–200mm
lens and 1.4x teleconverter,
1/1600 sec. at f/10, ISO 640
Franka Slothouber,
@frankaslothouber

⌐ **King Penguin**
Aptenodytes patagonicus
St. Andrews Bay,
South Georgia
Canon EOS 5D MkIII with
100–400mm lens, 1/1000
sec. at f/8, ISO 200
James Lowe, @jameslowe783

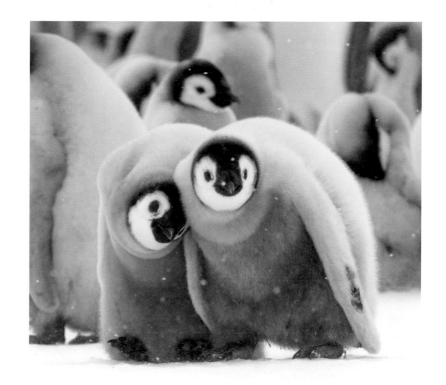

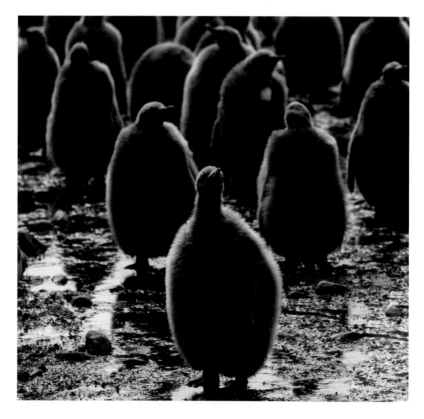

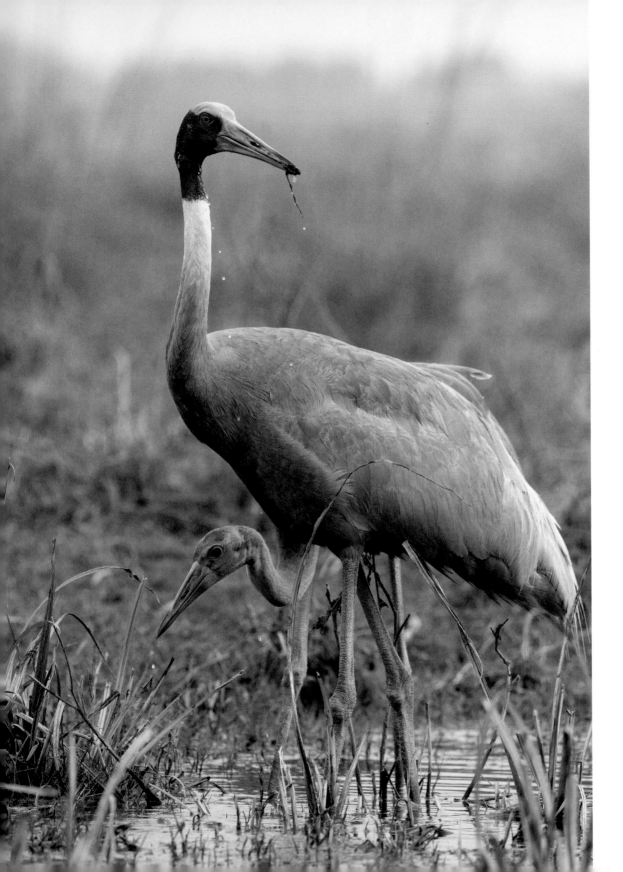

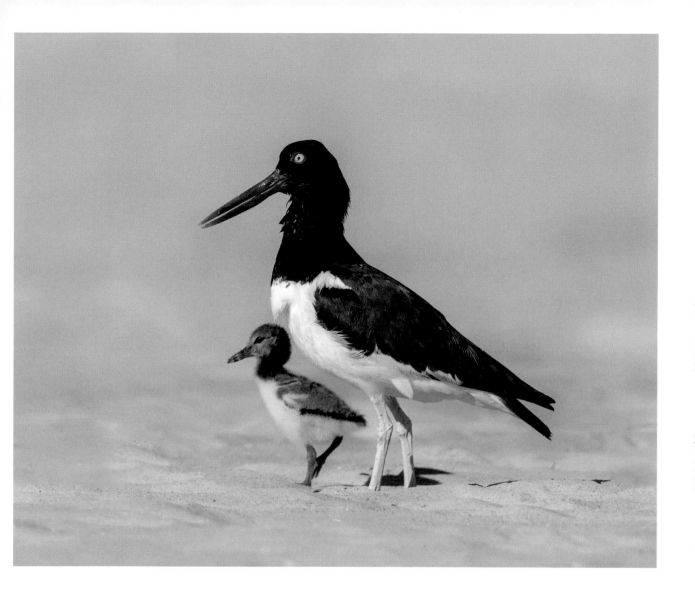

"I saw this family of Sarus Cranes in the distance, feeding and slowly moving in my direction, so sat down next to some reeds and waited for them. It took them almost half an hour to reach me, but by then they were comfortable with my presence—at times they got closer than my lens's minimum focus distance!"

∧ **American Oystercatcher**
Haematopus palliatus
Nickerson Beach, Long Island,
New York, USA
*Nikon D500 with 500mm lens and 1.4x
teleconverter, 1/1000 sec. at f/10, ISO 400*
Robert S. Parker, @robert.s.parker

‹ **Sarus Crane**
Antigone antigone
Bharatpur Bird Sanctuary, Rajasthan, India
*Nikon D750 with 200–500mm lens, 1/800 sec.
at f/8, ISO 800*
Pradeep Purushothaman, @pradeep.wildlens

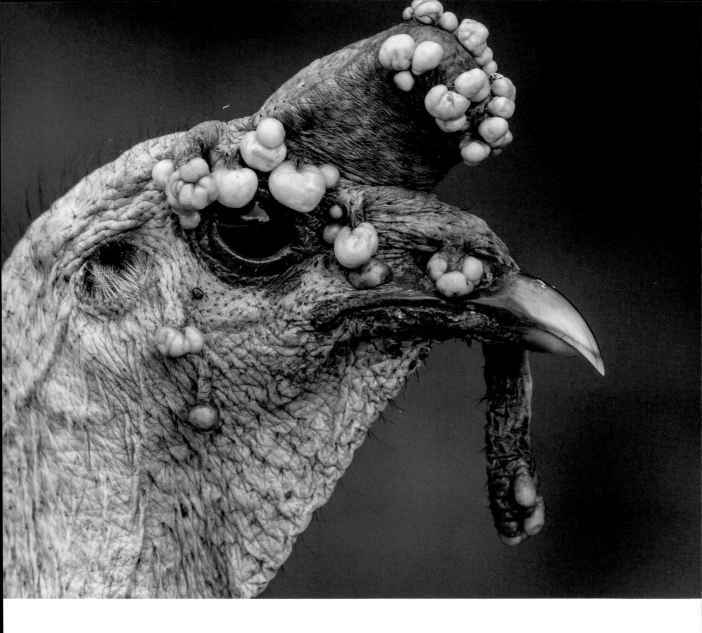

∧ **Ocellated Turkey**
Meleagris ocellata
Belize
*Olympus OM-D E-M1 MkII with 300mm lens
and 1.4x teleconverter, 1/160 sec. at f/5.6, ISO 200*
Ben Knoot, @benknoot

⌐ **Ocellated Turkey**
Meleagris ocellata
Tikal, Guatemala
*Canon EOS 7D MkII with 600mm
lens, 1/200 sec. at f/5.6, ISO 640*
Glenn Bartley, @bartleys_photo_workshops

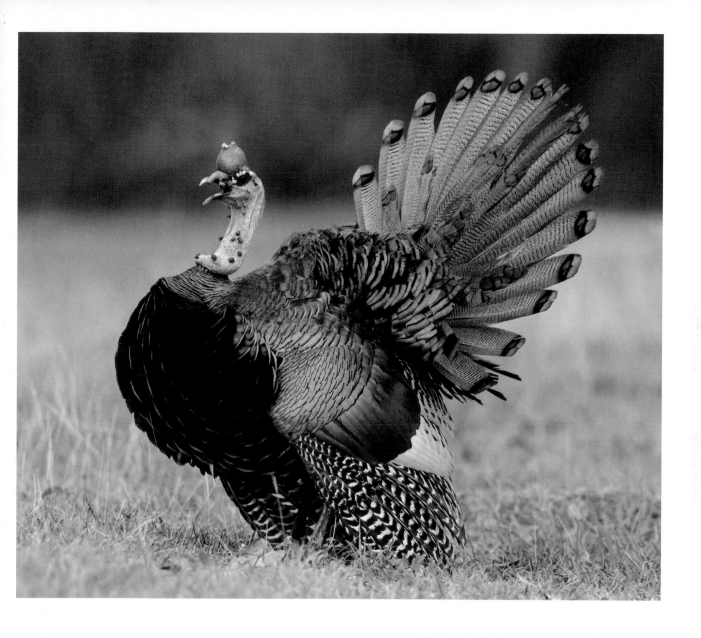

"Ocellated Turkeys are spectacular birds to observe, and there is nowhere better to do that than the UNESCO World Heritage site of Tikal National Park in Guatemala. While these birds are almost certainly very timid due to hunting in other areas, within the park they are common and bold. This individual spotted a female nearby and decided to put on a serious display!"

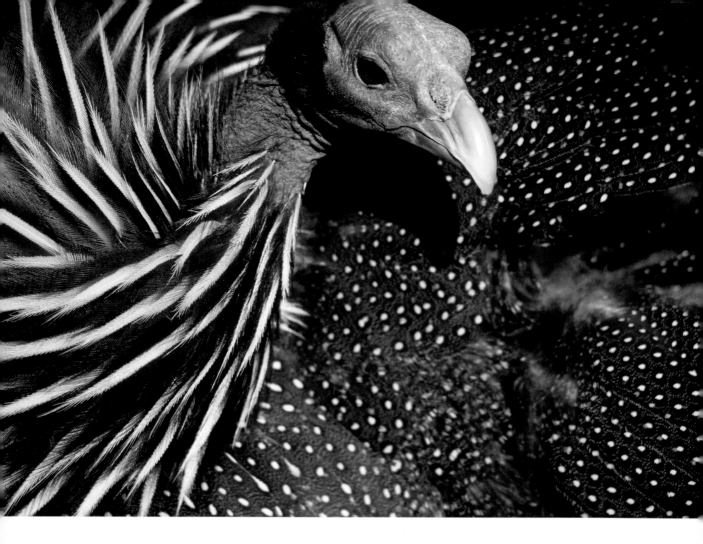

∧ **Vulturine Guineafowl**
Acryllium vulturinum
Vogelpark Avifauna, the Netherlands
Nikon D5600 with 150–600mm lens,
1/2000 sec. at f/6.3, ISO 2000
Femke van Willigen, @ajoebowan

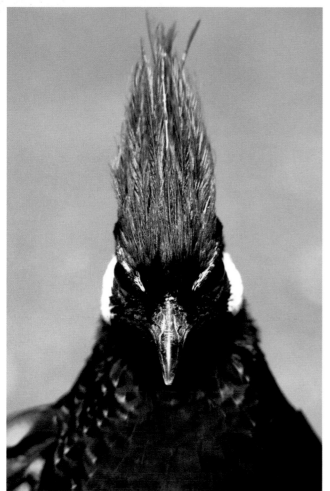

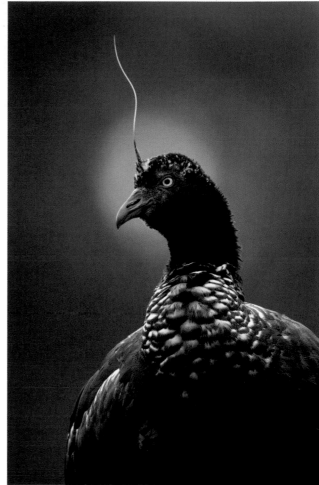

^ **Palawan Peacock-Pheasant**
Polyplectron napoleonis
Vogelpark Avifauna, the Netherlands
Nikon D5600 with 150–600mm lens,
1/50 sec. at f/6.3, ISO 2000
Femke van Willigen, @ajoebowan

⌐ **Horned Screamer**
Anhima cornuta
Madres De Dios, Peru
Canon EOS 7D MkII with 500mm lens and
1.4x teleconverter, 1/250 sec. at f/5.6, ISO 500
Jess Findlay, @jessfindlay

"The Amazon is home to an array of fantastical creatures, and the massive Horned Screamer is undoubtedly one of the most bizarre birds I've ever spent time observing. Bone spurs protrude from the edges of their wings, and this strange characteristic is rivaled only by their long keratinous horn. Seeing these giants really makes you feel like you've stepped back in time!"

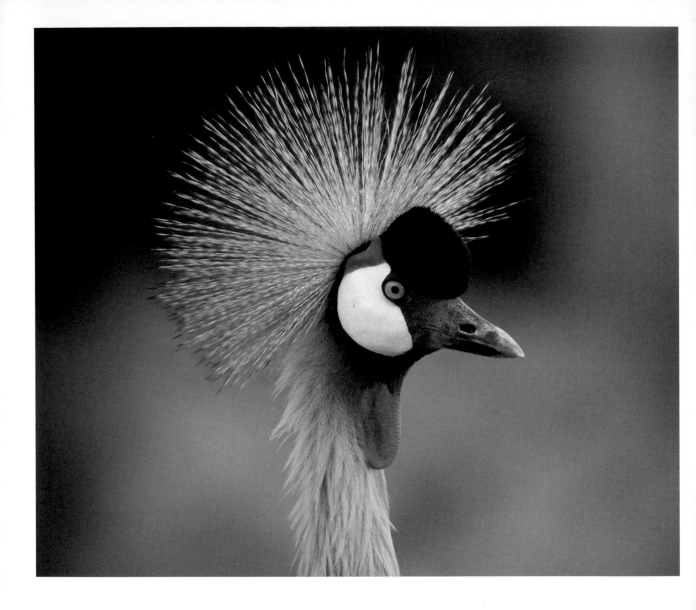

^ **Gray Crowned-Crane**
Balearica regulorum
Rift Valley region, Kenya
*Nikon D810 with 500mm lens and 1.4x
teleconverter, 1/1250 sec. at f/5.6, ISO 200*
John Crawley, @jc_wings

> **Hoatzin**
Opisthocomus hoazin
Madres De Dios, Peru
*Canon EOS 7D MkII with 500mm lens and
1.4x teleconverter, 1/250 sec. at f/5.6, ISO 1000*
Jess Findlay, @jessfindlay

"Hoatzin feed on the dense vegetation at the edges of slow-moving rivers and oxbow lakes in the Amazon rainforest and Venezuela's Orinoco Delta. As 'folivores' they eke out nutrients using a fermentation process in a specialized stomach called a rumen, which creates a viable diet from a nutrient-deficient food source. This is similar to cows and other large herbivorous mammals."

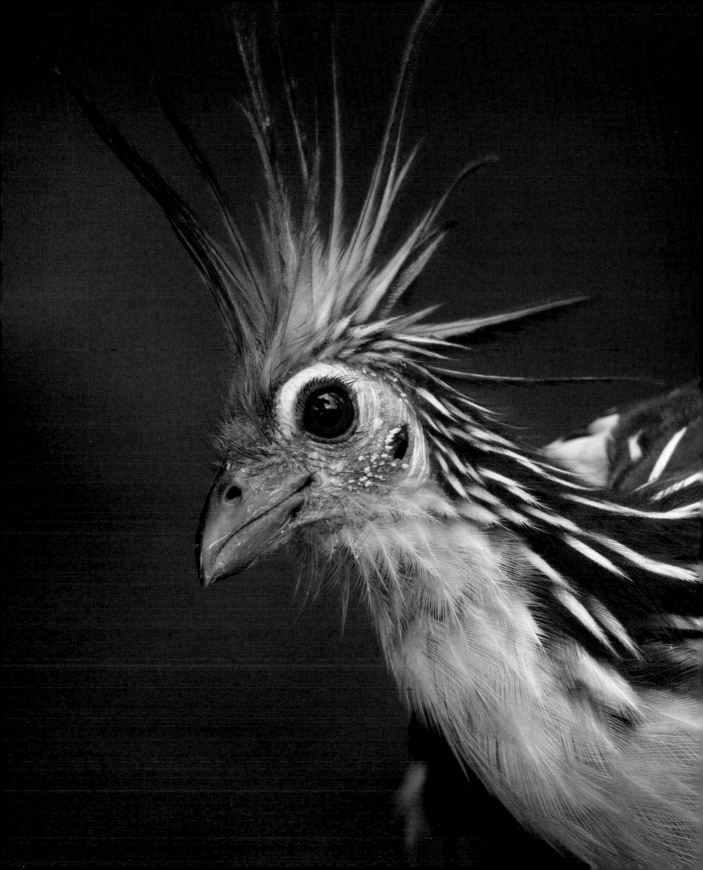

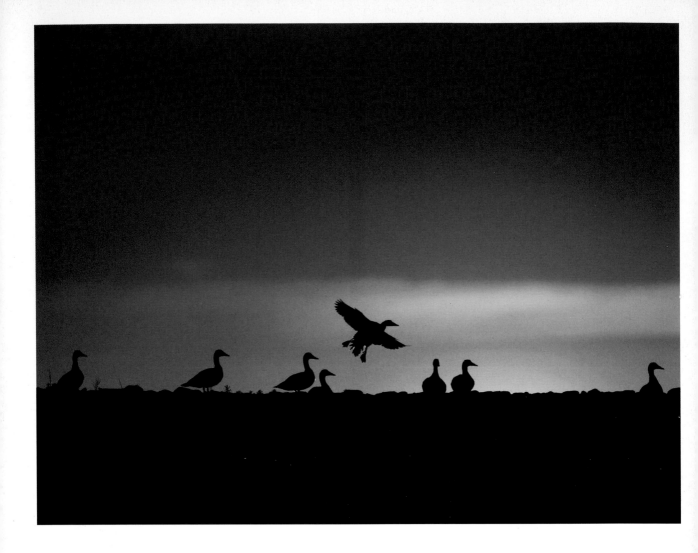

^ Common Eider
Somateria mollissima
Lågskär, Finland
*Canon EOS 1D MkIV with 500mm
lens, 1/1250 sec. at f/4.5, ISO 800*
Kimmo Lahikainen, @_lahki_birds_

"A composite of two silhouetted images
of Common Eiders at sunset on the
island of Lågskär. Lågskär has been
identified as one of the most important
breeding bird islands in the Finnish
Baltic Sea."

> Sri Lanka Hanging-Parrot
Loriculus beryllinus
Sinharaja Rainforest, Sri Lanka
*Nikon D500 with 600mm lens,
1/800 sec. at f/5.6, ISO 800*
Ananth Ramasamy, @ananth.ramasamy

"It was raining as I drove through
Sinharaja rainforest, when I noticed this
parrot on a branch. I stopped the car
and watched the parrot enjoying the
rain and preening for more than 10
minutes, which gave me a chance to
take this 'wet-look' portrait."

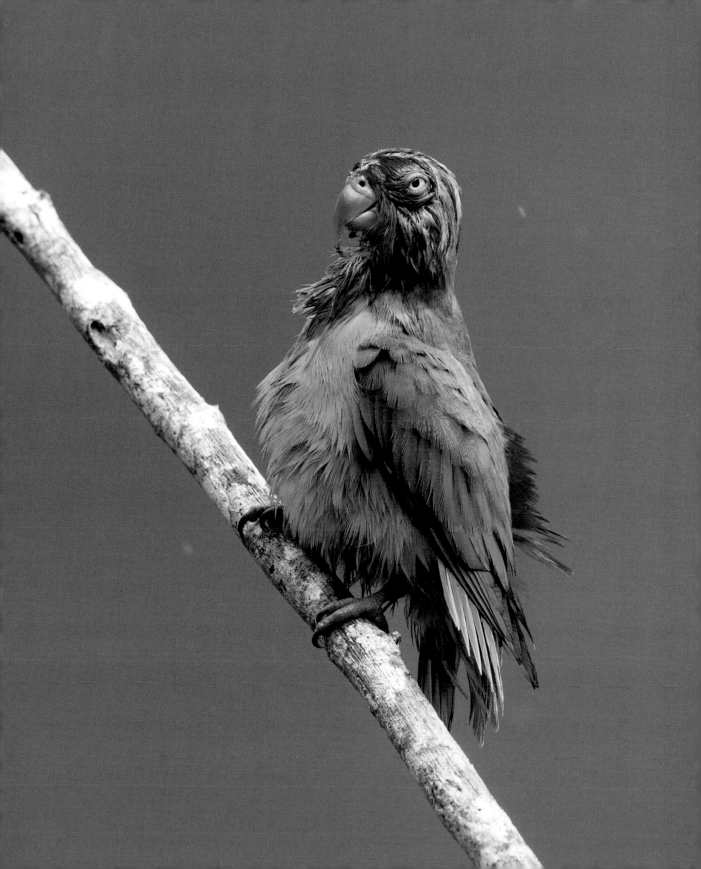

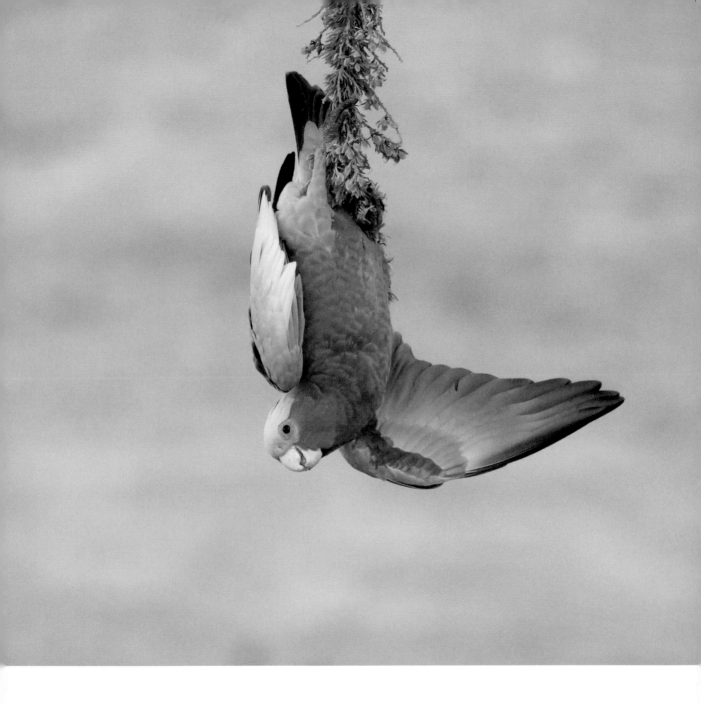

∧ **Galah**
Eolophus roseicapilla
Creery Wetlands, Australia
*Olympus OM-D E-M1 MkII with 300mm
lens, 1/640 sec. at f/4, ISO 640*
Alice Worswick, @alice_worswick

"Galahs are one of my favorite birds to watch—they are cheeky, full of character, and often engage in crazy behavior. This youngster was in a playful mood, which gave me the opportunity to get this shot."

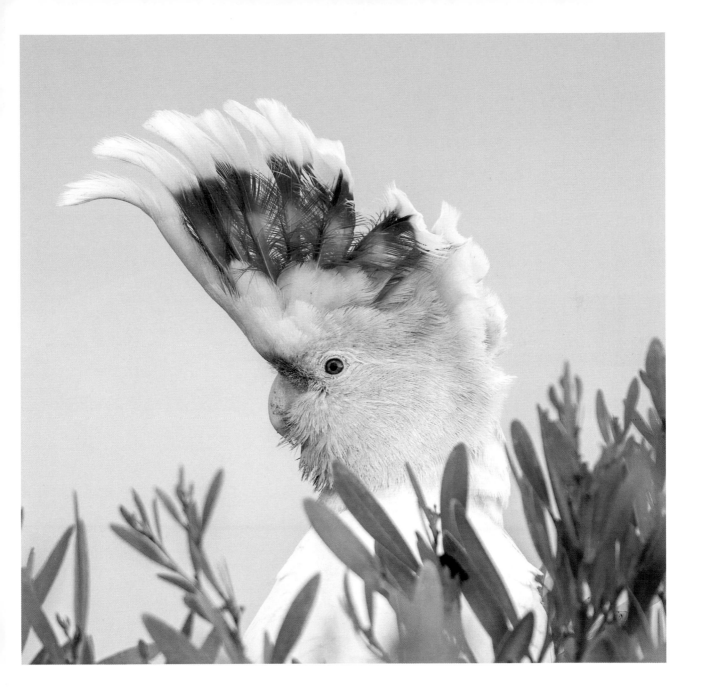

⌃ Pink Cockatoo
Lophochroa leadbeateri
Eyre Bird Observatory,
Cocklebiddy, Australia
Canon EOS 1D X with 600mm lens and 2x
teleconverter, 1/1600 sec. at f/8, ISO 1000
Georgina Steytler, @georgina_steytler

"I spotted this Pink Cockatoo peeking over the top of an acacia plant near a bird bath at Eyre Bird Observatory."

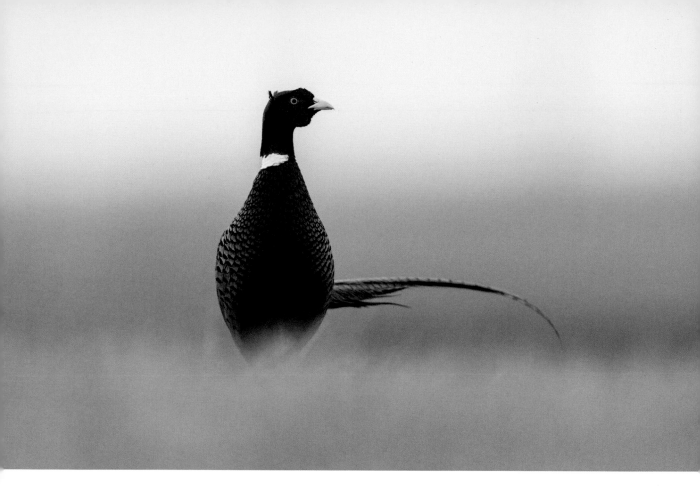

"I photographed this male Ring-necked
Pheasant from my fixed bird blind."

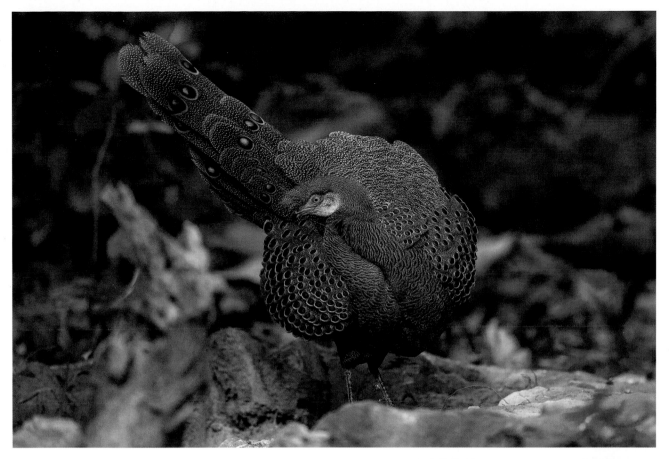

∧ Gray Peacock-Pheasant
Polyplectron bicalcaratum
Yunnan province, China
Sony α9 with 400mm lens,
1/2000 sec. at f/2.8, ISO 2500
Oleg Alexeyev, @oleg_alexeyev_photo

⌐ Ring-necked Pheasant
Phasianus colchicus
Lower Austria, Austria
Nikon D850 with 600mm lens,
1/400 sec. at f/4, ISO 2500
Robert Kreinz, @rkreinz

> Ring-necked Pheasant
Phasianus colchicus
Attenborough Nature Reserve,
Nottinghamshire, UK
Canon EOS 80D with 100–400mm
lens, 1/800 sec. at f/5.6, ISO 2500
Jason Ogbourne, @jasonogbourne

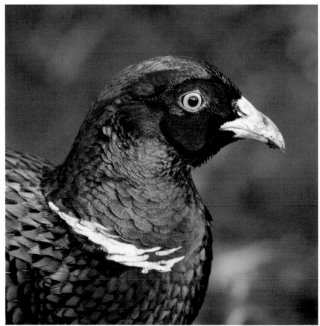

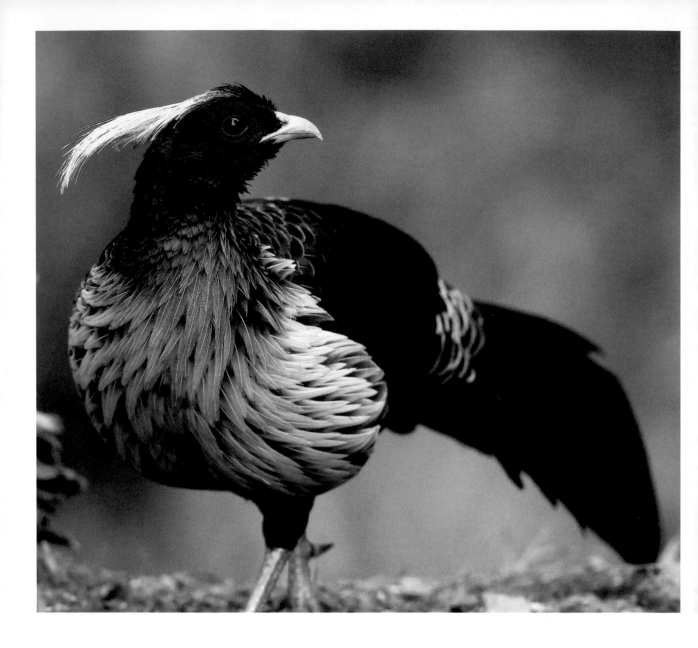

∧ **Kalij Pheasant**
Lophura leucomelanos
Pangot, India
Canon EOS 1D X with 500mm
lens, 1/250 sec. at f/4.5, ISO 2500
Gururaj Moorching, @gururaj_moorching

"I had set out before sunrise to photograph Black-chinned Babblers, but while I was waiting for the babblers I could hear a few Kalij Pheasants in the undergrowth nearby. I turned and focused close to a patch of rustling leaves, and after about five minutes this male bird stepped out and walked toward me."

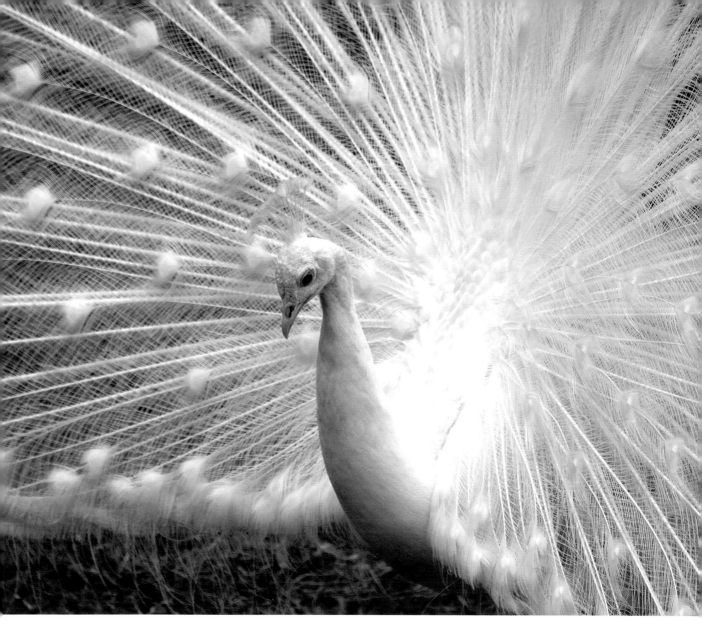

∧ Indian Peafowl
Pavo cristatus
Vogelpark Avifauna, the Netherlands
Nikon D5600 with 150–600mm
lens, 1/640 sec. at f/6, ISO 200
Femke van Willigen, @ajoebowan

"This peacock has a condition called 'leucism,' which means there is no coloring in the pigment in its plumage, resulting in it being all white."

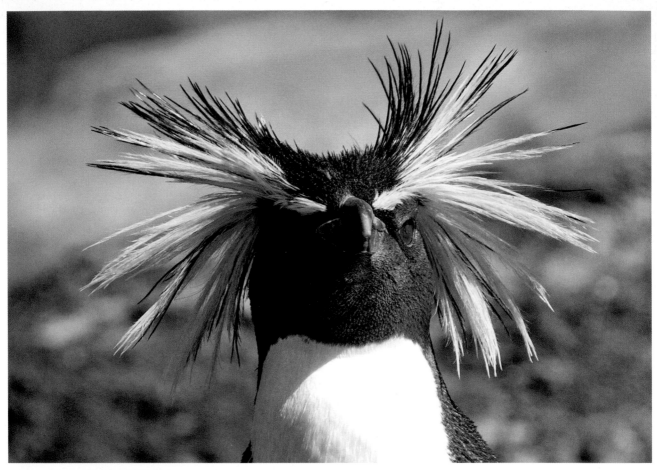

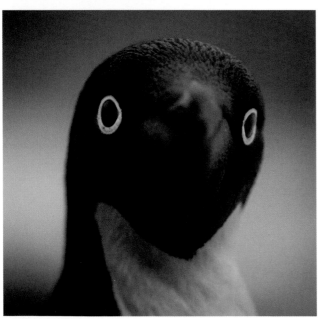

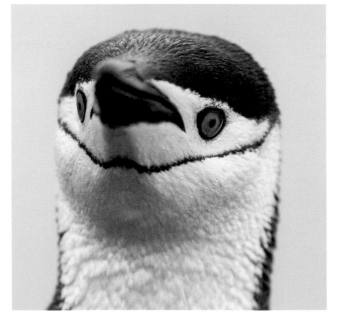

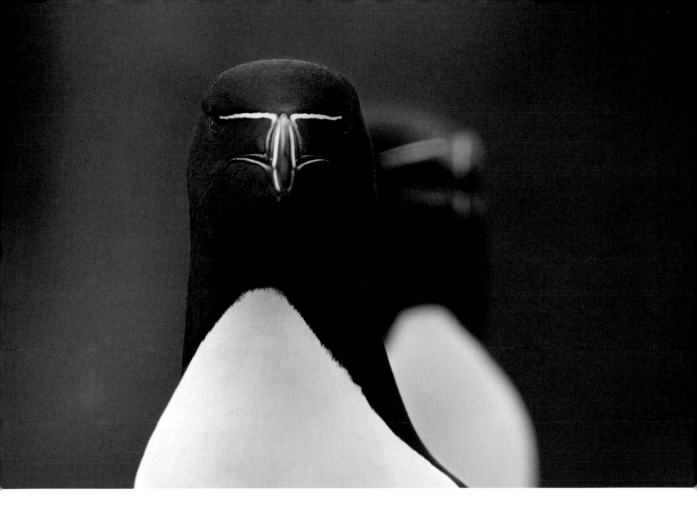

⌐ **Moseley's Rockhopper Penguin**
Eudyptes moseleyi
Gough Island
Canon EOS 5D MkIII with 100–400mm lens, 1/2500 sec. at f/7.1, ISO 500
James Lowe, @jameslowe783

⟪ **Adelie Penguin**
Pygoscelis adeliae
Brown Bluff,
Antarctic Peninsula
Canon EOS 5D MkIII with 100–400mm lens, 1/1000 sec. at f/5.6, ISO 320
James Lowe, @jameslowe783

⟨ **Chinstrap Penguin**
Pygoscelis antarcticus
Aicho Island, South
Shetland Islands,
Antarctic Peninsula
Canon EOS 5D MkIII with 100–400mm lens, 1/1250 sec. at f/5.6, ISO 500
James Lowe, @jameslowe783

⌃ **Razorbill**
Alca torda
Farne Islands, UK
Nikon D800 with 500mm lens, 1/2000 sec. at f/8, ISO 640
Franka Slothouber, @frankaslothouber

"When you visit the Farne Islands you know you are going to see puffins, but what I had not foreseen was my immediate infatuation with the Razorbills—such a beautiful, graphic design! After three days photographing on the Farnes this little scene took place: the frontal view shows the bird's magnificent face mask, which reminds me of Darth Vader."

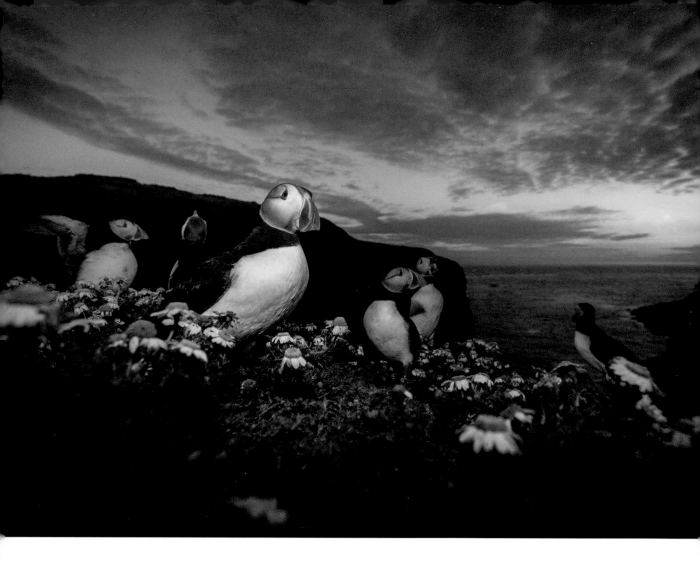

"A burst of flash lit up this Atlantic Puffin
group after sunset."

‹ Atlantic Puffin
Fratercula arctica
Skomer Island, UK
Canon EOS 5D MkIV with 16–35mm lens, 1/40 sec. at f/7.1, ISO 160
Drew Buckley, @drewbphotography

› Crested Auklet
Aethia cristatella
Yankitcha Island, Kuril Islands, Far East Russia
Canon EOS 5D MkIII with 70–200mm lens, 1/1600 sec. at f/3.2, ISO 1250
James Lowe, @jameslowe783

⌐ Northern Gannet
Morus bassanus
Grassholm Island, UK
Canon EOS 1D X with 500mm lens, 1/5000 sec. at f/5.6, ISO 800
Drew Buckley, @drewbphotography

⌄ Gentoo Penguin
Pygoscelis papua
Cierva Cove, Antarctic Peninsula
Canon EOS 5D MkIII with 100–400mm lens, 1/2500 sec. at f/6.3, ISO 500
James Lowe, @jameslowe783

"One of my goals is to get a shot like this, but with all the penguins facing me. It's not easy, though, as they see the boat and scatter or dive underwater. It also takes a lot of penguins for them to make formations like this."

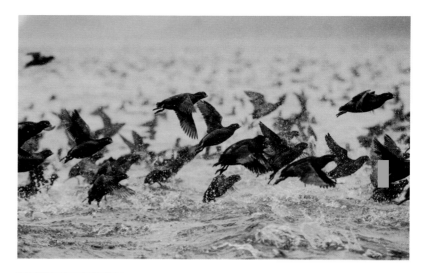

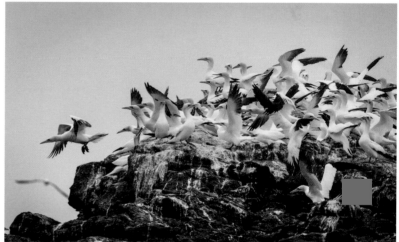

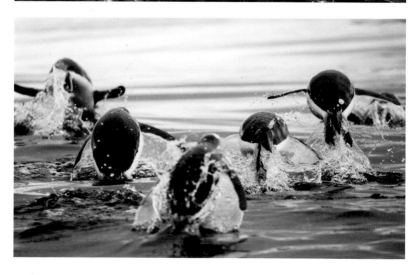

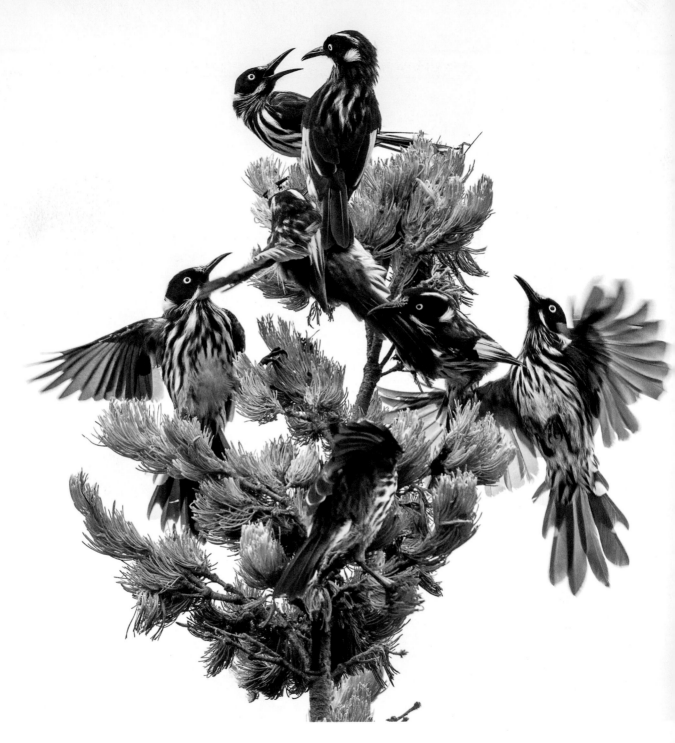

"Honeyeaters having arguments!"

< New Holland Honeyeater
Phylidonyris novaehollandiae
Middleton Beach, Australia
Canon EOS 1D X with 600mm lens and 2x
teleconverter, 1/1600 sec. at f/8, ISO 3200
Georgina Steytler, @georgina_steytler

> White-winged Fairywren
Malurus leucopterus
Mindarie coast, Perth, Australia
Canon EOS 5D MkIII with 500mm lens and
1.4x teleconverter, 1/320 sec. at f/6.3, ISO 800
Shelley Pearson, @shelley_pearson_

⌐ White-breasted Woodswallow
Artamus leucorynchus
Eighty Mile Beach, Kimberley, Australia
Canon EOS 1D X MkII with 500mm lens and
1.4x teleconverter, 1/4000 sec. at f/7.1, ISO 500
Shelley Pearson, @shelley_pearson

∨ Christmas Island Imperial-Pigeon
Ducula whartoni
Grants Well, Christmas Island
Canon EOS 1D X MkII with 600mm lens,
1/3200 sec. at f/5.6, ISO 1600
Georgina Steytler, @georgina_steytler

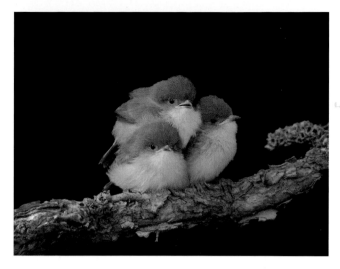

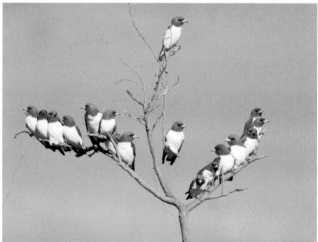

"It was an extremely hot day and these pigeons had found a tiny spray of cooling water. They were clambering to get to it, even if it meant standing on top of each other."

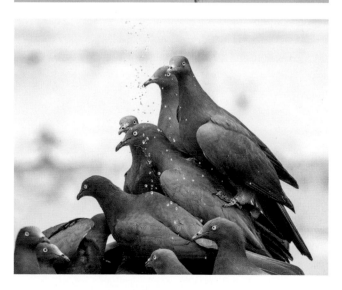

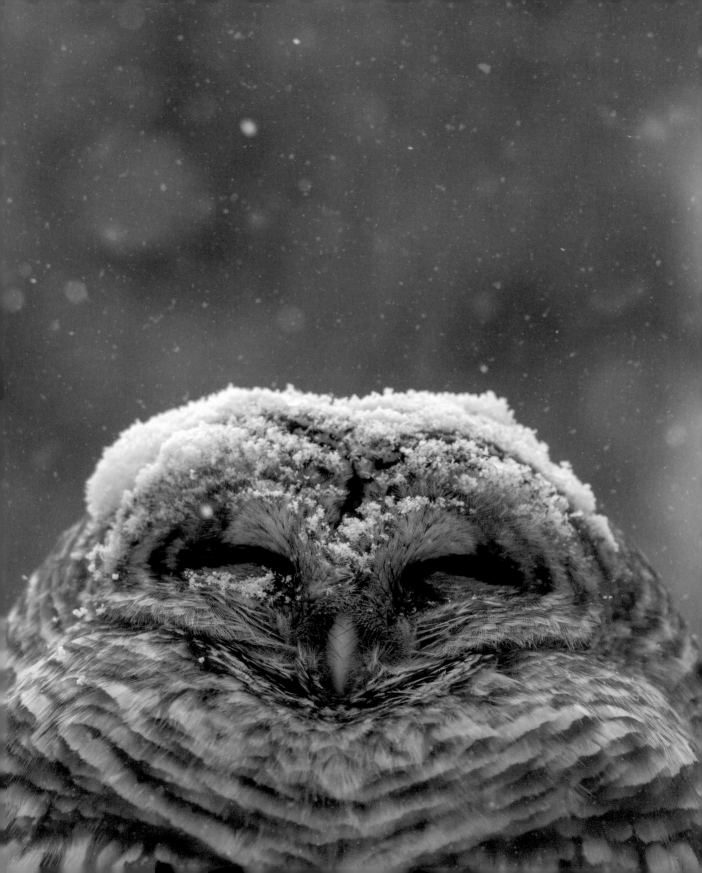

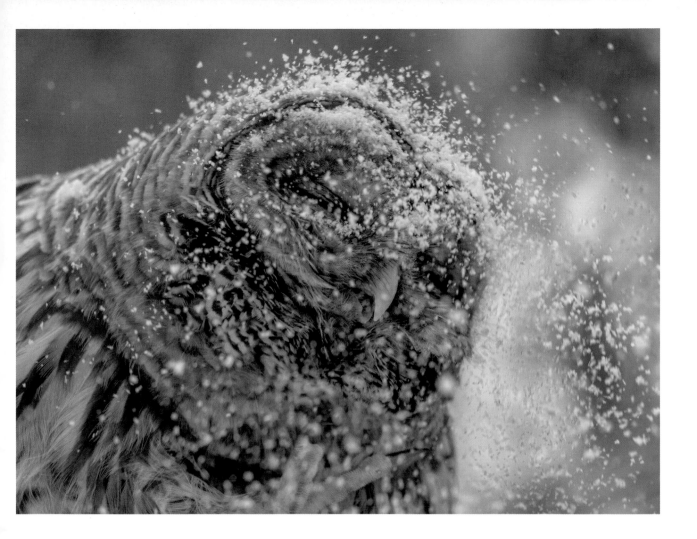

∧ **Barred Owl**
‹ *Strix varia*
Waterloo, Ontario, Canada
*Olympus OM-D E-M1 with 300mm
lens, 1/640 sec. at f/5.6, ISO 500*
Kevin Biskaborn, @kevinbiskaborn

"Dreaming of summer days, as snow
gently collected on its head, this Barred
Owl only opened its eyes when a red
squirrel or chickadee ventured too
close. Only adding to its camouflage,
the owl was seemingly unbothered by
the growing pile of snow on its head,
until it woke from its wintry nap and
shook off the thick layer of snow."

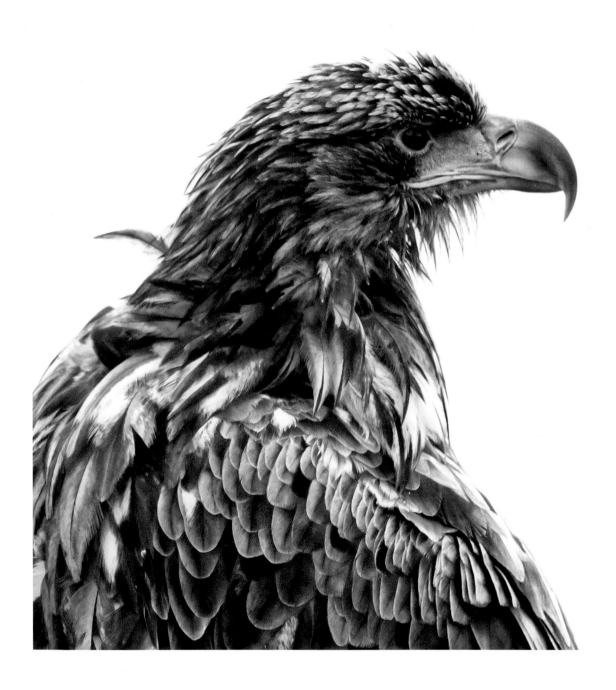

"I spotted this young White-tailed Eagle resting on a cliff near the road to Hamninberg and pulled over to take this shot from the car. Usually these eagles are quite timid, but this one did not fly away immediately."

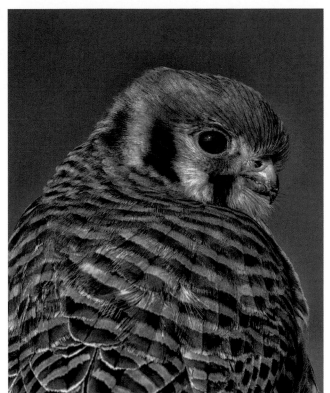 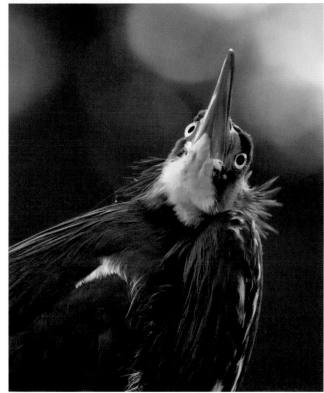

∧ **American Kestrel**
Falco sparverius
Southwestern Ontario, Canada
Nikon D850 with 500mm lens and 1.4x
teleconverter, 1/500 sec. at f/9, ISO 640
Robert S. Parker, @robert.s.parker

⌐ **Tricolored Heron**
Egretta tricolor
Boynton Beach, Florida, USA
Nikon D850 with 500mm lens and 1.4x
teleconverter, 1/640 sec. at f/7.1, ISO 3200
Greg Christoph, @gregxoph

< **White-tailed Eagle**
Haliaeetus albicilla
Persfjord, Norway
Canon EOS 1D X with 600mm lens and 1.4x
teleconverter, 1/1000 sec. at f/9, ISO 1600
Kimmo Lahikainen, @_lahki_birds_

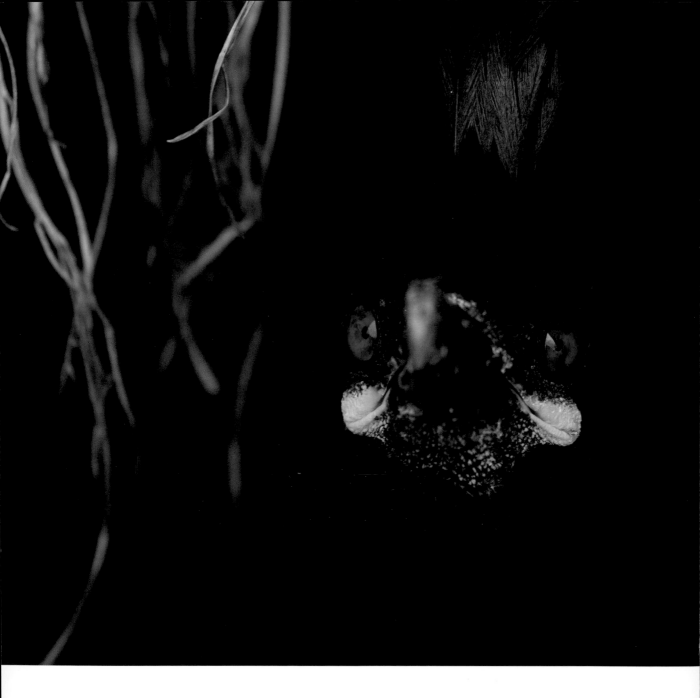

∧ **European Shag**
Phalacrocorax aristotelis
Hornøya, Norway
*Canon EOS 1D X with 100–400mm
lens, 1/200 sec. at f/8, ISO 1600*
Kimmo Lahikainen, @_lahki_birds_

"European Shags nest among the rocks
on this uninhabited island, which is the
most easterly point of Norway."

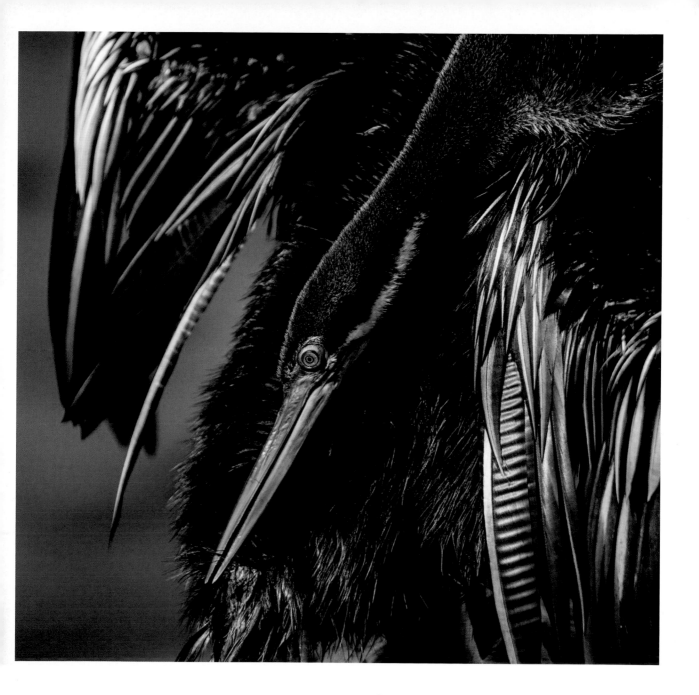

⌃ Australasian Darter
Anhinga novaehollandiae
Ballina, New South Wales, Australia
Nikon D800E with 150–600 lens,
1/500 sec. at f/6.3, ISO 500
Scott Rolph, @aussiebirdphotography

"The Australasian Darter is number four on my list of Aussie favorites. These birds have a pretty great life I reckon: going for a swim, catching fish, then sunbathing on the rocks. I could watch them for hours as they preen and go about their business."

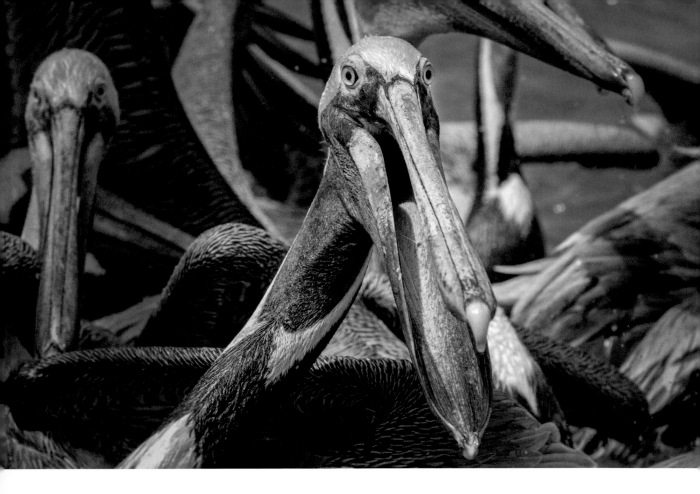

⌃ Brown Pelican
Pelecanus occidentalis
Magdalena Bay, Baja, Mexico
Canon EOS 7D with 100–400mm
lens, 1/1000 sec. at f/9, ISO 1000
Eli Martinez, @sdmdiving

"There's a spot in Magdalena Bay
where fishermen often clean the day's
catch, and the pelicans gather here in
the hope of snatching a free meal. I
visited in March to get shots of these
birds with their breeding plumage, and
spent the whole morning snapping.
This close-up portrait was my favorite
photograph of the day."

⌐ Greater Flamingo
Phoenicopterus roseus
Singapore
Sony α9 with 400mm lens,
1/2000 sec. at f/5.6, ISO 400
Oleg Alexeyev, @oleg_alexeyev_photo

⟩ Pied Stilt
Himantopus leucocephalus
Wilcannia, Australia
Canon EOS 1D X MkII with 600mm lens and
1.4x teleconverter, 1/5000 sec. at f/6.3, ISO 320
Georgina Steytler, @georgina_steytler

⟩⟩ Black Skimmer
Rynchops niger
Pantanal, Brazil
Canon EOS 7D MkII with 600mm
lens, 1/2000 sec. at f/7.1, ISO 400
Glenn Bartley, @bartleys_photo_workshops

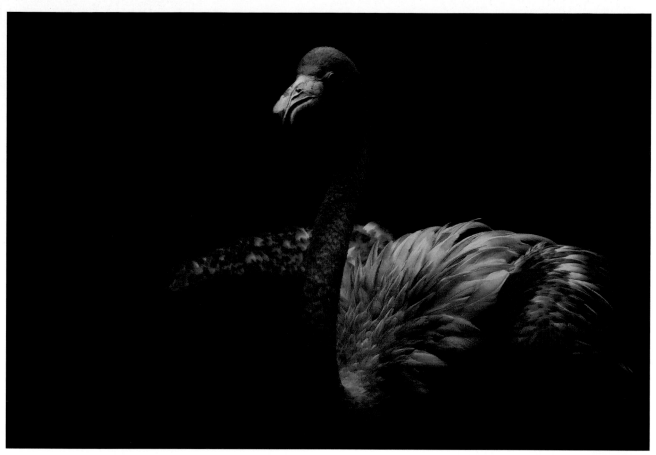

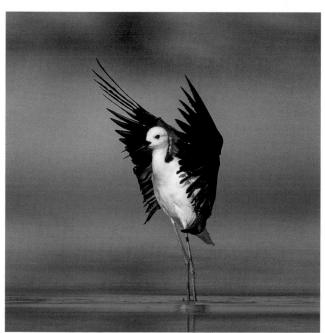

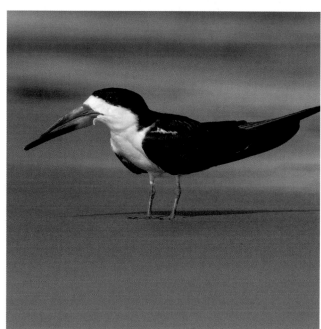

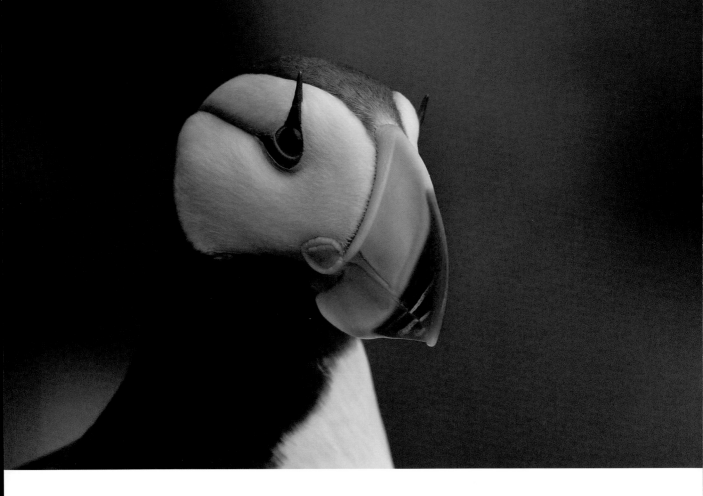

∧ **Horned Puffin**
Fratercula corniculata
Saint Paul Island, Alaska, USA
Nikon D4S with 80–400mm lens,
1/2000 sec. at f/5.6, ISO 1000
John Crawley, @jc_wings

⌐ **Tufted Puffin**
Fratercula cirrhata
Saint Paul Island, Alaska, USA
Nikon D810 with 500mm lens and 1.4x
teleconverter, 1/1000 sec. at f/8, ISO 500
John Crawley, @jc_wings

> **Atlantic Puffin**
Fratercula arctica
Machias Seal Island, Canada
Canon EOS 5D MkIV with 100–400mm
lens, 1/1250 sec. at f/5.6, ISO 200
Rina Miele, @rinamiele

"Horned Puffins are named for the fleshy projections that grow above their eyes. It is easy to see why they have garnered the nickname of 'clowns of the sea,' but in my opinion they are one of the most striking birds."

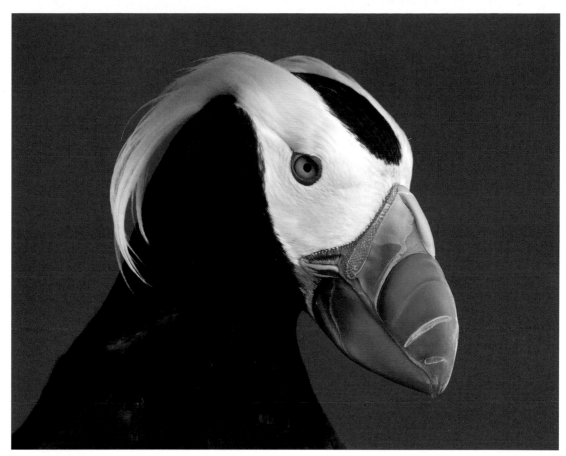

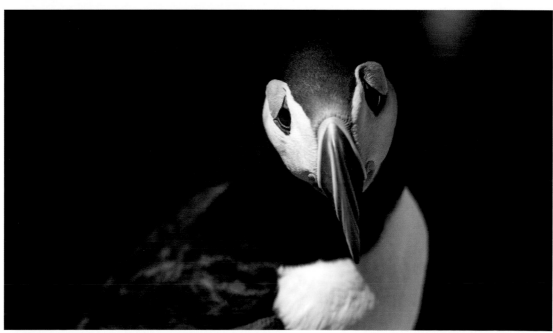

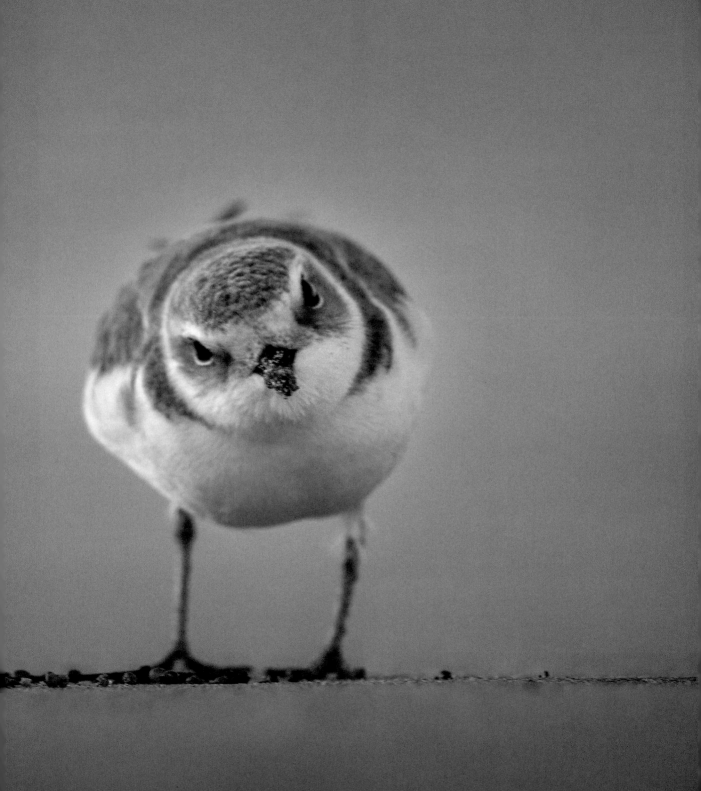

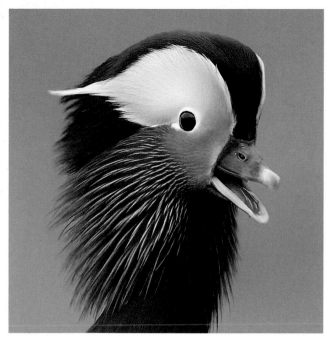

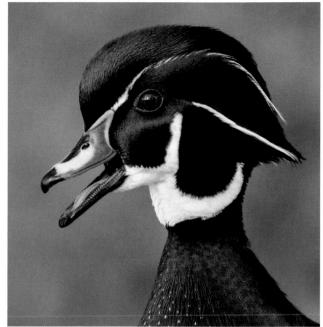

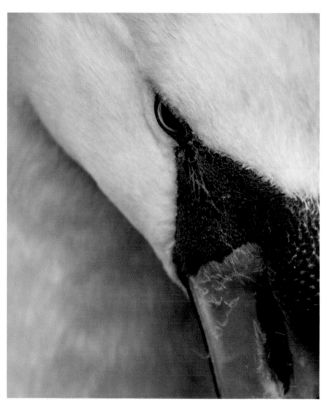

⌃ Mandarin Duck
Aix galericulata
Canon EOS 1D X with 300mm
lens, 1/2000 sec. at f/4, ISO 2000
Stefano Ronchi, @stefanoronchi

⌐ Wood Duck
Aix sponsa
Vancouver, Canada
Canon EOS 7D MkII with 100–400mm
lens, 1/250 sec. at f/8, ISO 400
Ben Knoot, @benknoot

> Mute Swan
Cygnus olor
Somerset, UK
Canon EOS 5D MkII with 100–400mm
lens, 1/640 sec. at f/10, ISO 1600
Mark Eastment, @markeastmentphotography

< Snowy Plover
Charadrius nivosus
Ormond Beach, California, USA
Nikon D750 with 150–600mm lens,
1/125 sec. at f/6.3, ISO 900
Alecia Smith, @alecia_birds

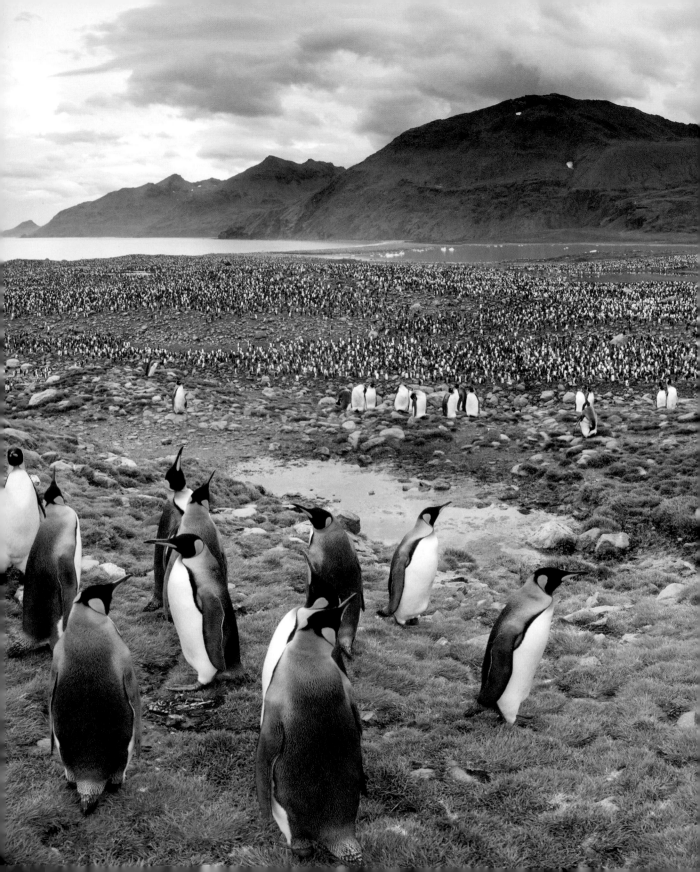

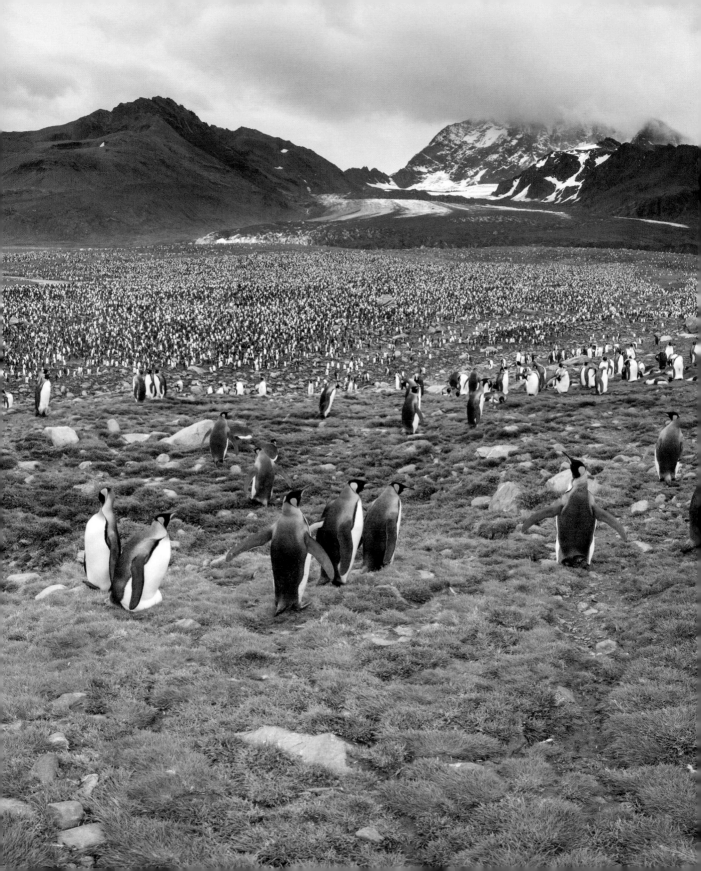

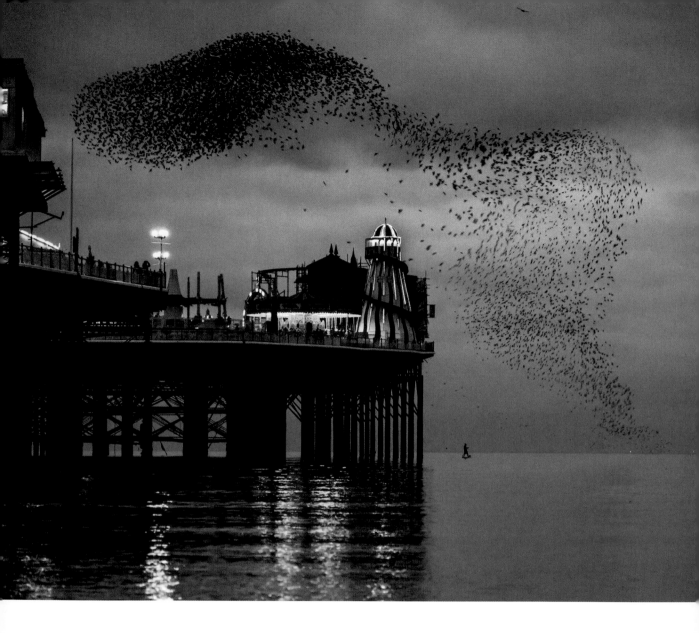

King Penguin
Aptenodytes patagonicus
St. Andrews Bay, South Georgia
*Canon EOS 5D MkIII with 24–105mm
lens, 1/400 sec. at f/5, ISO 800*
James Lowe, @jameslowe783

"Starlings over Brighton pier. I believe that might be a peregrine at the top—there was definitely one around, as I saw it up close later on."

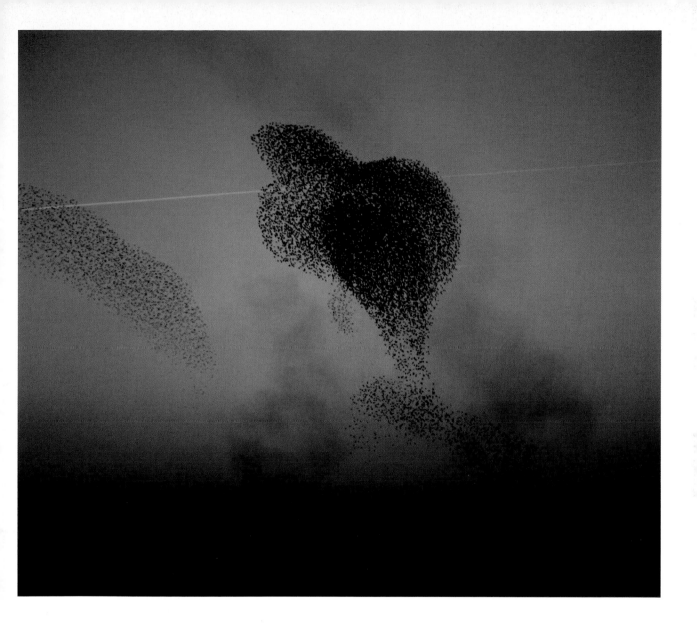

∧ European Starling
Sturnus vulgaris
Somerset, UK
Canon EOS 5D MkII with 100–400mm
lens, 1/100 sec. at f/5, ISO 100
Mark Eastment, @markeastmentphotography

⌐ European Starling
Sturnus vulgaris
Brighton, UK
Canon EOS 5D MkII with 100–400mm
lens, 1/100 sec. at f/4.5, ISO 3200
Mark Eastment, @markeastmentphotography

"Tens of thousands of starlings roost overnight in the reed beds on the Somerset Levels, and it is a spectacle that I go and see every winter. On this occasion the flocks were settling in to the reed beds just in front of me. With lots of predators around, the birds were putting on a great show, which gave me plenty of opportunities to capture their aerial patterns against the dwindling orange glow of sunset. I like to think that at this moment in time they resembled a cobra."

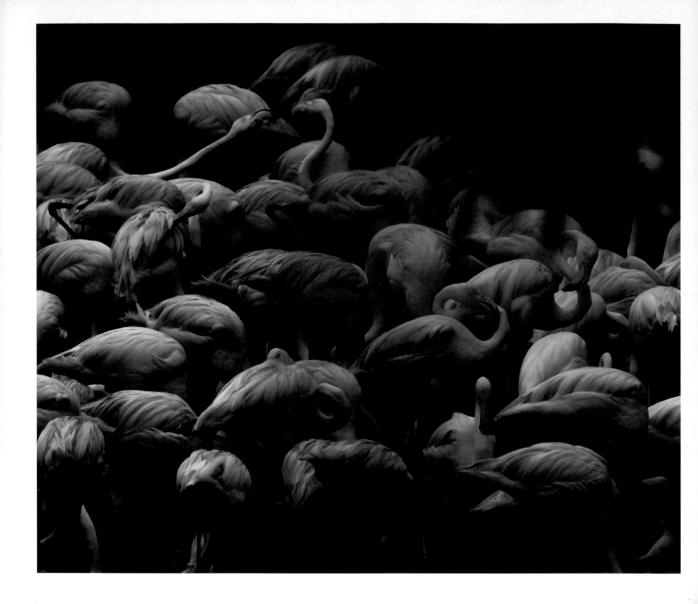

^ Greater Flamingo
Phoenicopterus roseus
Singapore
Sony α9 with 400mm lens,
1/2000 sec. at f/8, ISO 2000
Oleg Alexeyev, @oleg_alexeyev_photo

> European Starling
Sturnus vulgaris
Somerset, UK
Canon EOS 5D MkII with 100–400mm
lens, 1/30 sec. at f/5, ISO 6400
Mark Eastment, @markeastmentphotography

"A slow-shutter-speed shot of starlings on the Somerset Levels, flying against a rather nice sunset."

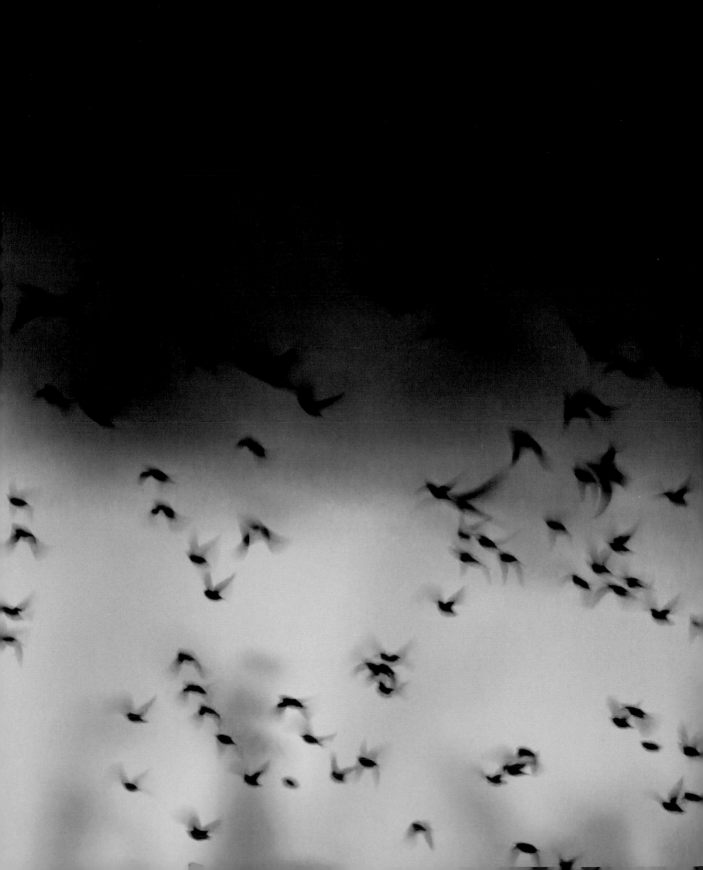

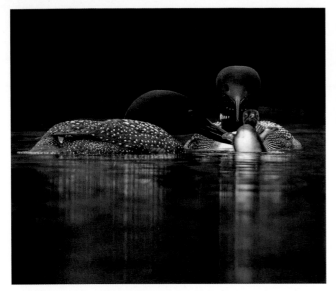

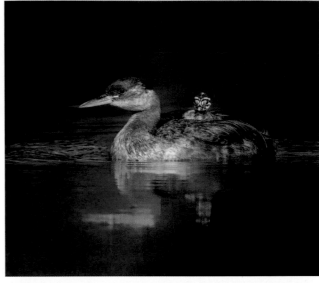

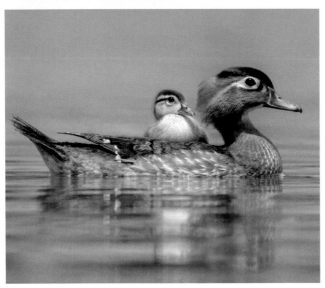

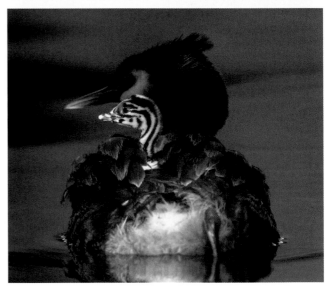

∧ **Common Loon**
Gavia immer
Kawarthas, Ontario, Canada
Nikon D7100 with 300mm lens and 1.4x teleconverter, 1/250 sec. at f/8, ISO 800
Robert S. Parker, @robert.s.parker

∧ **Wood Duck**
Aix sponsa
Zephyrhills, Florida, USA
Nikon D7000 with 150–500mm lens, 1/1600 sec. at f/8, ISO 800
Peter Brannon, @peter.brannon

˥˥ **Red-necked Grebe**
Podiceps grisegena
Toronto, Ontario, Canada
Nikon D500 with 500mm lens and 1.4x teleconverter, 1/800 sec. at f/8, ISO 500
Robert S. Parker, @robert.s.parker

˥ **Great Crested Grebe**
Podiceps cristatus
Amsterdam, the Netherlands
Nikon D850 with 500mm lens and 1.4x teleconverter, 1/1000 sec. at f/8, ISO 1000
Franka Slothouber, @frankaslothouber

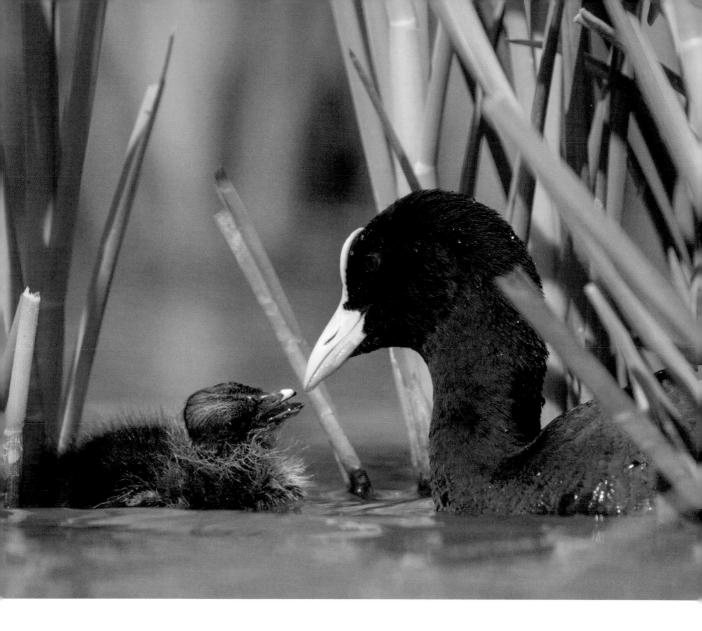

⌃ Eurasian Coot
Fulica atra
Friesland, the Netherlands
*Nikon D850 with 500mm lens and 1.4x
teleconverter, 1/600 sec. at f/8, ISO 640*
Franka Slothouber, @frankaslothouber

"A face only a mother could love! This
Eurasian Coot chick was expecting to
be fed by its mother."

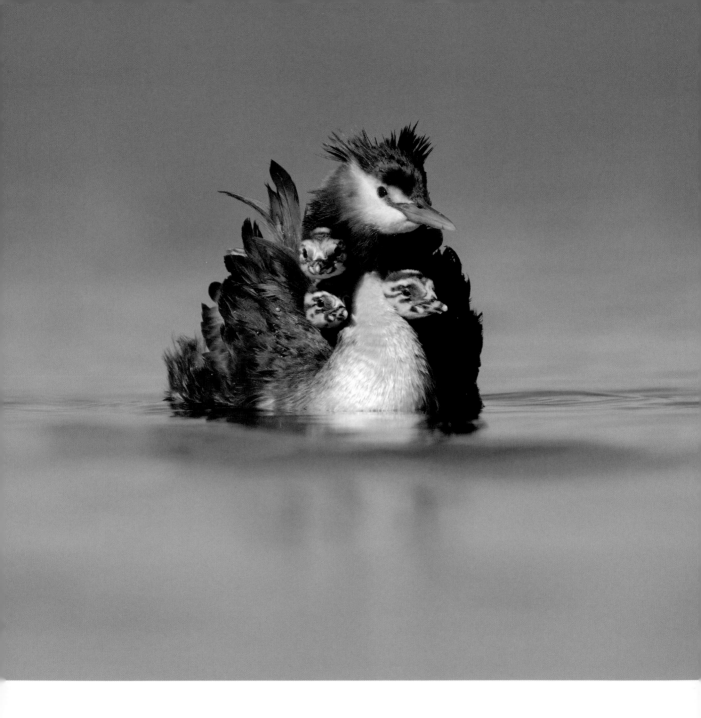

"These beautiful birds carry their chicks
around on their back while the other
parent goes off looking for fish to bring
back and feed them with."

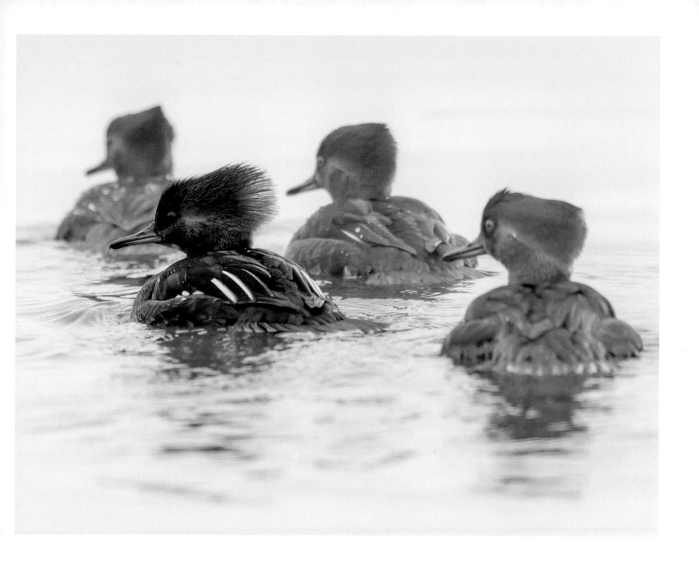

∧ **Hooded Merganser**
Lophodytes cucullatus
Barrie, Ontario, Canada
Olympus OM-D E-M5 with 300mm
lens, 1/1000 sec. at f/4, ISO 640
Kevin Biskaborn, @kevinbiskaborn

< **Great Crested Grebe**
Podiceps cristatus
Herdsman Lake, Herdsman, Australia
Canon EOS 1D X with 500mm lens and 1.4x
teleconverter, 1/2000 sec. at f/8, ISO 500
Shelley Pearson, @shelley_pearson_

"Dare to be different and be yourself.
That might have been on the mind
of the duck with her collapsible crest
raised. Either way, this group of female
Hooded Merganser nicely depicted
a motivational image."

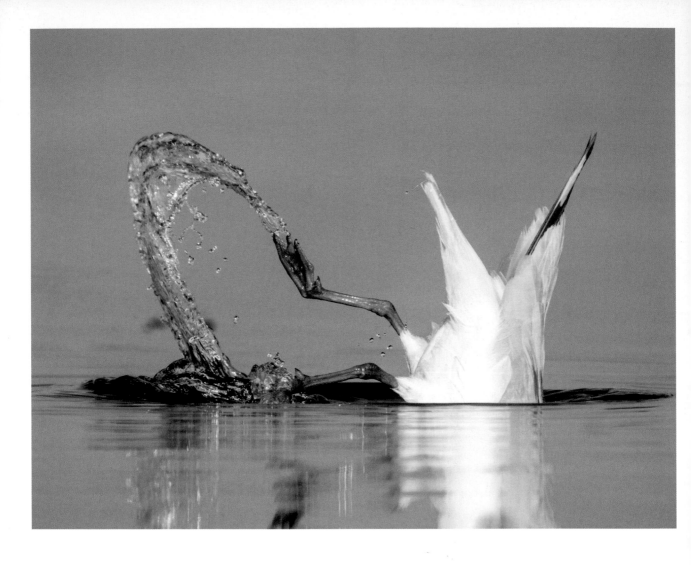

^ **Silver Gull**
Chroicocephalus novaehollandiae
Western Treatment Plant, Victoria, Australia
Nikon D800E with 150–600mm lens, 1/4000 sec. at f/8, ISO 800
Scott Rolph, @aussiebirdphotography

> **Dalmatian Pelican**
Pelecanus crispus
Lake Kerkini, Greece
Canon EOS 5D MkIV with 300mm lens and 1.4x teleconverter, 1/320 sec. at f/4, ISO 2500
Drew Buckley, @drewbphotography

"I was hoping for something a little more exciting than a Silver Gull while waiting for two hours, but I'm pretty happy with this shot. It's surprising as bird photographers how often we overlook common birds."

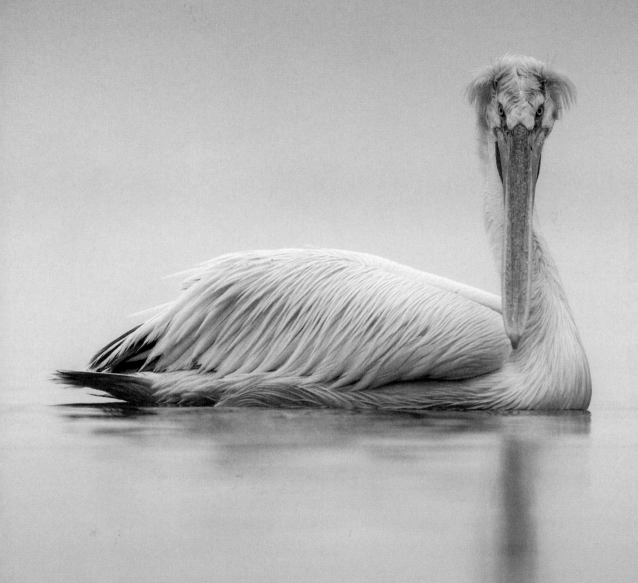

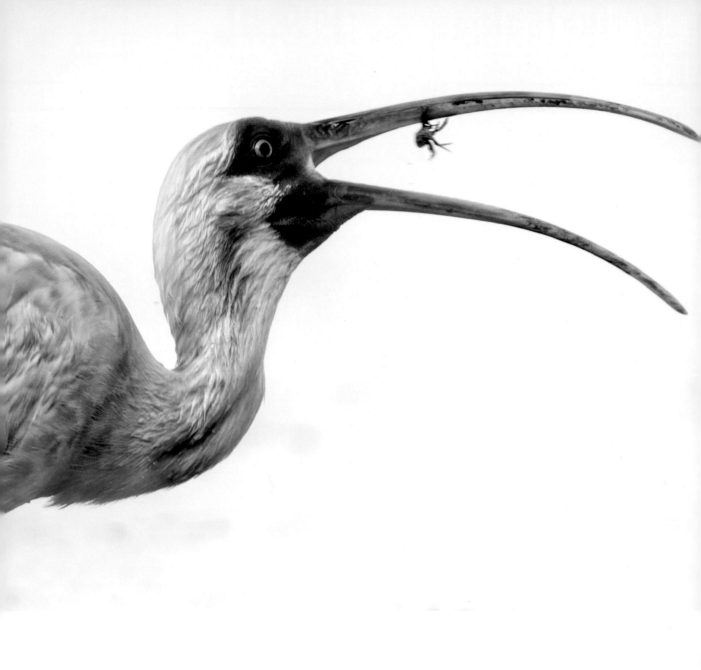

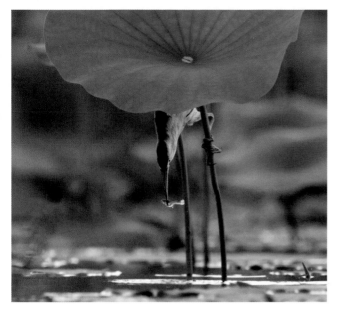

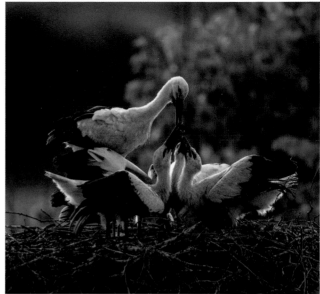

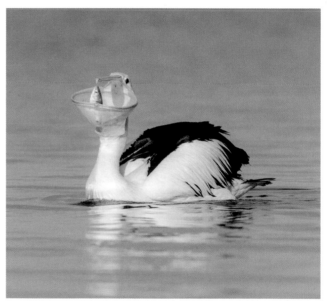

∧ **Least Bittern**
Ixobrychus exilis
Lakeland, Florida, USA
Nikon D500 with 500mm lens,
1/1600 sec. at f/5, ISO 560
Peter Brannon, @peter.brannon

‹ **White Ibis**
Eudocimus albus
Naples, Florida, USA
Nikon D7200 with 300mm lens and 1.7x
teleconverter, 1/1250 sec. at f/5.6, ISO 500
Robert S. Parker, @robert.s.parker

˥ **White Stork**
Ciconia ciconia
Styria, Austria
Nikon D500 with 600mm lens and 1.4x
teleconverter, 1/160 sec. at f/5.6, ISO 3200
Robert Kreinz, @rkreinz

› **Australian Pelican**
Pelecanus conspicillatus
Coodanup Foreshore, Mandurah, Australia
Canon EOS 1D X MkII with 600mm lens and
1.4x teleconverter, 1/3200 sec. at f/8, ISO 640
Shelley Pearson, @shelley_pearson_

"The pelicans gather close to a little inlet on Mandurah estuary, hoping to get fish swept in by the high tide. It is fascinating to observe pelicans using their pouch to not only contain fish, but also toss them around so they're easier to swallow. On this occassion the conditions were perfect, with very little wind, so I laid down on the shoreline and waited. After an hour or so, the fish started to arrive—fortunately the light was still nice."

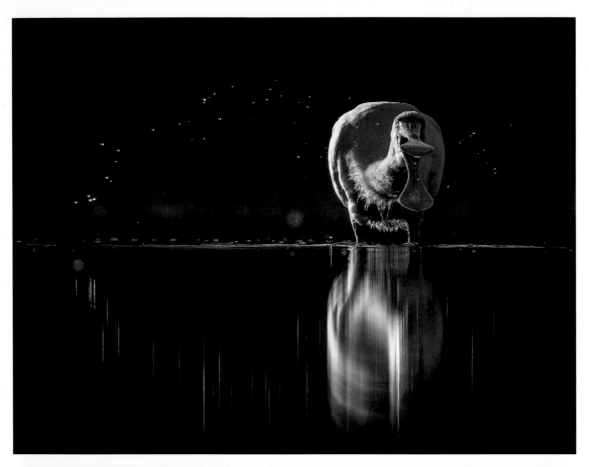

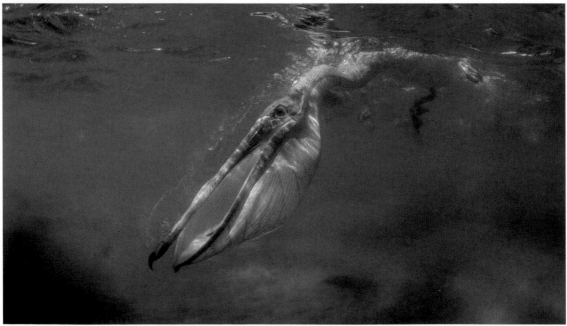

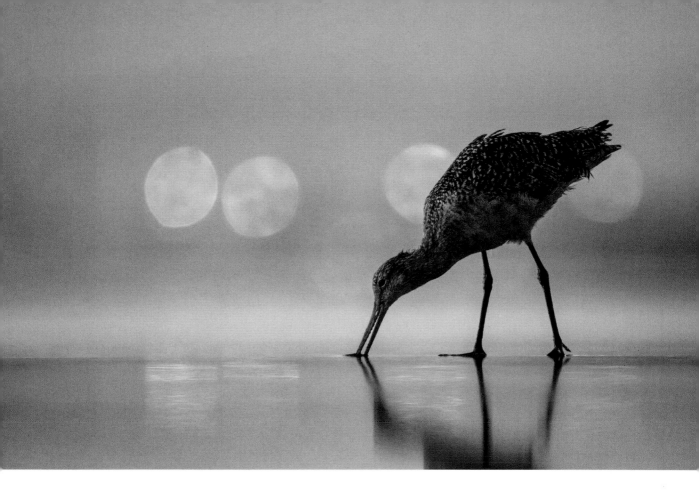

∧ **Marbled Godwit**
Limosa fedoa
Ormond Beach, California, USA
Nikon D750 with 150–600mm lens,
1/125 sec. at f/6.3, ISO 4500
Alecia Smith, @alecia_birds

⌐ **Yellow-billed Spoonbill**
Platalea flavipes
Northam, Australia
Canon EOS 1D X with 600mm
lens, 1/1600 sec. at f/5, ISO 400
Georgina Steytler, @georgina_steytler

‹ **Brown Pelican**
Pelecanus occidentalis
Magdalena Bay, Baja, Mexico
Canon EOS 5D MkIV with 8–15mm
lens, 1/500 sec. at f/8, ISO 400
Eli Martinez, @sdmdiving

"After I took this photo, I had to remind myself that the departure from wildlife is just as important as the approach. It was cold enough that I couldn't really feel my big toes anymore—I had spent some time in the water with my legs stretched out and my feet pressed in the sand. Still, I crawled and knee-walked my way back to the dry sand."

101

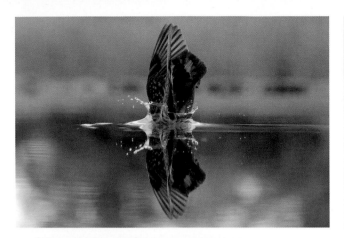

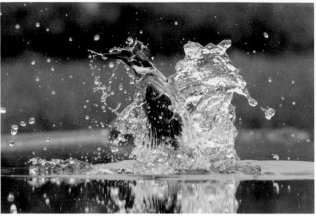

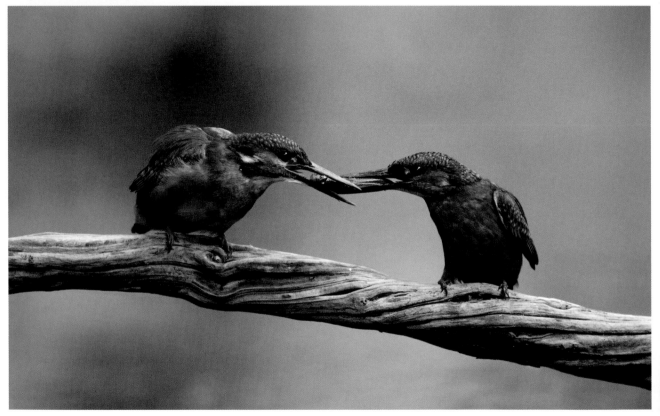

^ **Common Kingfisher**
Alcedo atthis
UK
Sony α9 with 400mm lens,
1/4000 sec. at f/8, ISO 3200
Oleg Alexeyev,
@oleg_alexeyev_photo

⌐⌐ **Common Kingfisher**
Alcedo atthis
UK
Sony α9 with 400mm lens,
1/4000 sec. at f/8, ISO 6400
Oleg Alexeyev,
@oleg_alexeyev_photo

^ **Common Kingfisher**
Alcedo atthis
Noord-Holland,
the Netherlands
Nikon D700 with 500mm lens,
1/1000 sec. at f/8, ISO 1000
Franka Slothouber,
@frankaslothouber

> **Black-backed Dwarf-**
Kingfisher
Ceyx erithaca
Chiplun, Maharashtra, India
Nikon D7200 with 200-500mm
lens, 1/80 sec. at f/8, ISO 800
Digvijay Chaugle, @_birdboy_

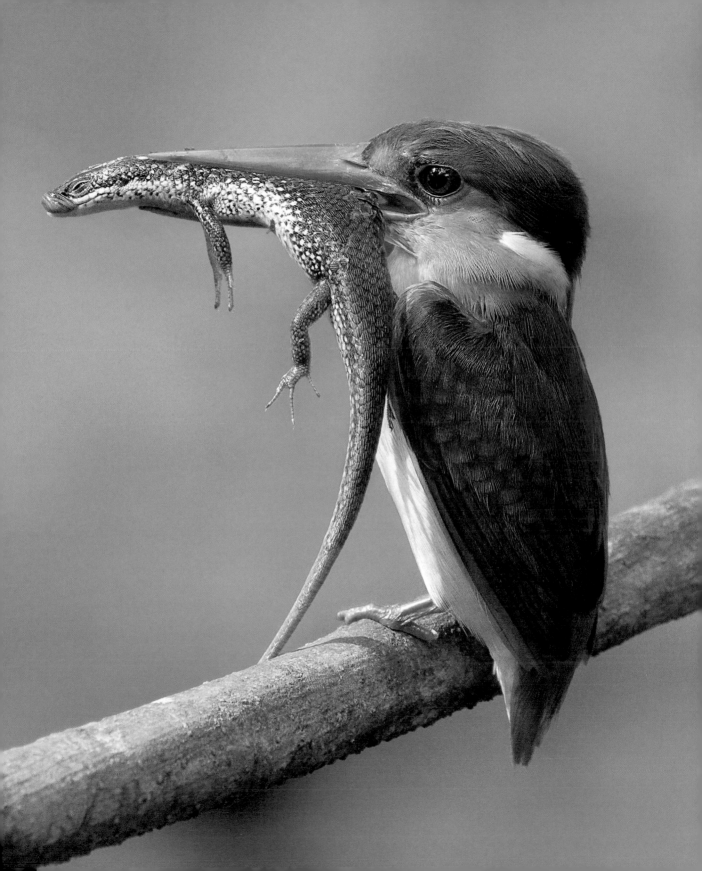

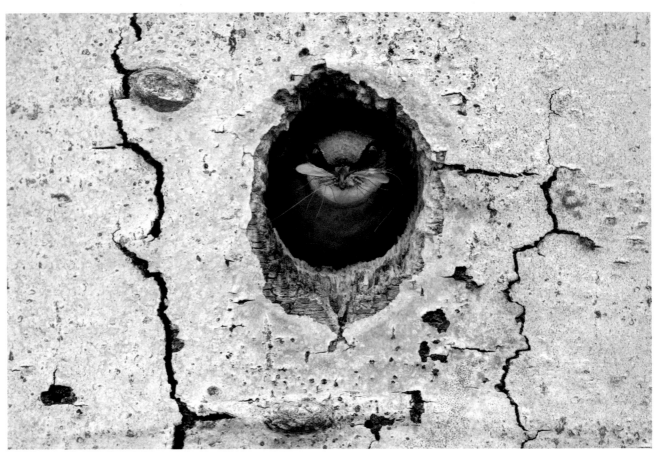

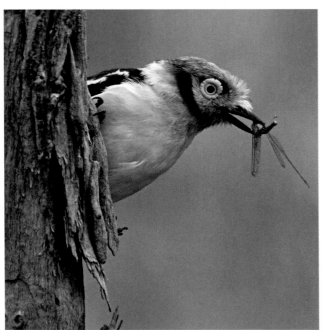

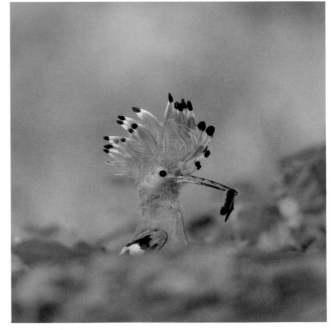

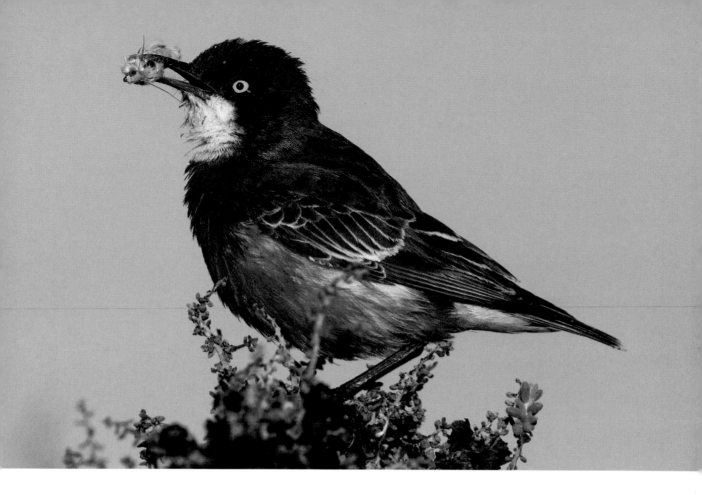

⌐ Tree Swallow
Tachycineta bicolor
Cariboo Region, British Columbia, Canada
Canon EOS 7D MkII with 500mm lens and
1.4x teleconverter, 1/200 sec. at f/8, ISO 1600
Jess Findlay, @jessfindlay

‹‹ White-crested Helmet-Shrike
Prionops plumatus
Sabiepark Nature Reserve,
bordering Kruger National Park,
Mpumalanga, South Africa
Nikon D500 with 500mm lens,
1/500 sec. at f/5.6, ISO 560
Heinrich Human, @heinrich_human

‹ Eurasian Hoopoe
Upupa epops
Bulgaria
Nikon D700 with 600mm lens,
1/1600 sec. at f/4, ISO 800
Robert Kreinz, @rkreinz

⌃ Crimson Chat
Epthianura tricolor
Lake Tyrrell, Victoria, Australia
Sony a7rIII with 200–600mm
lens, 1/2000 sec. at f/8, ISO 800
Scott Rolph, @aussiebirdphotography

"This Crimson Chat was having moth for
breakfast. A barley crop provided plenty
of food for the chats, as well as a great
neutral background for this shot."

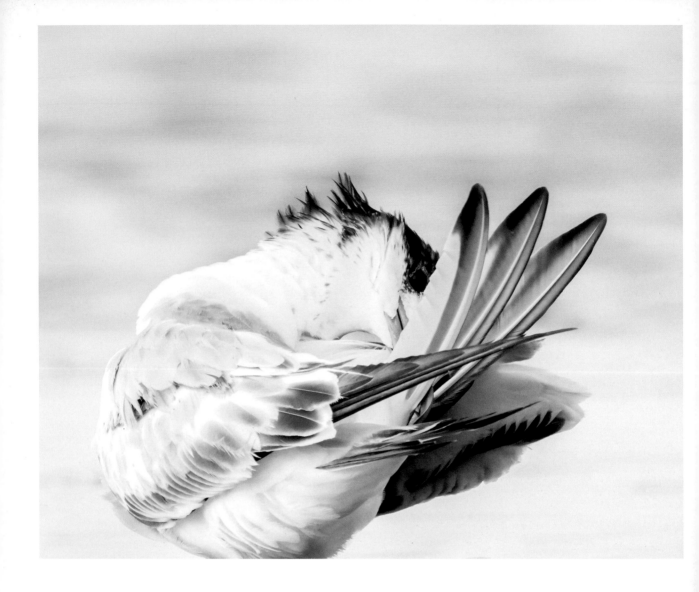

∧ **Great Crested Tern**
Thalasseus bergii
Coodanup Foreshore, Australia
Olympus OM-D E-M1 MkII with 300mm
lens, 1/1250 sec. at f/4.5, ISO 2000
Alice Worswick, @alice_worswick

❯ **Laysan Albatross**
Phoebastria immutabilis
Ka'ena Point, O'ahu, Hawaii
Canon EOS 5D MkIII with 100–400mm
lens, 1/250 sec. at f/5.6, ISO 1600
James Lowe, @jameslowe783

"This beautiful bird was hiding in
the bush, tending to its chick. Ka'ena
Point provides a small sanctuary for
albatrosses to nest, with protection in
place against introduced predators."

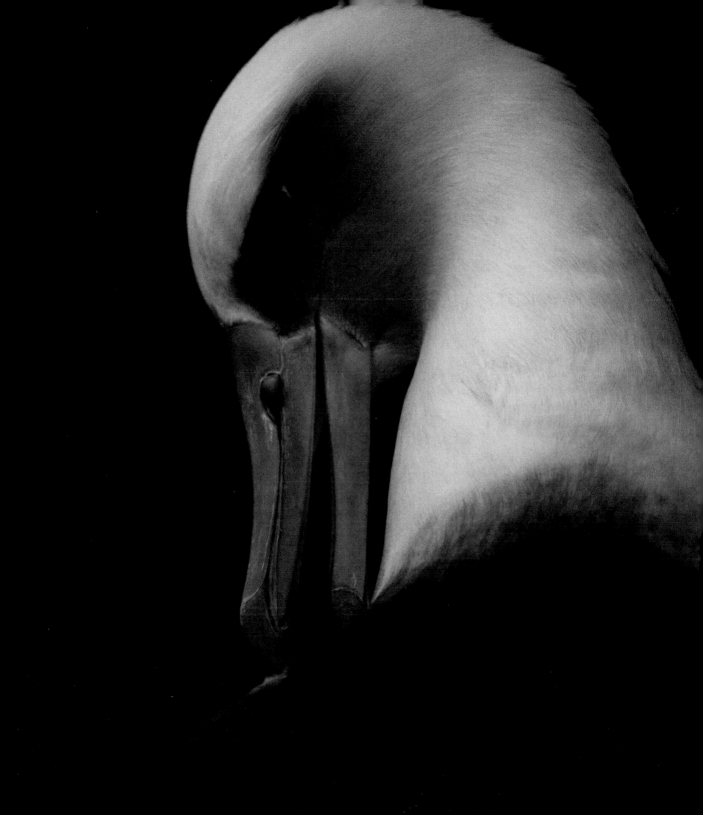

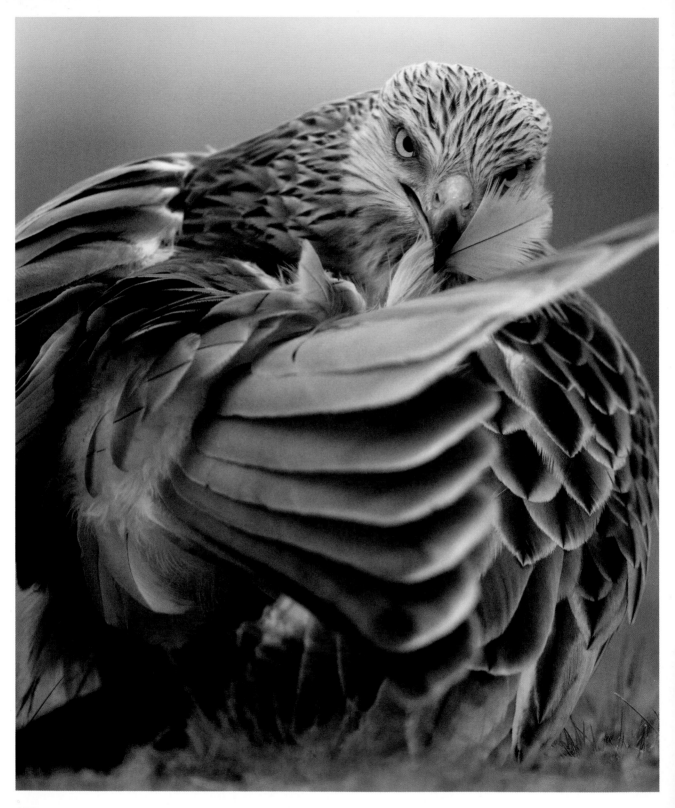

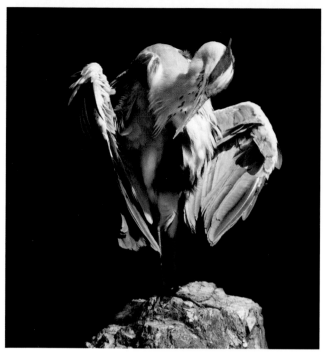

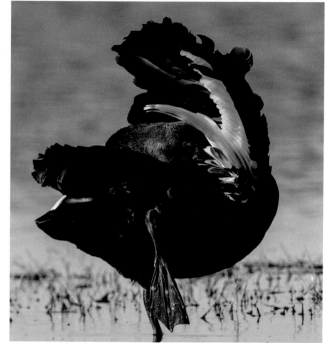

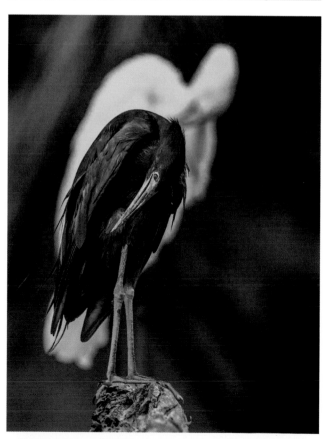

∧ **Grey Heron**
Ardea cinerea
Kyoto, Japan
Sony α7rIII with 100–400mm lens,
1/1000 sec. at f/5.6, ISO 400
Scott Rolph, @aussiebirdphotography

‹ **Red Kite**
Milvus milvus
Lower Austria, Austria
Nikon Z6 with 600mm lens and 1.4x
teleconverter, 1/800 sec. at f/5.6, ISO 8000
Robert Kreinz, @rkreinz

⌐ **Black Swan**
Cygnus atratus
Western Treatment Plant, Victoria, Australia
Nikon D800E with 150–600mm
lens, 1/1000 sec. at f/8, ISO 400
Scott Rolph, @aussiebirdphotography

› **Little Blue Heron & Great Egret**
Egretta caerulea & Ardea alba
West Palm Beach, Florida, USA
Nikon D850 with 500mm lens,
1/3200 sec. at f/6.3, ISO 1100
Greg Christoph, @gregxoph

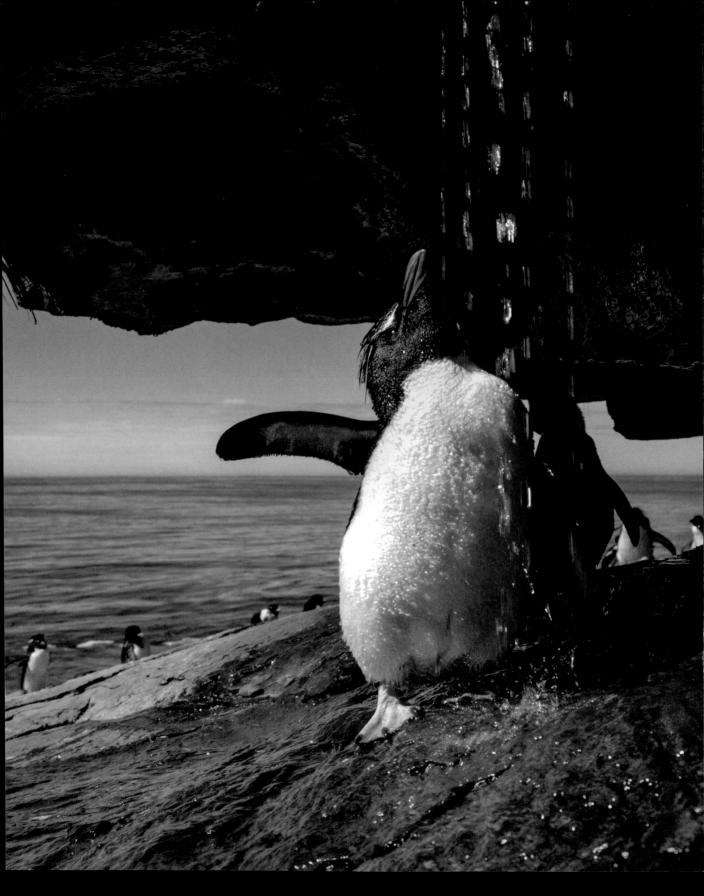

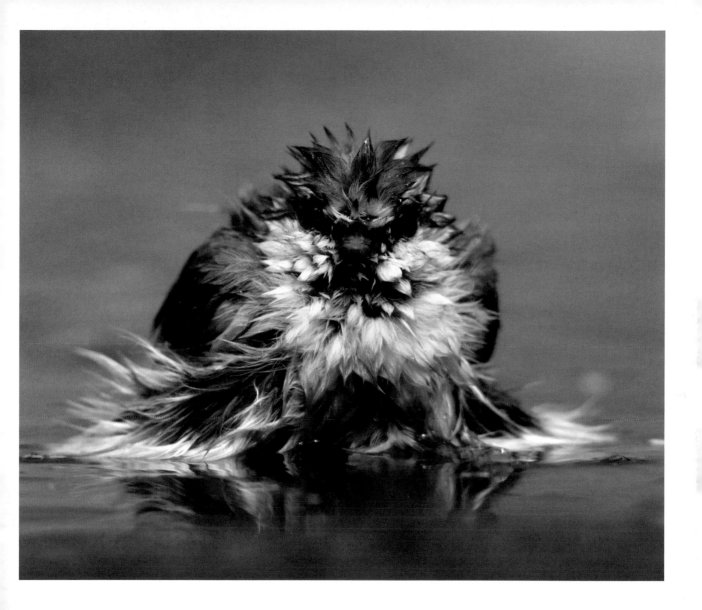

∧ **Eurasian Blue Tit**
Cyanistes caeruleus
Espelo, the Netherlands
Nikon D5600 with 150–600mm
lens, 1/1600 sec. at f/6.3, ISO 2000
Femke van Willigen, @ajoebowan

‹ **Southern Rockhopper Penguin**
Eudyptes crestatus
Saunders Island, Falkland Islands
Nikon D610 with 24–85mm
lens, 1/160 sec. at f/10, ISO 200
Franka Slothouber, @frankaslothouber

"Bathing birds are so much fun
to watch, as they always turn into
these adorable little punk rockers!"

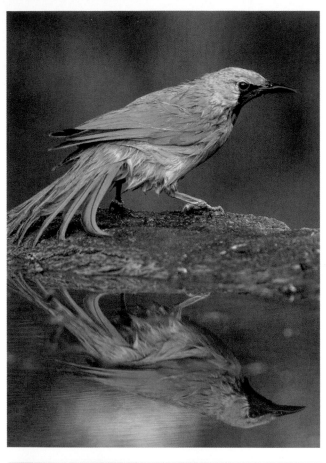

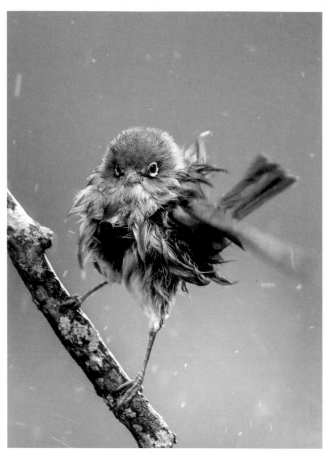

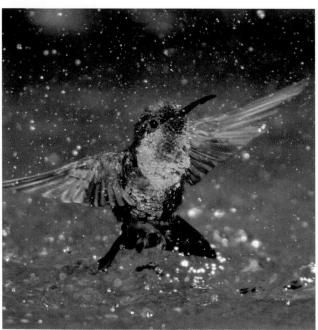

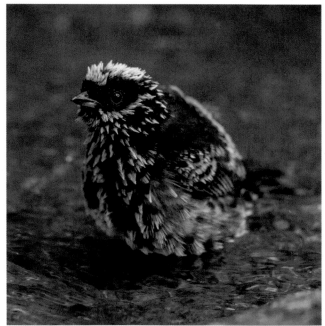

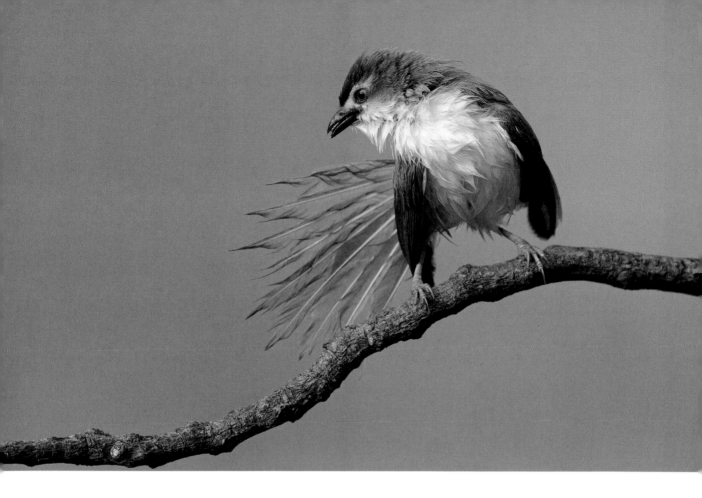

⌐⌐ Jerdon's Leafbird
Chloropsis jerdoni
Bengaluru, India
Nikon D500 with 200–500mm lens, 1/500 sec. at f/5.6, ISO 1250
Pradeep Purushothaman, @pradeep.wildlens

≪ Crowned Woodnymph
Thalurania colombica
Turrialba, Costa Rica
Canon EOS 7D with 500mm lens and 1.4x teleconverter, 1/200 sec. at f/5.6, ISO 800
Glenn Bartley, @bartleys_photo_workshops

⌐ Silvereye
Zosterops lateralis
Donnybrook, Australia
Canon EOS 1D X with 600mm lens, 1/500 sec. at f/4, ISO 1000
Georgina Steytler, @georgina_steytler

< Beryl-spangled Tanager
Tangara nigroviridis
San Tadeo, Pichincha region, Ecuador
Canon EOS 1D MkIV with 500mm lens and 1.4x teleconverter, 1/320 sec. at f/5.6, ISO 1600
Ben Knoot, @benknoot

⌃ Yellow-eyed Babbler
Chrysomma sinense
Bengaluru, Karnataka, India
Canon EOS 1D X with 500mm lens, 1/2500 sec. at f/4, ISO 800
Praveen Siddannavar, @praveensiddannavar

"This Yellow-eyed Babbler stole the show as she enjoyed a bath in a pool of water right in front of me. I think she just loved to bathe, as I saw her taking dips in the water at regular intervals before preening, drying, and cleaning her feathers."

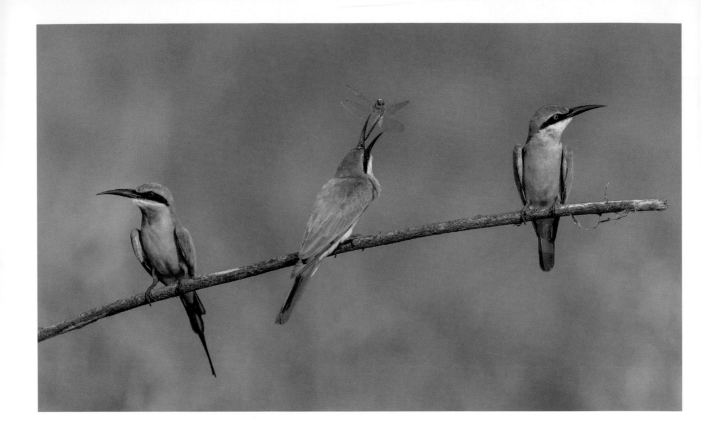

Blue-tailed Bee-Eater
Merops philippinus
Kadamakkudy Islands, India
Nikon D850 with 500mm lens,
1/800 sec. at f/8, ISO 200
Ganesh Balakrishnan, @the_lord_of_the_light

"Photographing Blue-tailed Bee-Eaters in flight is quite challenging, so when I came across a small group chasing dragonflies, I focused on a branch close to me and hoped they would perch on it. I waited for almost an hour for this wonderful moment, when three birds landed on the branch. One of them had caught a dragonfly and tossed it up in the air before finishing it off—the exact moment I took my shot. What made it more special was the look of disappointment of the other two birds!"

Common Cuckoo & Eurasian Reed Warbler
Cuculus canorus & Acrocephalus scirpaceus
Noord-Holland, the Netherlands
Nikon D610 with 500mm lens and 1.4x teleconverter, 1/1600 sec. at f/8, ISO 1000
Franka Slothouber, @frankaslothouber

Eastern Bluebird
Sialia sialis
St. Catharines, Ontario, Canada
Nikon D7200 with 300mm lens and 1.7x teleconverter, 1/250 sec. at f/7.1, ISO 500
Robert S. Parker, @robert.s.parker

Yellow-vented Bulbul
Pycnonotus goiavier
Jurong West, Singapore
Nikon D850 with 400mm lens, 1/500 sec. at f/8, ISO 250
Vincent Chiang, @vincent_ckx

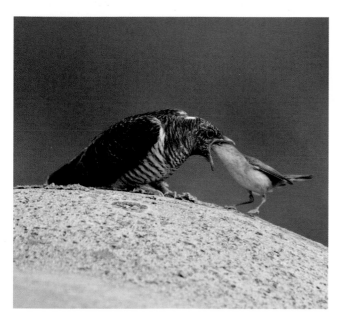

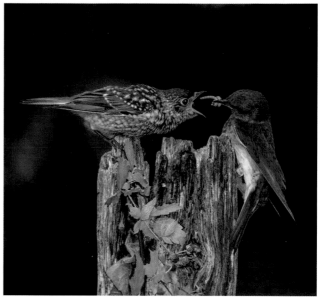

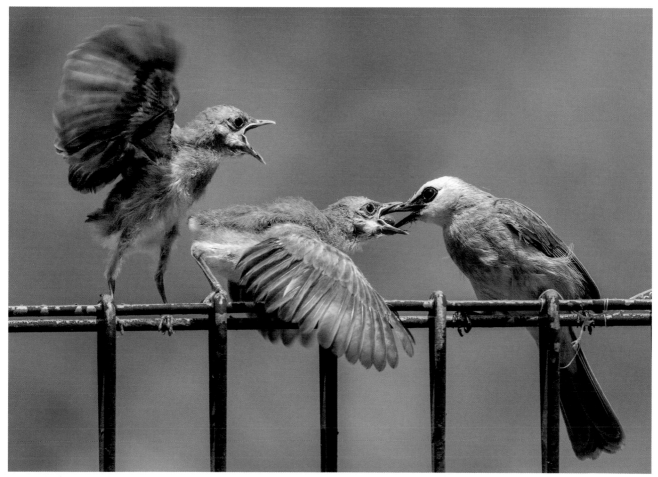

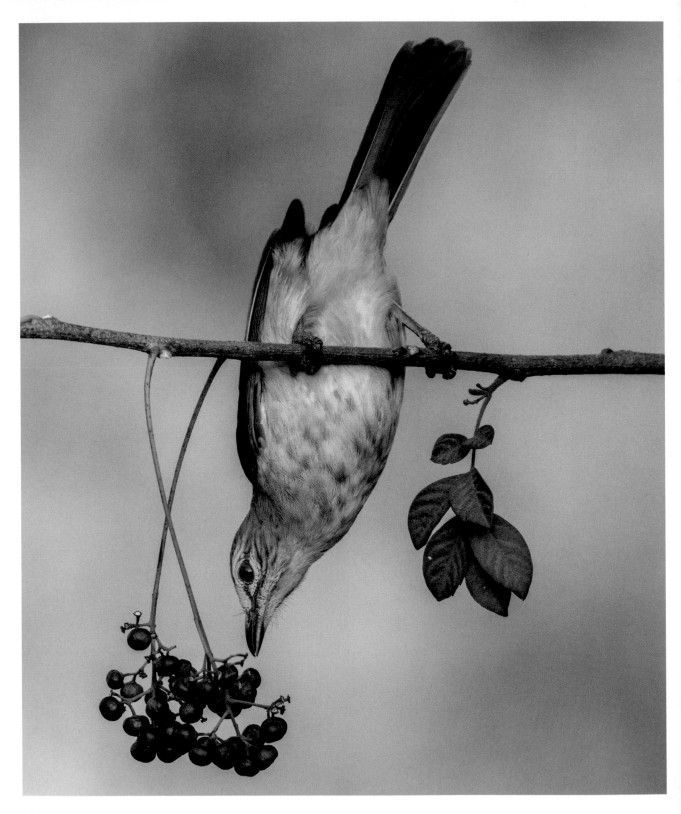

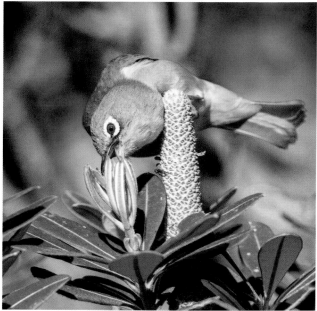

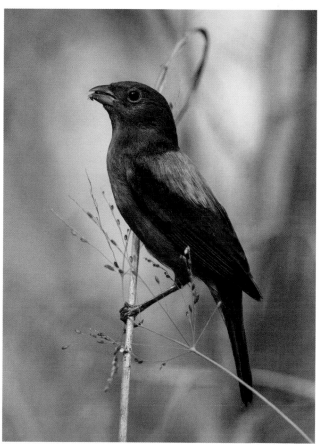

∧ Metallic Starling
Aplonis metallica
Queensland, Australia
Olympus OM-D E-M1X with 300mm lens and
1.4x teleconverter, 1/640 sec. at f/5.6, ISO 250
Ben Knoot, @benknoot

‹ White-browed Bulbul
Pycnonotus luteolus
Bengaluru, India
Nikon D500 with 200–500mm
lens, 1/2500 sec. at f/5.6, ISO 1250
Pradeep Purushothaman, @pradeep.wildlens

¬ Silvereye
Zosterops lateralis
Ballina, New South Wales, Australia
Nikon D800E with 150–600mm
lens, 1/1250sec. at f/7.1, ISO 800
Scott Rolph, @aussiebirdphotography

› Painted Bunting
Passerina ciris
Circle B Bar Reserve, Florida, USA
Nikon D500 with 300mm lens,
1/1000 sec. at f/8, ISO 640
Peter Brannon, @peter.brannon

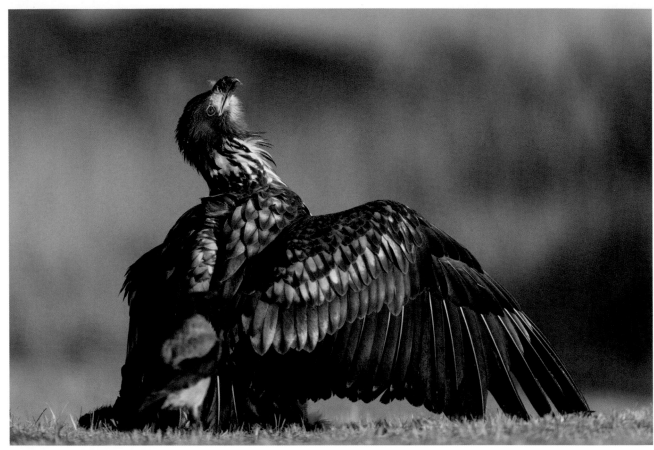

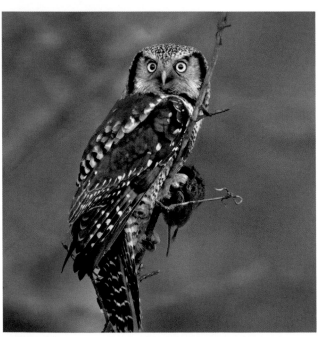

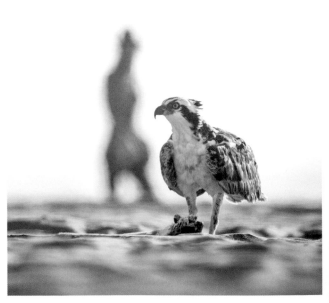

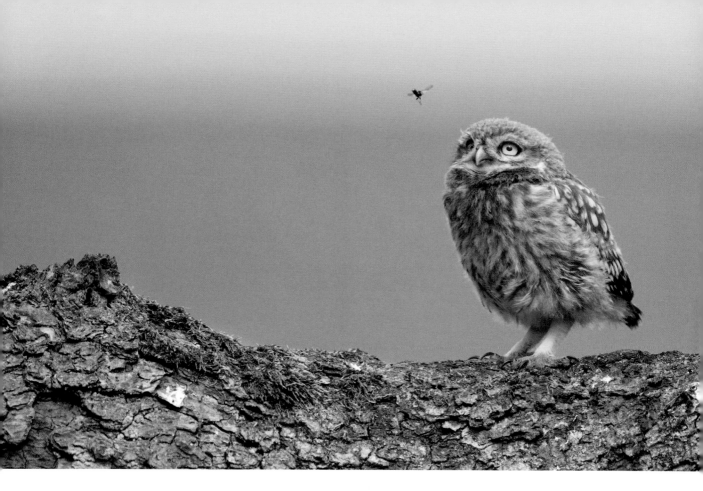

⌐ White-tailed Eagle
Haliaeetus albicilla
Lower Austria, Austria
Nikon D850 with 600mm lens,
1/2500 sec. at f/4, ISO 800
Robert Kreinz, @rkreinz

‹‹ Northern Hawk Owl
Surnia ulula
Southwestern Ontario, Canada
Nikon D850 with 500mm lens and 1.4x
teleconverter, 1/200 sec. at f/5.6, ISO 2000
Robert S. Parker, @robert.s.parker

‹ Osprey
Pandion haliaetus
Dockweiler Beach, Los Angeles,
California, USA
Nikon D750 with 150–600mm
lens, 1/640 sec. at f/8, ISO 320
Alecia Smith, @alecia_birds

∧ Little Owl
Athene noctua
Gelderland, the Netherlands
Nikon D700 with 500mm lens and 1.4x
teleconverter, 1/640 sec. at f/8, ISO 640
Franka Slothouber, @frankaslothouber

"A fellow photographer who owns a dairy
farm invited me to photograph a Little
Owl family nesting in the old pear tree in
his yard. He had built a blind in front of
the tree and I enjoyed photographing
from it for a whole week. At the time,
the chicks were being fed by their
parents and still had to learn to forage
on their own, so when this insect flew
by, this chick just watched it, rather than
attempting to catch it."

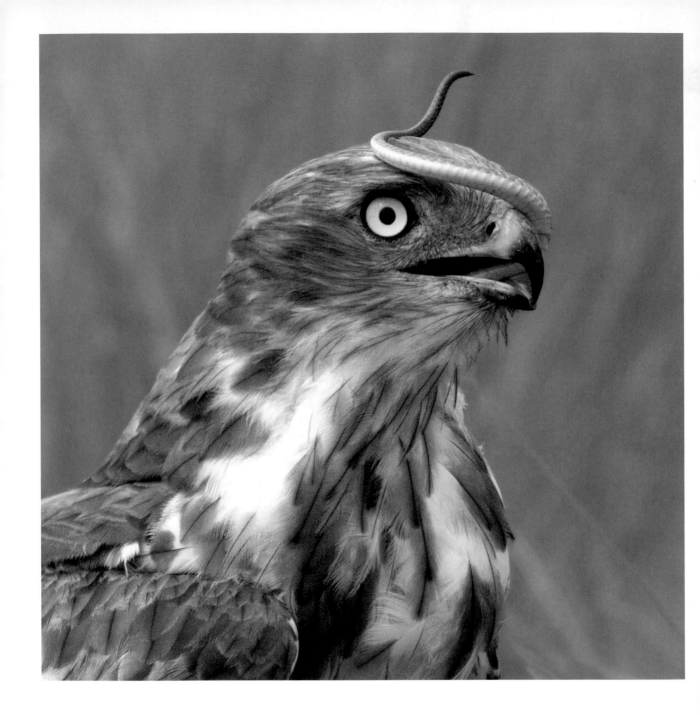

∧ **Short-toed Snake-Eagle**
Circaetus gallicus
Chennai, India
*Nikon D500 with 600mm lens,
1/2000 sec. at f/8, ISO 800*
Ananth Ramasamy, @ananth.ramasamy

"While driving through grassland with my friend, we saw a Short-toed Snake-Eagle dive down and land. As we approached the bird, we saw it had killed a cobra—I took this photograph as it started to swallow the snake's tail."

Greater Roadrunner
Geococcyx californianus
Santa Clara Wildlife Ranch,
Texas, USA
Canon EOS 5D MkIV with
150–600mm lens, 1/3200
sec. at f/6.3, ISO 2000
Eli Martinez, @sdmdiving

Snail Kite
Rostrhamus sociabilis
Lakeland, Florida, USA
Nikon D850 with 500mm lens,
1/3200 sec. at f/6.3, ISO 500
Peter Brannon,
@peter.brannon

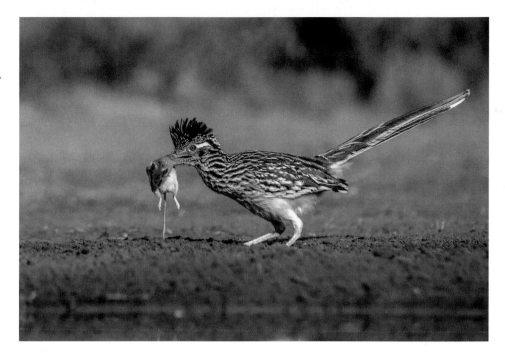

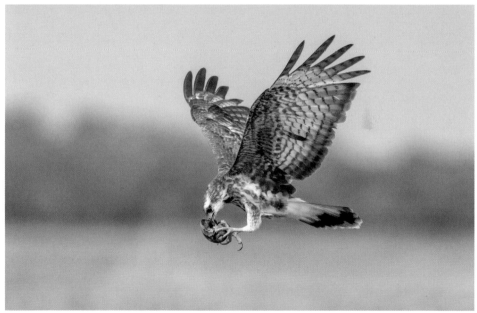

"Fast food. For a busy Snail Kite who
doesn't have time to find a nice perch
and enjoy its snail, there is always
eating on the go!"

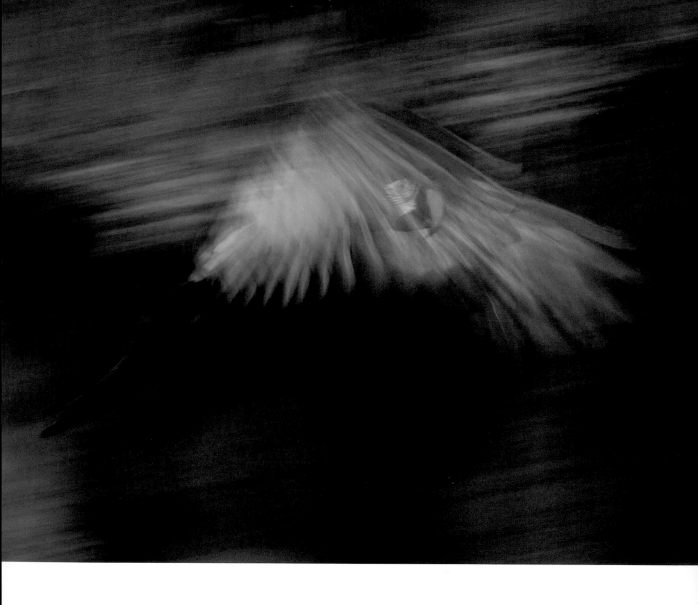

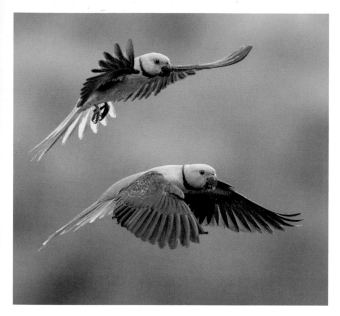

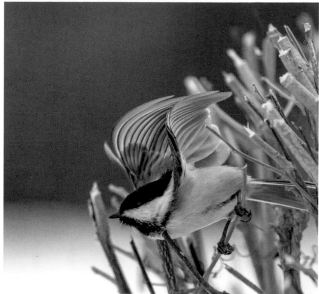

∧ Malabar Parakeet
Psittacula columboides
Hosanagara, Karnataka, India
*Canon EOS 1D X MkII with 400mm
lens, 1/5000 sec. at f/5.6, ISO 6400*
Praveen Siddannavar, @praveensiddannavar

‹ Red-and-green Macaw
Ara chloropterus
Madre de Dios river, Peru
*Canon EOS 7D MkII with 500mm lens and
1.4x teleconverter, 1/40 sec. at f/20, ISO 100*
Jess Findlay, @jessfindlay

┐ Black-capped Chickadee
Poecile atricapillus
London, Ontario, Canada
*Olympus OM-D E-M1 with 40–150mm
lens, 1/6400 sec. at f/2.8, ISO 640*
Kevin Biskaborn, @kevinbiskaborn

› Pin-tailed Whydah
Vidua macroura
Pulau Punggol Barat, Singapore
*Nikon D7200 with 300mm lens and 1.4x
teleconverter, 1/1600 sec. at f/5.6, ISO 125*
Ananth Ramasamy, @ananth.ramasamy

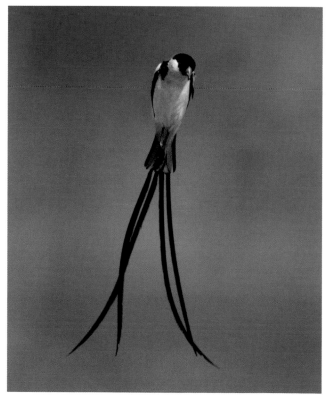

"The male Pin-tailed Whydah is territorial,
and one male often has several females
in his small group. His elaborate courtship
flight display includes hovering over the
female to display his tail."

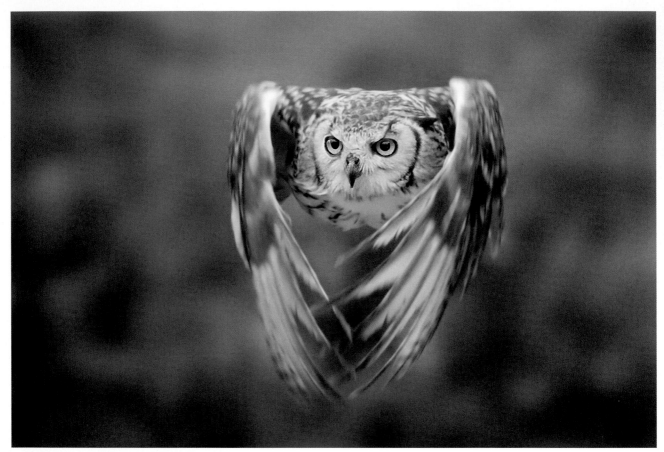

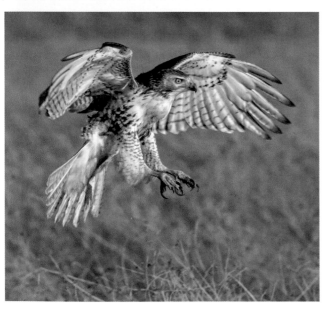

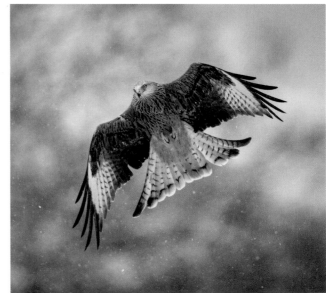

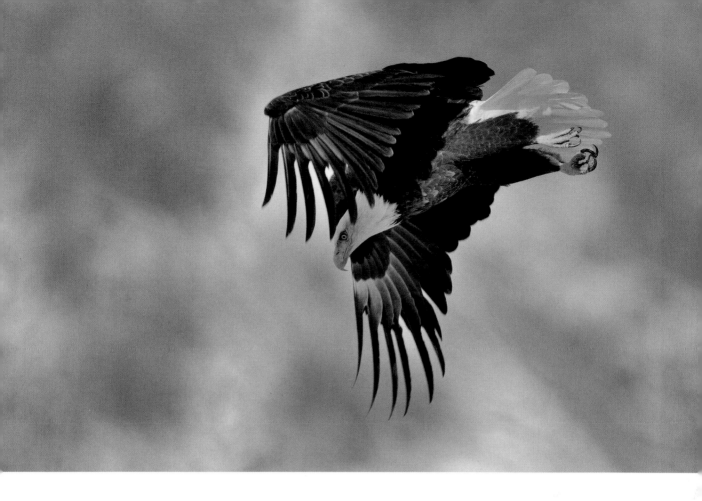

"Many Bald Eagles make Utah their winter home, and a number of pairs have even made it their permanent residence. I photographed this bird as it jumped from its perch after a night's rest and headed off in search of food."

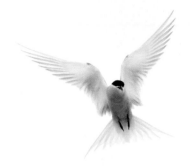

∧ **Antarctic Tern**
Sterna vittata
Cierva Cove, Antarctic Peninsula
*Canon EOS 5D MkIII with 100–400mm
lens, 1/1600 sec. at f/5.6, ISO 400*
James Lowe, @jameslowe783

> **Black-naped Tern**
Sterna sumatrana
Changi, Singapore
*Nikon D850 with 300mm lens,
1/2500 sec. at f/5.6, ISO 250*
Vincent Chiang, @vincent_ckx

"Black-naped Tern have nested on
a rocky islet off eastern Singapore
since the 1950s and can be seen in
the breeding season that runs from
April to August. From 1976 to 1984
the bird also featured on the one
Singapore dollar note."

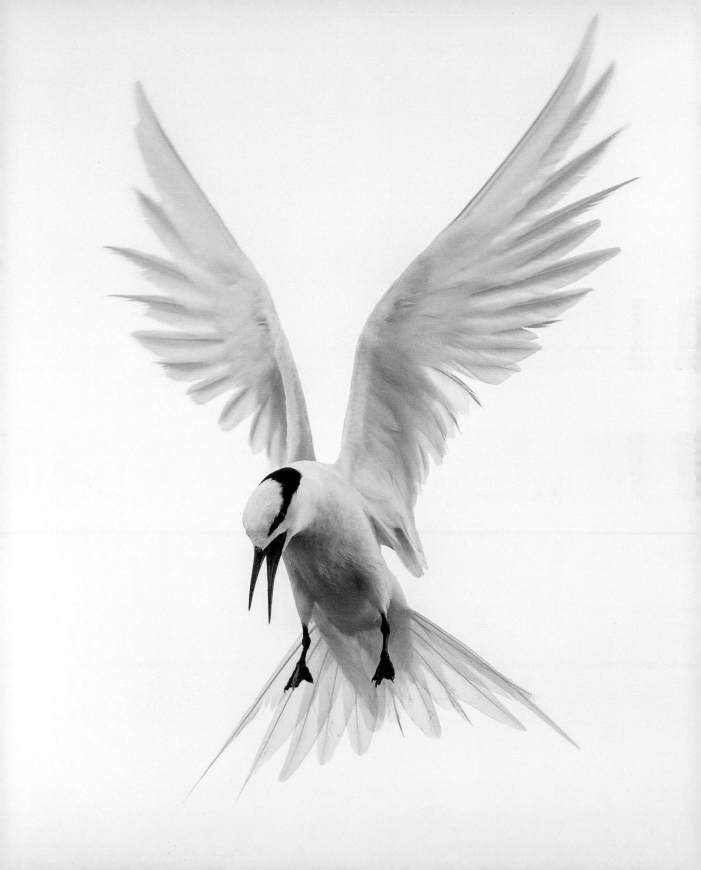

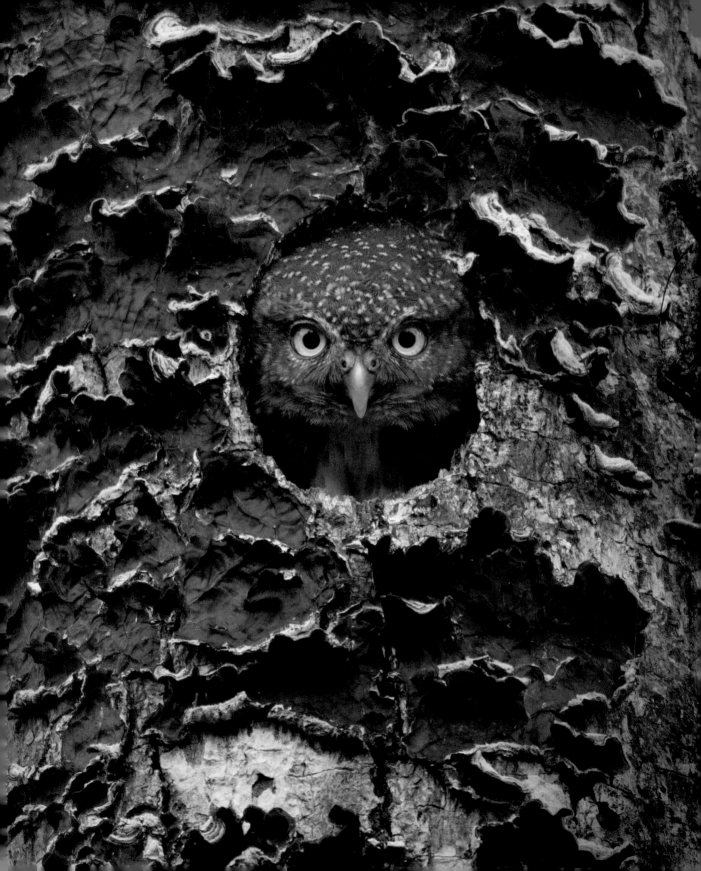

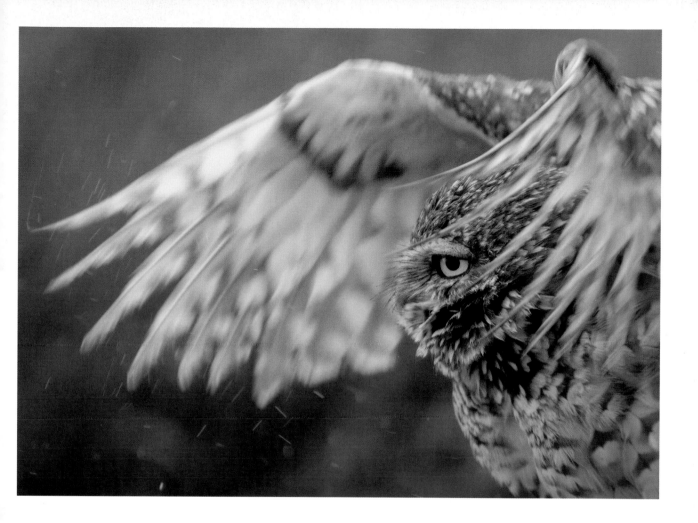

Burrowing Owl
Athene cunicularia
Davis, California, USA
Nikon D850 with 200–500mm lens, 1/1000 sec. at f/5.6, ISO 640
Elijah Gildea, @elijahs_photography

Central American Pygmy-Owl
Glaucidium griseiceps
Border of Costa Rica and Nicaragua
Canon EOS 7D MkII with 500mm lens and 2x teleconverter, 1/15 sec. at f/10, ISO 800
Jess Findlay, @jessfindlay

"These owls are about the size of an adult's hand and hunt bugs and small rodents. This is one of a group of about five adults living by the side of a series of agricultural roads outside Davis."

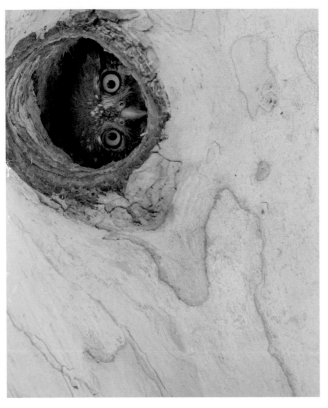

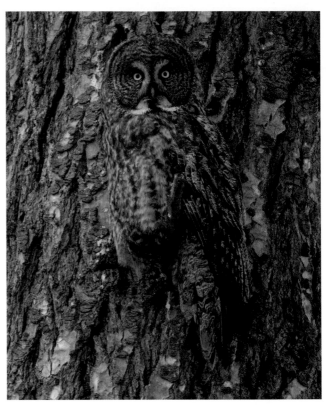

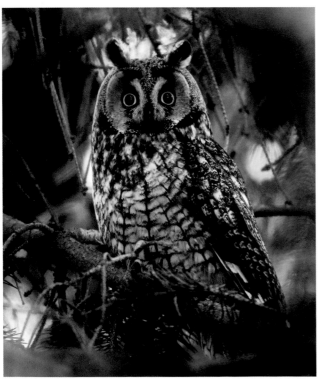

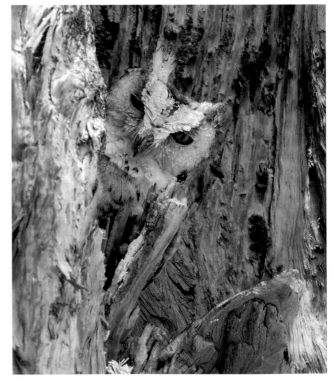

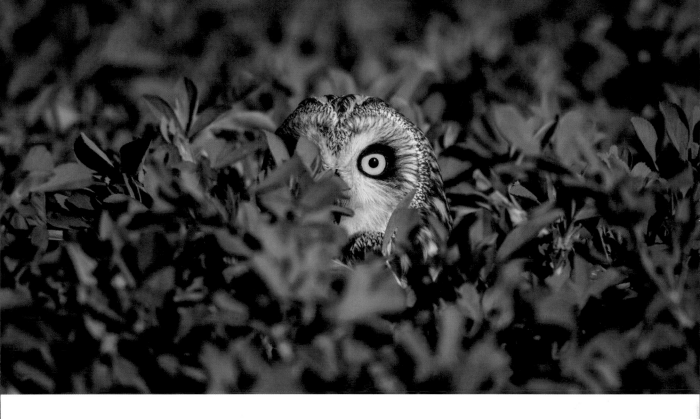

⌐⌐ Northern Pygmy-Owl
Glaucidium gnoma
Green Valley, Arizona, USA
*Canon EOS 1D MkIV with
500mm lens and 1.4x
teleconverter, 1/160
sec. at f/5.6, ISO 320*
Ben Knoot, @benknoot

⟨⟨ Long-eared Owl
Asio otus
Rockland County,
New York, USA
*Canon EOS 5D MkIV
with 600mm lens and
1.4x teleconverter, 1/640
sec. at f/5.6, ISO 12,800*
Rina Miele, @rinamiele

⌐ Great Gray Owl
Strix nebulosa
British Columbia, Canada
*Canon EOS 7D MkII with
100–400mm lens, 1/5
sec. at f/16, ISO 160*
Jess Findlay, @jessfindlay

⟨ Collared Scops-Owl
Otus lettia
Keshopur Wetland,
Gurdaspur, India
*Canon EOS 7D MkII
with 400mm lens, 1/400
sec. at f/8, ISO 640*
Vishesh Kamboj,
@visheshkambojj

⌃ Short-eared Owl
Asio flammeus
Lower Austria, Austria
*Nikon D500 with 600mm lens and 1.4x
teleconverter, 1/2500 sec. at f/6.3, ISO 500*
Robert Kreinz, @rkreinz

"I found this Short-eared Owl in an
agriculture field one afternoon. It was
resting, but sometimes looked up to
give me a curious look."

∧ **Common Pauraque**
Nyctidromus albicollis
South Texas, USA
*Canon EOS5D MkIII with 400mm
lens, 1/5 sec. at f/16, ISO 100*
Jess Findlay, @jessfindlay

"A nocturnal bird, the Common
Pauraque is found throughout the
New World Tropics. It has amazing
plumage that mimics leaf litter,
allowing it to roost undisturbed in
the forest understory during the day."

> **Common Potoo**
Nyctibius griseus
Manizales region, Colombia
*Nikon D850 with 800mm lens,
1/125 sec. at f/5.6, ISO 400*
John Crawley, @jc_wings

"Common Potoo are nocturnal birds
that rely on camouflage and holding
perfectly still during the day to avoid
predation. Here, a Common Potoo
and her chick sit motionless on the
top of a broken-off tree."

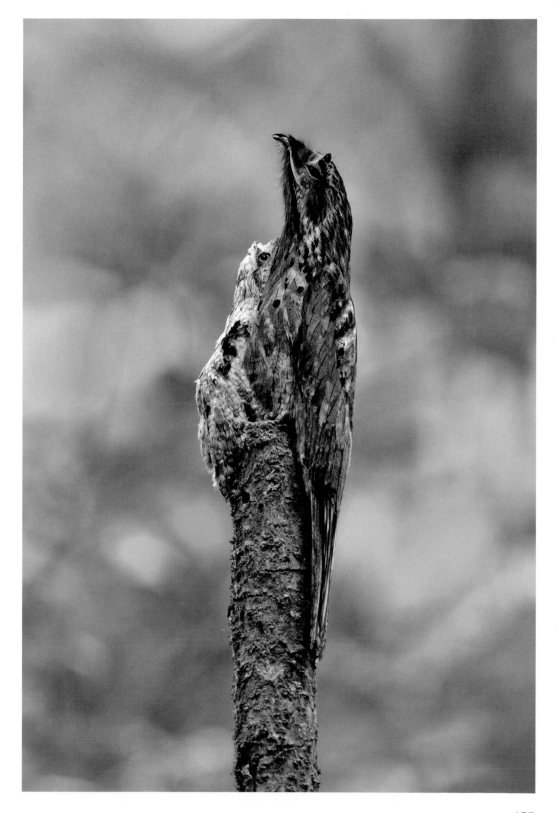

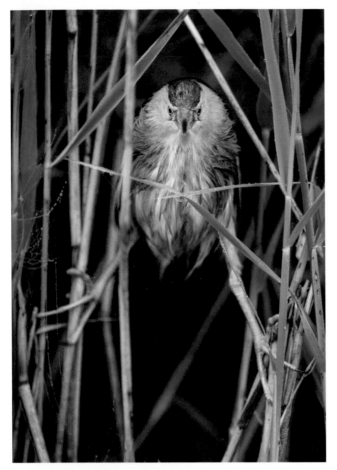

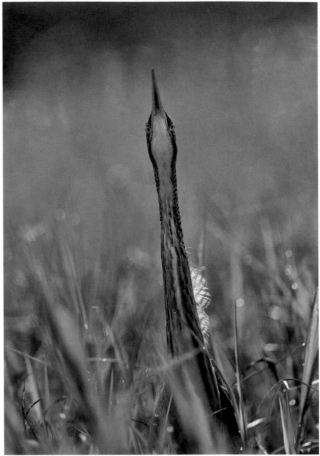

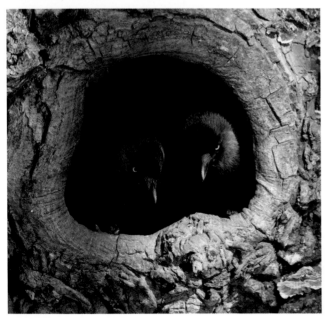

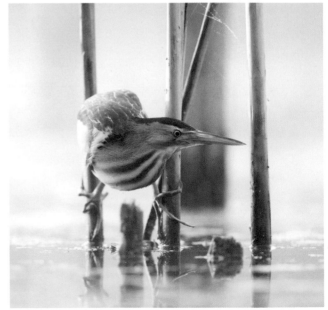

134

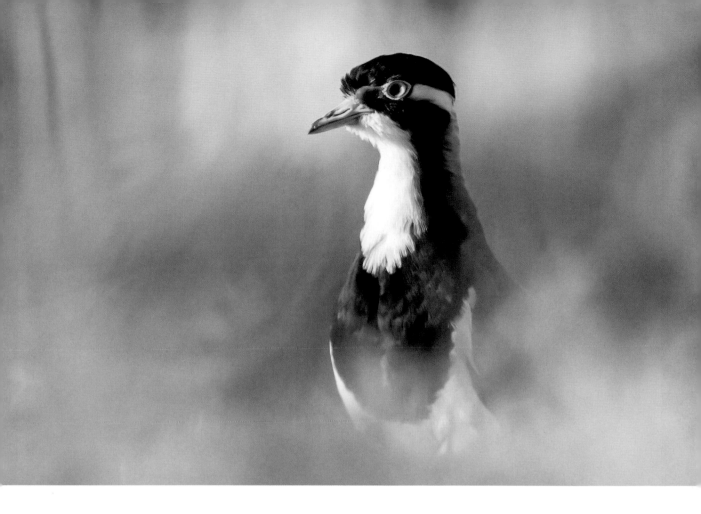

┌ ┌ **Little Bittern**
Ixobrychus minutus
Bratislava, Slovakia
*Nikon D700 with 600mm lens
and 1.4x teleconverter, 1/400
sec. at f/5.6, ISO 1280*
Robert Kreinz, @rkreinz

‹ ‹ **Eurasian Jackdaw**
Coloeus monedula
Alphen aan den Rijn,
the Netherlands
*Nikon D5600 with 150–
600mm lens, 1/3200
sec. at f/6.3, ISO 2000*
Femke van Willigen,
@ajoebowan

┌ **American Bittern**
Botaurus lentiginosus
Cano Negro Wildlife Refuge,
Costa Rica
*Nikon D850 with 800mm lens,
1/4000 sec. at f/5.6, ISO 500*
John Crawley, @jc_wings

‹ **Little Bittern**
Ixobrychus minutus
Rusenski Lom Nature
Park, Bulgaria
*Canon EOS 1D X MkII
with 600mm lens, 1/1250
sec. at f/5.6, ISO 5000*
Erik Ruiterman, @erikruiterman

∧ **Banded Lapwing**
Vanellus tricolor
Golden Bay, Australia
*Olympus OM-D E-M1 MkII with 300mm
lens, 1/2000 sec. at f/4.5, ISO 500*
Alice Worswick, @alice_worswick

"Even though they are considered a
shore bird, I observed a small flock
of Banded Lapwings hanging out at a
local open grassland area. I had been
lying on the ground for a while, hoping
to remain undetected, when this
youngster who was feeding in the tall
grass looked up and surprised me."

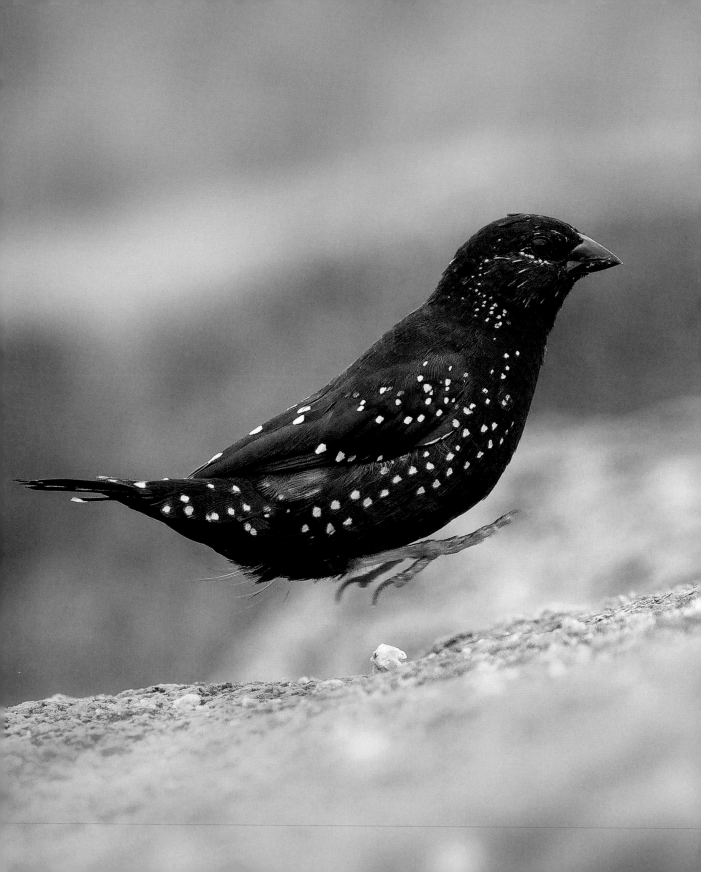

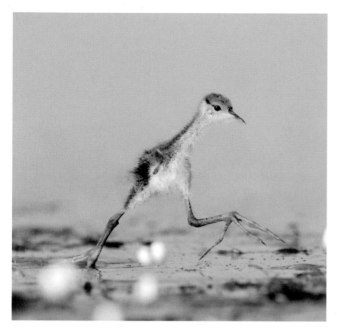

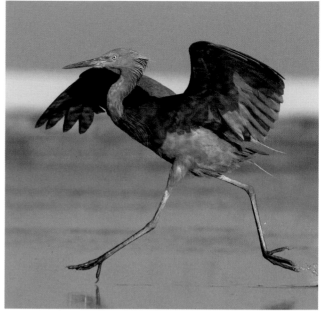

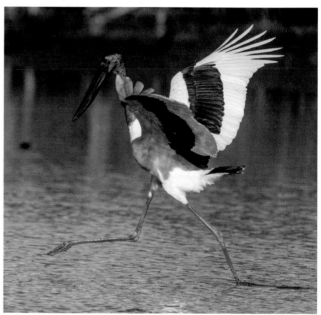

^ **Comb-crested Jacana**
Irediparra gallinacea
Kununurra, Australia
Canon EOS 1D X with 500mm lens and 1.4x teleconverter, 1/4000 sec. at f/7.1, ISO 800
Shelley Pearson, @shelley_pearson_

< **Red Avadavat**
Amandava amandava
Hampi, Karnataka, India
Nikon D500 with 600mm lens, 1/2500 sec. at f/4, ISO 500
Pradeep Purushothaman, @pradeep.wildlens

┐ **Reddish Egret**
Egretta rufescens
Sarasota, Florida, USA
Nikon D500 with 300mm lens, 1/4000 sec. at f/6.3, ISO 400
Peter Brannon, @peter.brannon

> **Black-necked Stork**
Ephippiorhynchus asiaticus
Ballina, New South Wales, Australia
Nikon D800E with 150–600 lens, 1/4000 sec. at f/6.3, ISO 800
Scott Rolph, @aussiebirdphotography

"The Black-necked Stork is number five in my list of favorite Australian birds. These birds are so graceful for a big bird and I always get a buzz when seeing them."

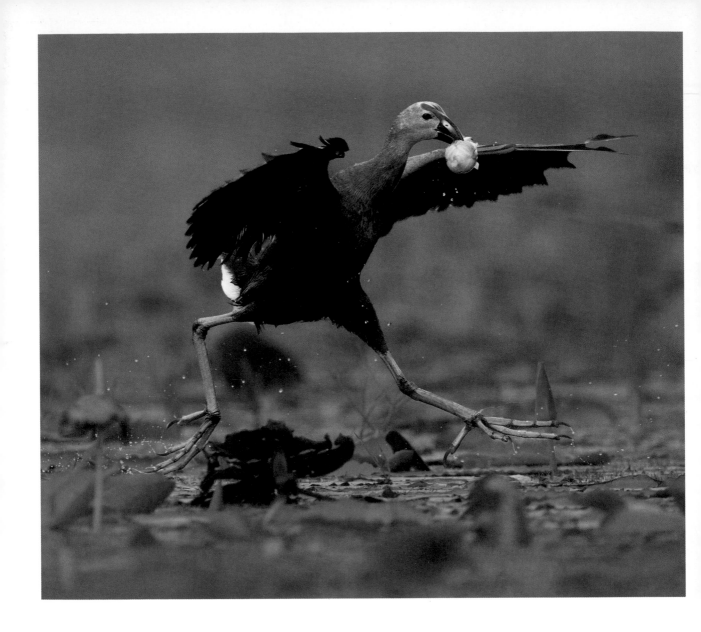

⌃ Gray-headed Swamphen
Porphyrio poliocephalus
Chennai, India
Nikon D500 with 600mm lens,
1/3200 sec. at f/4, ISO 1000
Ananth Ramasamy, @ananth.ramasamy

"I saw this Gray-headed Swamphen feeding close to a nesting Pheasant-tailed Jacana. I expected the jacana would chase away the swamphen, which would give me the opportunity to take this picture. Understanding a bird's behavior is crucial if you want to capture a specific moment."

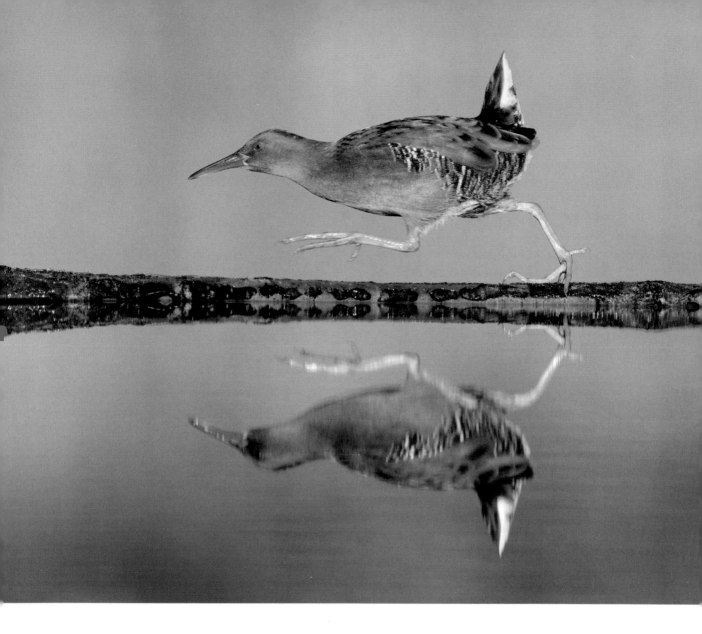

∧ Water Rail
Rallus aquaticus
Amsterdam, the Netherlands
*Nikon D610 with 500mm lens,
1/2000 sec. at f/8, ISO 1000*
Franka Slothouber, @frankaslothouber

"A shy bird like a Water Rail can only be photographed from a blind, and I knew a photographer who had built one in a swamp just outside Amsterdam. One day I placed a branch with some mealworms on it in the water in front of the hide. This Water Rail soon came to fetch them, running across the branch and then disappearing into the reed collar."

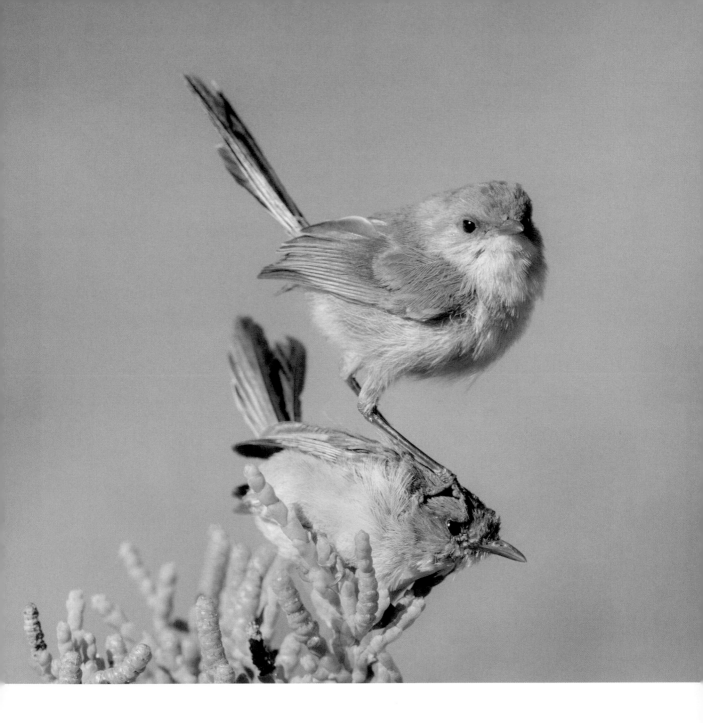

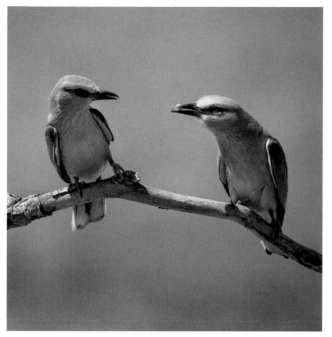

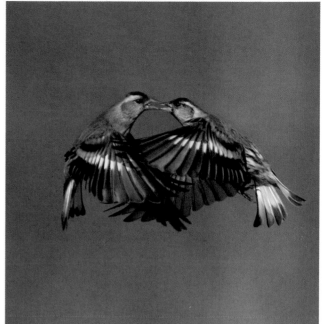

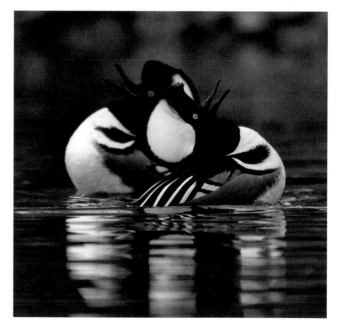

∧ **European Roller**
Coracias garrulus
Danube Delta, Romania
Canon EOS 1D X MkII with 100–400mm
lens, 1/2000 sec. at f/5.6, ISO 1600
Erik Ruiterman, @erikruiterman

‹ **Splendid Fairywren**
Malurus splendens
Creery Wetlands, Mandurah, Australia
Canon EOS 1D X MkII with 600mm lens and
1.4x teleconverter, 1/2000 sec. at f/8, ISO 1000
Shelley Pearson, @shelley_pearson_

⌐ **Eurasian Siskin**
Spinus spinus
Canon EOS 1D X with 300mm lens and 1.4x
teleconverter, 1/8000 sec. at f/4, ISO 500
Stefano Ronchi, @stefanoronchi

› **Hooded Merganser**
Lophodytes cucullatus
Southern Utah, USA
Nikon D500 with 500mm lens and 1.4x
teleconverter, 1/1600 sec. at f/5.6, ISO 800
John Crawley, @jc_wings

"At some point in the year, Hooded Mergansers can be found throughout North America; they are winter visitors in Utah. These two male birds were displaying on a small pond, as they sized each other up."

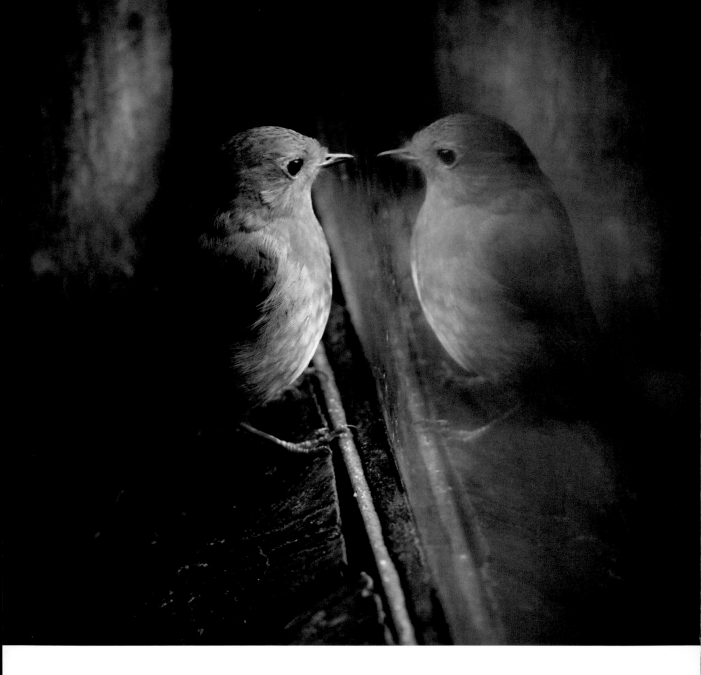

^ European Robin
Erithacus rubecula
Devon, UK
Canon EOS 5D MkII with 100–400mm
lens, 1/125 sec. at f/5.6, ISO 3200
Mark Eastment, @markeastmentphotography

Short-toed Snake-Eagle & Indian cobra
Circaetus gallicus & Naja naja
Thenneri Lake, India
Nikon D850 with 400mm lens,
1/640 sec. at f/5.6, ISO 140
Ganesh Balakrishnan, @the_lord_of_the_light

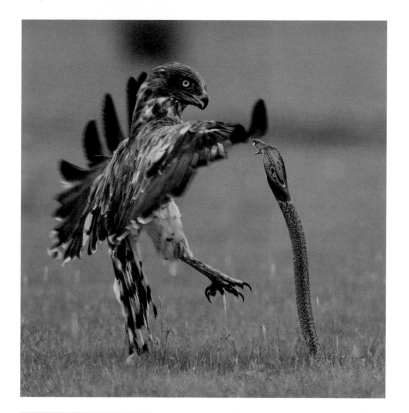

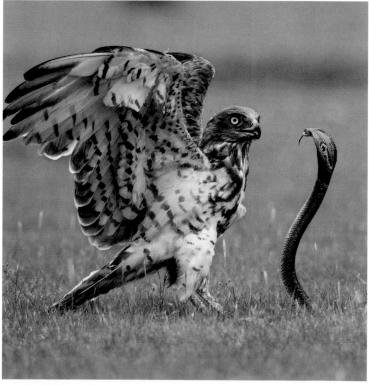

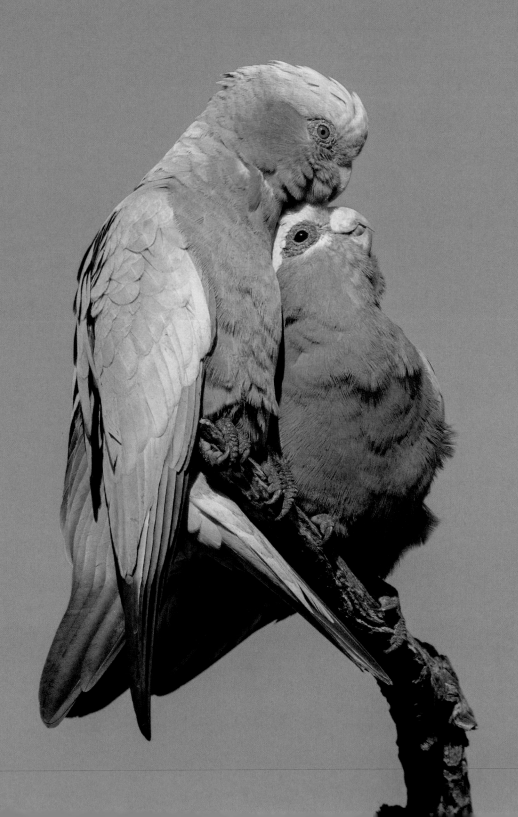

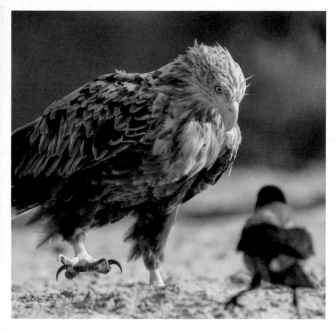

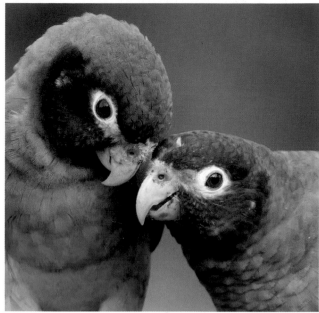

∧ White-tailed Eagle & Hooded Crow
Haliaeetus albicilla & Corvus cornix
Danube Delta, Romania
*Canon EOS 1D X MkII with 600mm
lens, 1/2500 sec. at f/5.6, ISO 2500*
Erik Ruiterman, @erikruiterman

< Galah
Eolophus roseicapilla
Rockingham, Australia
*Canon EOS 1D X MkII with 500mm lens and
2x teleconverter, 1/2500 sec. at f/13, ISO 1600*
Shelley Pearson, @shelley_pearson_

¬ Brown-hooded Parrot
Pyrilia haematotis
Boca Tapada, Costa Rica
*Olympus OM-D E-M1 MkII with
300mm lens and 1.4x teleconverter,
1/320 sec. at f/5.6, ISO 1000*
Ben Knoot, @benknoot

> Bare-throated Tiger-Heron
Tigrisoma mexicanum
Tarcoles, Costa Rica
*Olympus OM-D E-M1 MkII with
300mm lens and 1.4x teleconverter,
1/320 sec. at f/5.6, ISO 1600*
Ben Knoot, @benknoot

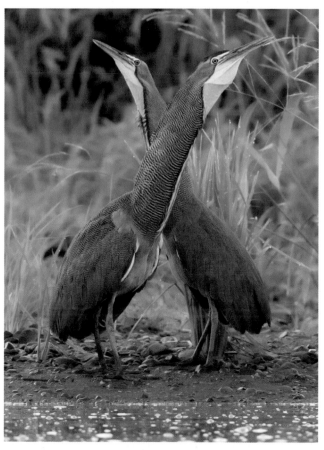

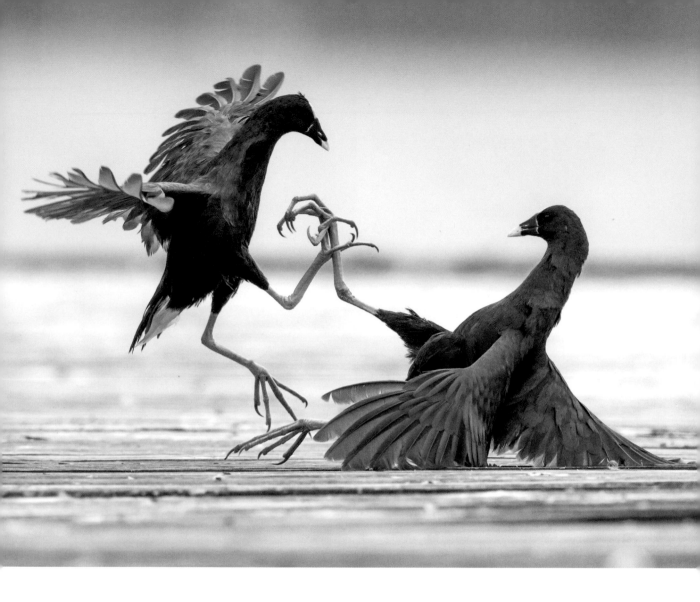

∧ **Purple Gallinule**
Porphyrio martinica
Lakeland, Florida, USA
Nikon D850 with 500mm lens,
1/3200 sec. at f/5.6, ISO 1600
Peter Brannon, @peter.brannon

"These crazy Purple Gallinules are just
so amusing when they get territorial—
they remind me of some of the action
sequences from *The Matrix* movies!"

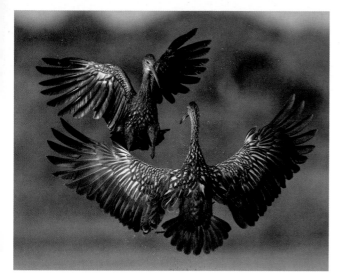

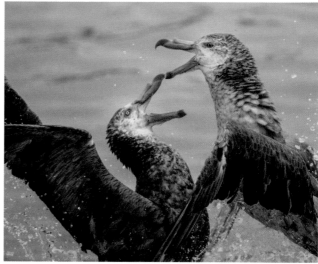

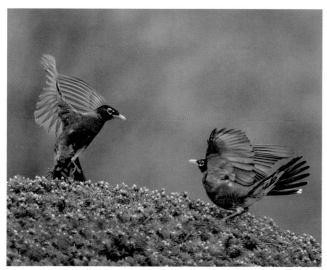

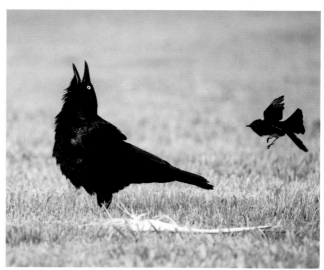

∧ **Limpkin**
Aramus guarauna
Myakka State Park, Florida, USA
Nikon D500 with 500mm lens, 1/3200 sec. at f/5.6, ISO 400
Peter Brannon, @peter.brannon

∧ **American Robin**
Turdus migratorius
London, Ontario, Canada
Olympus OM-D E-M1 with 300mm lens, 1/2000 sec. at f/4, ISO 640
Kevin Biskaborn, @kevinbiskaborn

⌐⌐ **Northern Giant-Petrel**
Macronectes halli
Gold Harbour, South Georgia Island
Canon EOS 5D MkIII with 100–400mm lens, 1/2500 sec. at f/5.6, ISO 400
James Lowe, @jameslowe783

⌐ **Torresian Crow & Willie-Wagtail**
Corvus orru & Rhipidura leucophrys
Ballina, New South Wales, Australia
Nikon D800E with 150–600mm lens, 1/800 sec. at f/6.3, ISO 1000
Scott Rolph, @aussiebirdphotography

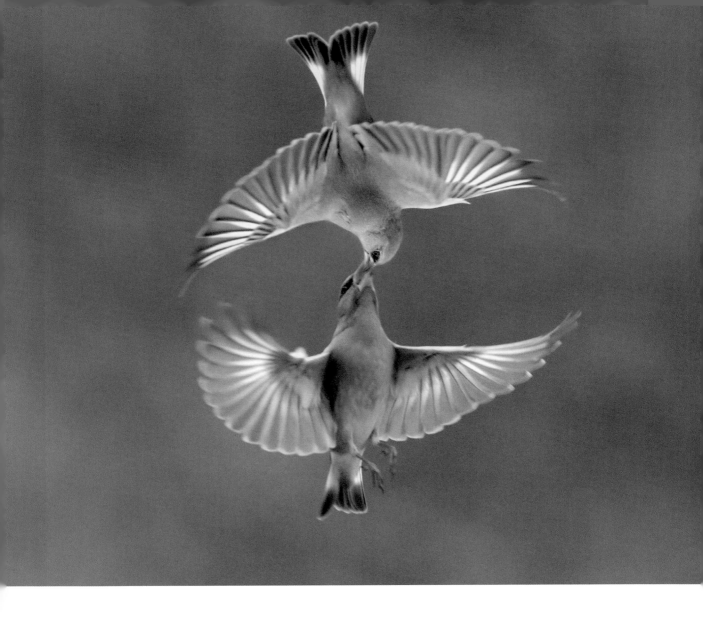

⌃ **European Greenfinch**
Chloris chloris
Canon EOS 1D X with 300mm lens,
1/1600 sec. at f/3.2, ISO 1250
Stefano Ronchi, @stefanoronchi

⌐ **Plum-headed Parakeet**
Psittacula cyanocephala
Hosanagara, Karnataka, India
Canon EOS 1D X MkII with 400mm lens and
1.4x teleconverter, 1/1000 sec. at f/7.1, ISO 800
Praveen Siddannavar, @praveensiddannavar

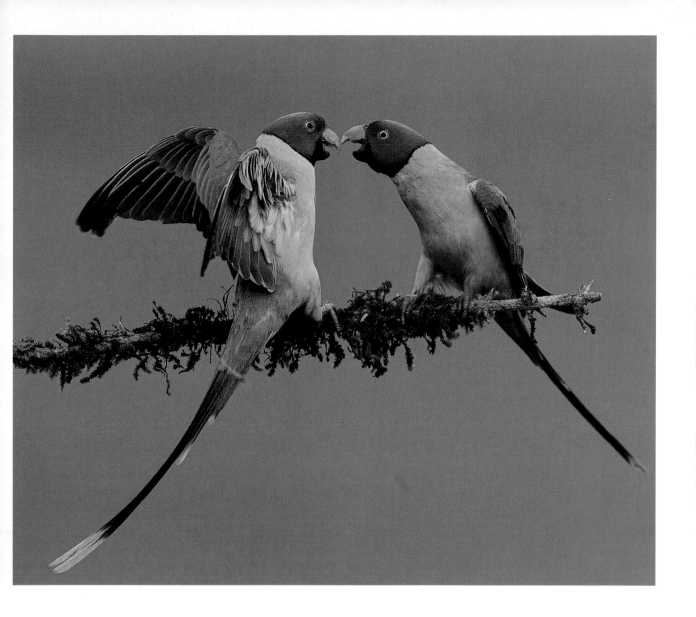

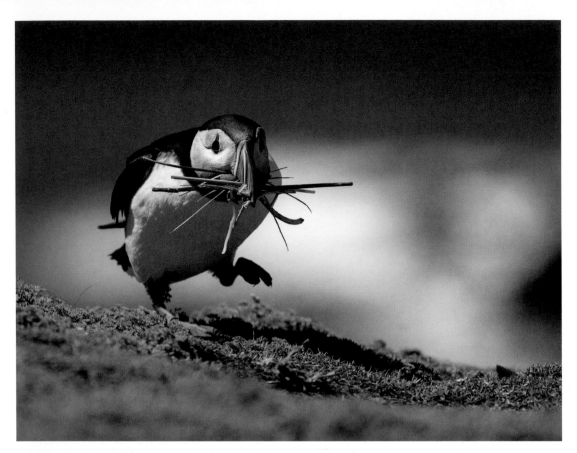

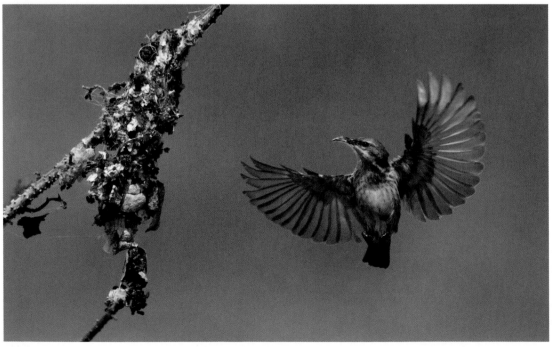

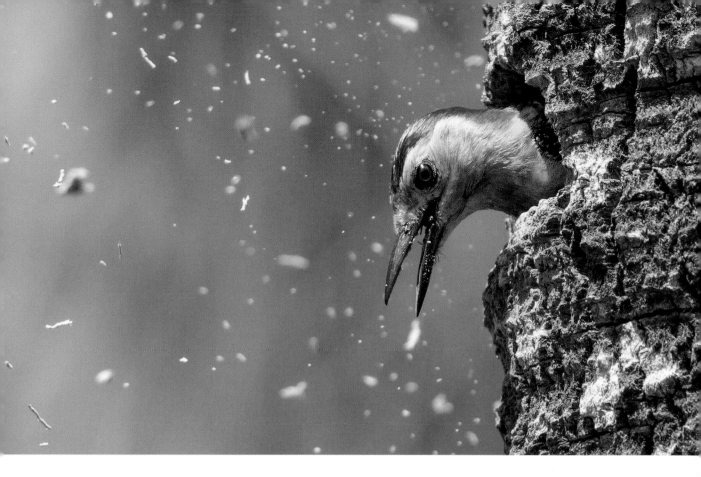

Atlantic Puffin
Fratercula arctica
Skomer Island, UK
*Canon EOS 5D MkIV with 100–400mm
lens, 1/1600 sec. at f/5.6, ISO 500*
Drew Buckley, @drewbphotography

Purple-banded Sunbird
Cinnyris bifasciatus
Villa no Mar Beach Lodge,
Xai-Xai, Mozambique
*Nikon D610 with 200–500mm
lens, 1/4000 sec. at f/6.3, ISO 1250*
Heinrich Human, @heinrich_human

Red-bellied Woodpecker
Melanerpes carolinus
Tampa, Florida, USA
*Nikon D500 with 300mm lens,
1/3200 sec. at f/5.6, ISO 1100*
Peter Brannon, @peter.brannon

"A Red-bellied Woodpecker
moves into a new house!"

"I spotted this female Purple-banded
Sunbird using spiderwebs to bind
her nest and knew it would make
an interesting photograph."

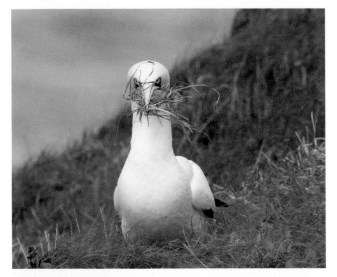

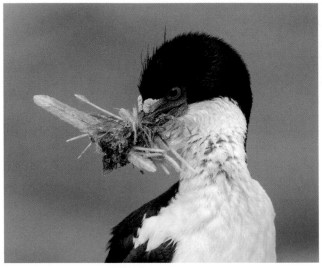

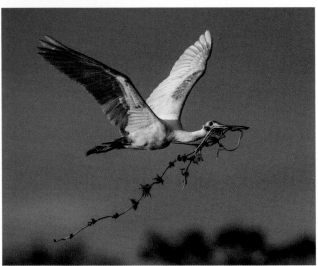

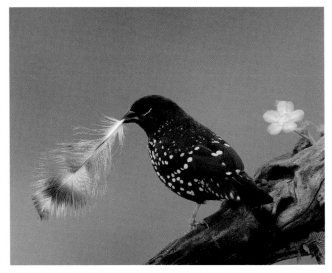

∧ **Northern Gannet**
Morus bassanus
Bempton Cliffs, Yorkshire, UK
*Canon EOS 6D MkII with 100–400mm lens and
1.4x teleconverter, 1/800 sec. at f/9, ISO 1000*
Jason Ogbourne, @jasonogbourne

∧ **Roseate Spoonbill**
Platalea ajaja
Sarasota, Florida, USA
*Nikon D850 with 500mm lens, 1/4000 sec.
at f/6.3, ISO 640*
Peter Brannon, @peter.brannon

⌐ **Imperial Cormorant**
Phalacrocorax atriceps
Sea Lion Island, Falkland Islands
*Nikon D610 with 500mm lens, 1/1000 sec.
at f/8, ISO 1000*
Franka Slothouber, @frankaslothouber

⌐ **Red Avadavat**
Amandava amandava
Mysore, Karnataka, India
*Canon EOS 1D X MkII with 500mm lens and
1.4x teleconverter, 1/1250 sec. at f/9, ISO 1000*
Praveen Siddannavar, @praveensiddannavar

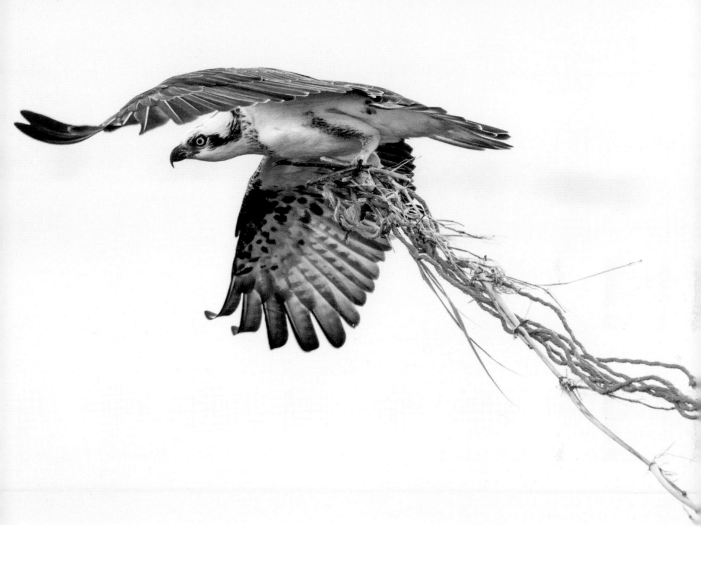

^ Osprey
Pandion haliaetus
Ballina, New South Wales, Australia
Nikon D800E with 300mm lens,
1/1600 sec. at f/8, ISO 800
Scott Rolph, @aussiebirdphotography

"This Osprey had a bounty of rope and straw to take back to its nest. Due to habitat loss, several Australian councils have erected nesting platforms to help the Osprey survive."

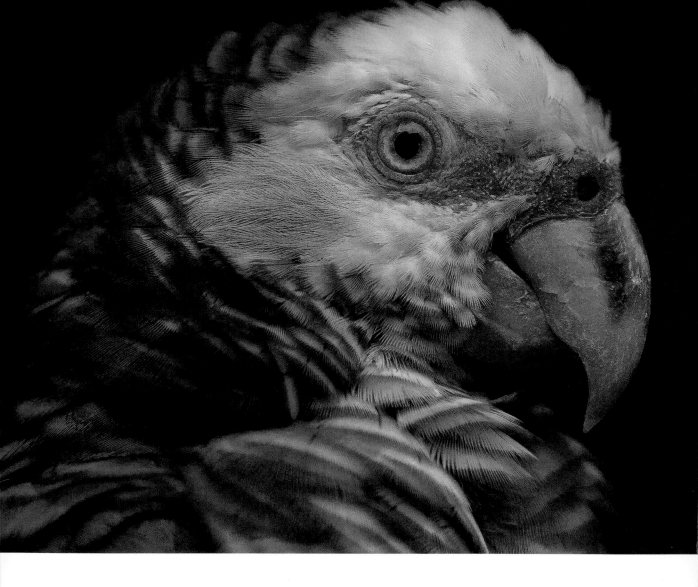

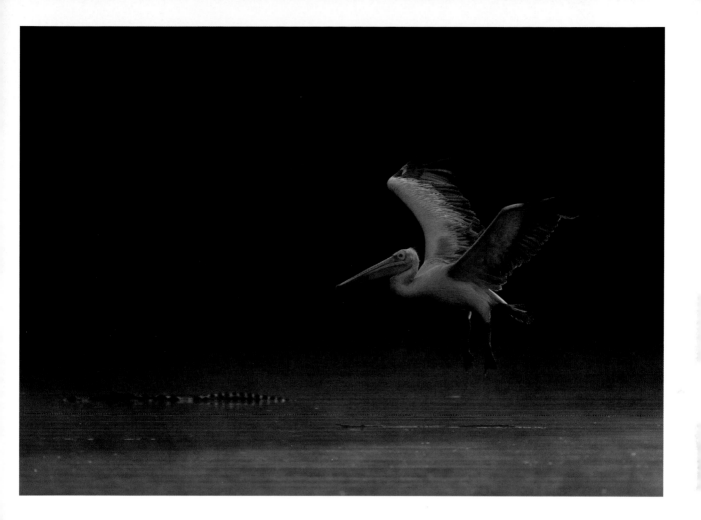

⌃ Spot-billed Pelican & Mugger crocodile
Pelecanus philippensis
& Crocodylus palustris
Ranganathittu Bird Sanctuary,
Karnataka, India
Nikon D750 with 200–500mm
lens, 1/1250 sec. at f/5.6, ISO 400
Pradeep Purushothaman, @pradeep.wildlens

‹ Yellow-shouldered Parrot
Amazona barbadensis
Singapore
Sony α9 with 400mm lens,
1/2000 sec. at f/5.6, ISO 400
Oleg Alexeyev, @oleg_alexeyev_photo

"Beauty and the beast. A Spot-billed
Pelican flying low over a Mugger
(or Marsh) crocodile on a chilly
winter morning at Ranganathittu
Bird Sanctuary."

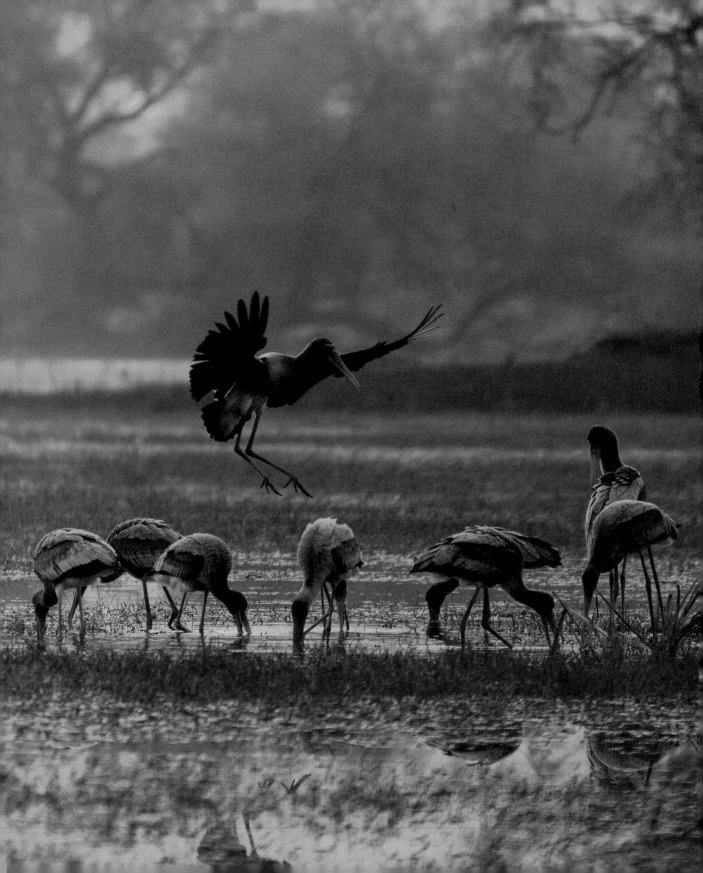

< Painted Stork
Mycteria leucocephala
Bharatpur Bird Sanctuary,
Rajasthan, India
*Nikon D750 with 200–500mm
lens, 1/1000 sec. at f/5.6,
ISO 1250*
Pradeep Purushothaman,
@pradeep.wildlens

> Blue-tailed Bee-Eater
Merops philippinus
Kathlaur Kulshian Wildlife
Sanctuary, Pathankot,
India
*Canon EOS 7D MkII
with 400mm lens, 1/3200
sec. at f/5.6, ISO 800*
Vishesh Kamboj,
@visheshkambojj

⌐ Common Kingfisher
Alcedo atthis
Keshopur Wetland,
Gurdaspur, India
*Canon EOS 7D MkII
with 400mm lens, 1/3200
sec. at f/5.6, ISO 640*
Vishesh Kamboj,
@visheshkambojj

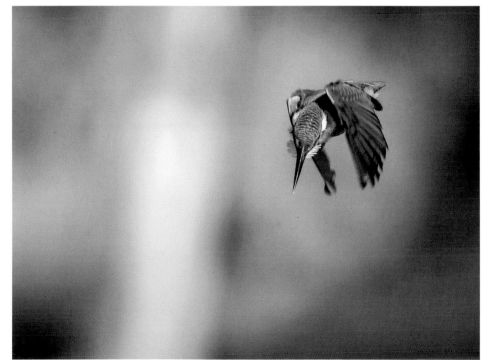

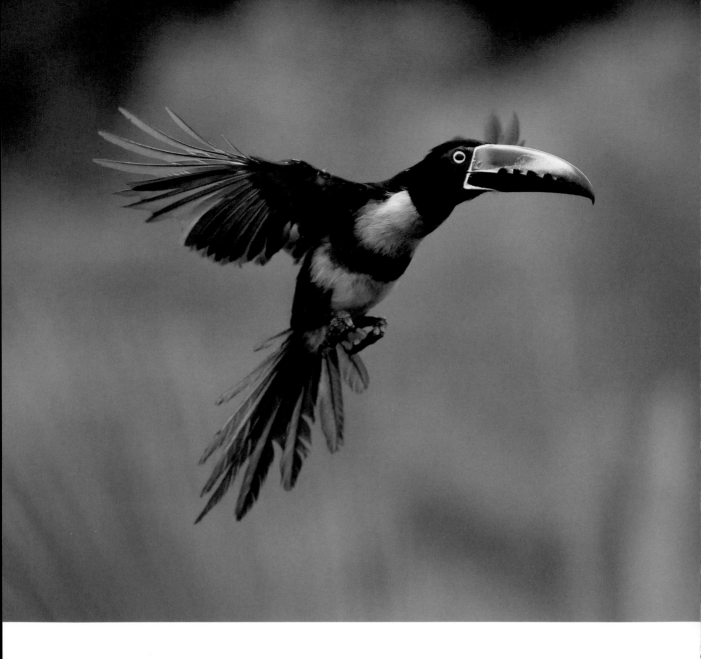

"Collared Aracaris are small members of the toucan family, which often travel in small groups and bully other birds away from food sources. Like most toucans they are mainly fruit eaters, but will also feed on small animals, birds, and eggs when the opportunity arises."

< **Collared Aracari**
Pteroglossus torquatus
Northern Costa Rica
Nikon D5 with 80–400mm lens,
1/2500 sec. at f/5.6, ISO 4000
John Crawley, @jc_wings

> **Indian Peafowl**
Pavo cristatus
Ranganathittu Bird Sanctuary,
Karnataka, India
Nikon D750 with 200–500mm lens,
1/4000 sec. at f/5.6, ISO 2000
Pradeep Purushothaman, @pradeep.wildlens

⌐ **Southern Yellow-billed Hornbill**
Tockus leucomelas
Rhino River Lodge, South Africa
Canon EOS 5D MkIV with 150–600mm
lens, 1/1600 sec. at f/6.3, ISO 400
Eli Martinez, @sdmdiving

∨ **Northern Pintail**
Anas acuta
Canon EOS 1D X with 300mm
lens, 1/800 sec. at f/2.8, ISO 400
Stefano Ronchi, @stefanoronchi

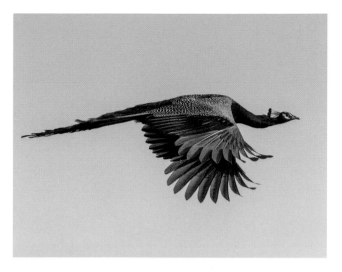

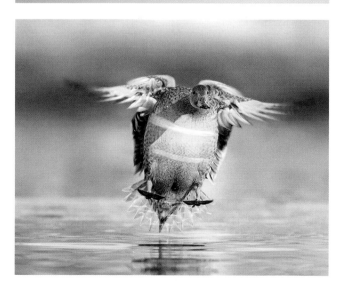

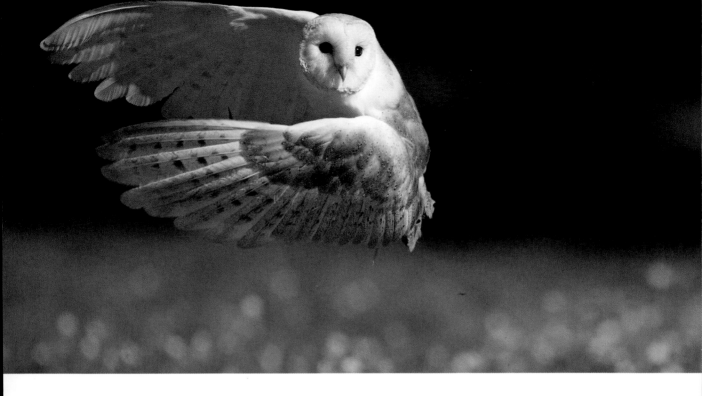

∧ **Barn Owl**
Tyto alba
Canon EOS 1D X with 300mm lens, 1/8000 sec.
at f/2.8, ISO 400
Stefano Ronchi, @stefanoronchi

> **Rock Pigeon**
Columba livia
Hussainiwala Reservoir, Ferozepur, India
Nikon D750 with 200–500mm lens, 1/2000 sec.
at f/5.6, ISO 640
Vishesh Kamboj, @visheshkambojj

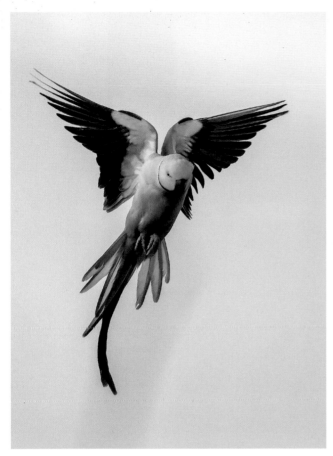

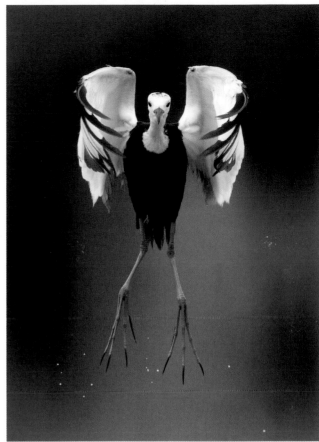

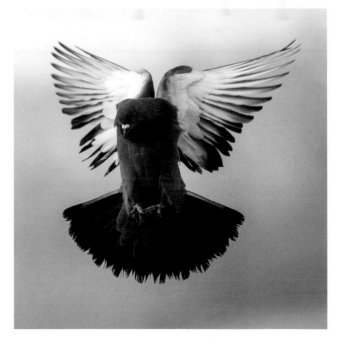

^ **Rose-ringed Parakeet**
Psittacula krameri
Gurdaspur, India
*Nikon D750 with 200–500mm
lens, 1/2500 sec. at f/5.6, ISO 1250*
Vishesh Kamboj, @visheshkambojj

¬ **Pheasant-tailed Jacana**
Hydrophasianus chirurgus
Chennai, India
*Nikon D500 with 600mm lens,
1/3200 sec. at f/4, ISO 1000*
Ananth Ramasamy, @ananth.ramasamy

"The Pheasant-tailed Jacana is a
common bird around the Pallikaranai
marshlands in the city of Chennai,
despite the increasingly poor quality of
the water. This picture was taken on a
vacant plot between apartment blocks."

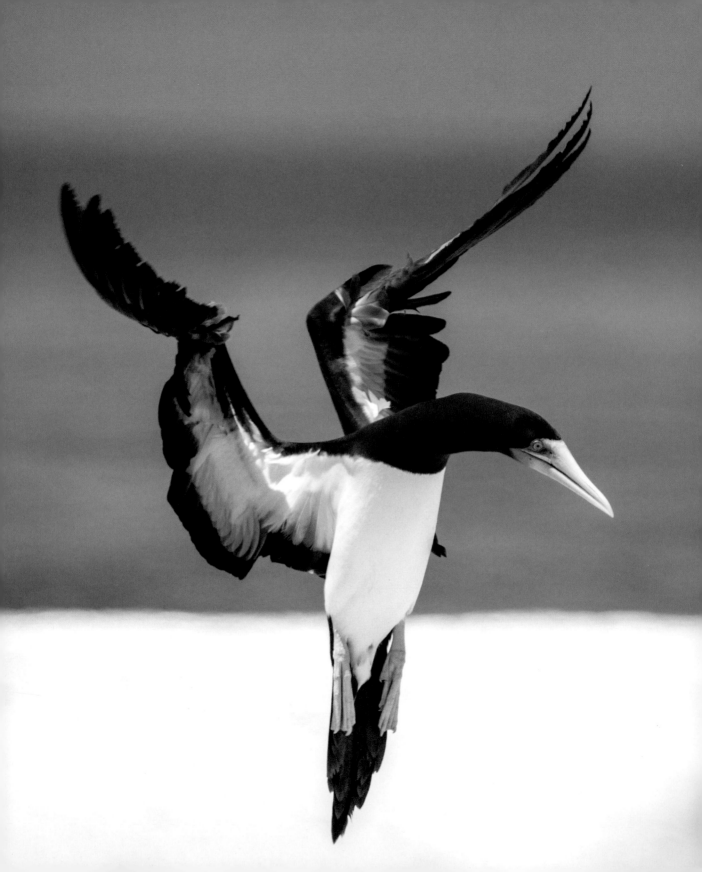

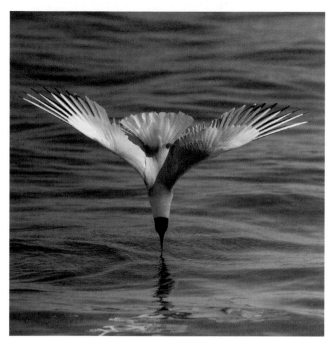

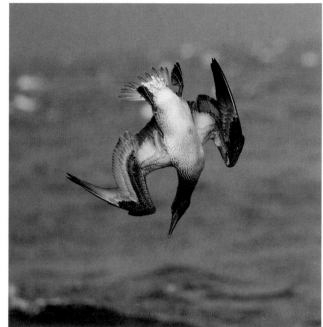

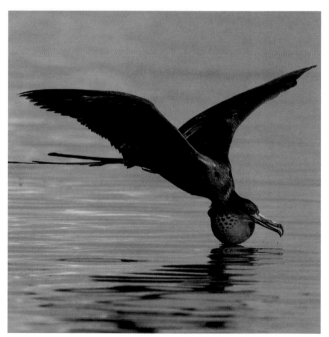

∧ **Black-headed Gull**
Chroicocephalus ridibundus
Leidschendam, the Netherlands
*Canon EOS 1D MkIV with 200mm
lens, 1/4000 sec. at f/2.8, ISO 100*
Erik Ruiterman, @erikruiterman

‹ **Brown Booby**
Sula leucogaster
Michalemas Cay, Great Barrier
Reef, Australia
*Sony α7rIII with 200–600mm
lens, 1/4000 sec. at f/6.3, ISO 500*
Scott Rolph, @aussiebirdphotography

⌐ **Northern Gannet**
Morus bassanus
North Sea near Texel, the Netherlands
*Canon EOS 1D MkIV with 100–400mm
lens, 1/4000 sec. at f/5.6, ISO 800*
Erik Ruiterman, @erikruiterman

› **Magnificent Frigatebird**
Fregata magnificens
Tampa, Florida, USA
*Nikon D850 with 500mm lens,
1/2500 sec. at f/6.3, ISO 360*
Peter Brannon, @peter.brannon

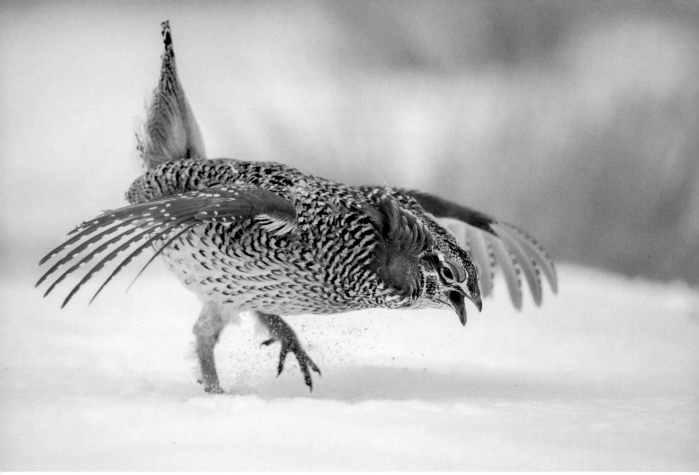

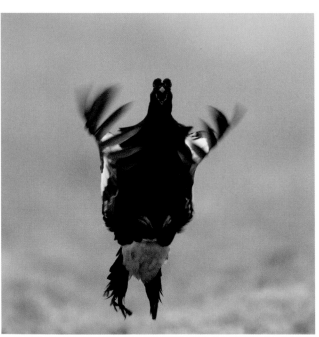

∧ Sharp-tailed Grouse
Tympanuchus phasianellus
British Columbia, Canada
*Canon EOS 5D MkIII with 500mm
lens, 1/2000 sec. at f/4, ISO 3200*
Jess Findlay, @jessfindlay

< Black Grouse
Tetrao tetrix
Poland
*Nikon D700 with 600mm lens and 1.4x
teleconverter, 1/640 sec. at f/5.6, ISO 1250*
Robert Kreinz, @rkreinz

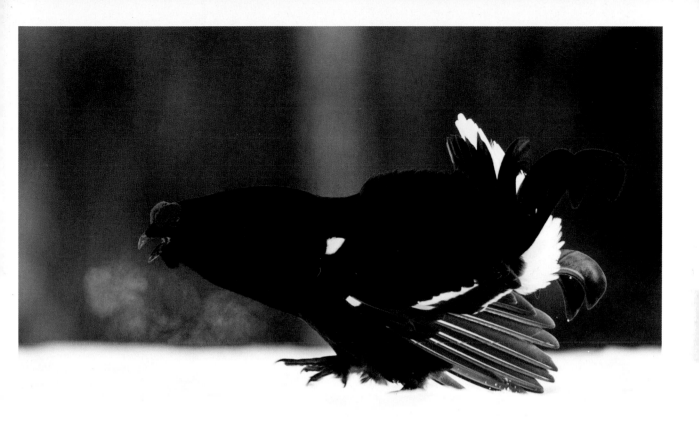

Black Grouse
Tetrao tetrix
Kuusamo, Finland
*Canon EOS 1D X with 150–600mm
lens, 1/640 sec. at f/6.3, ISO 3200*
Juho Salo, @jsalophotography

"This image was taken on a cold, early spring morning in north-east Finland, from a photography blind I rented from a local bird tour company. The Black Grouse lekking season runs from mid-March to mid-May, but there's really only an hour each day for photography, between 5am and 6am. So you have to be ready for the short time you spend in the hide."

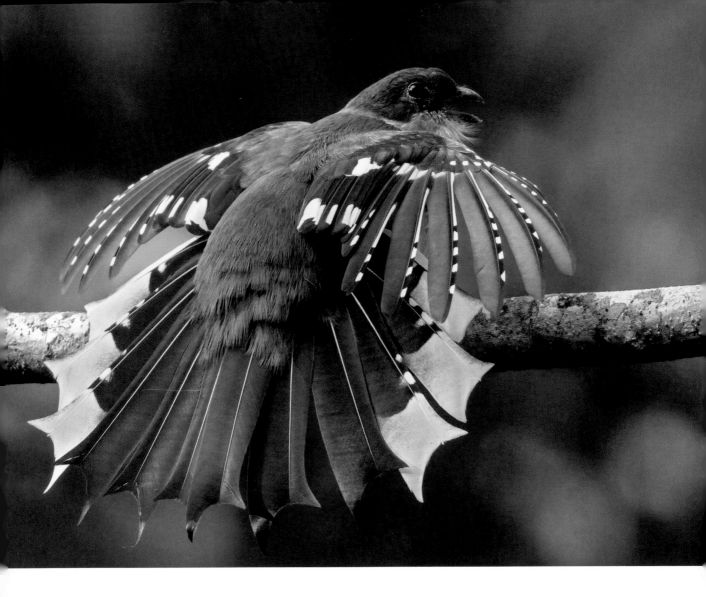

⌃ Cuban Trogon
Priotelus temnurus
Pinar del Rio, Cuba
Canon EOS 7D MkII with 600mm
lens, 1/400 sec. at f/5.6, ISO 800
Glenn Bartley, @bartleys_photo_workshops

"The Cuban Trogon is the national bird of Cuba. In this image, a male trogon spreads its impressive tail feathers and wings in an attempt to scare off a nearby rival. I had been watching this bird for several minutes prior to taking this shot, and when the second bird flew in I made sure my camera was pre-focused, just in case something interesting happened. It paid off, as I can't imagine a better pose to show off this birds best feature!"

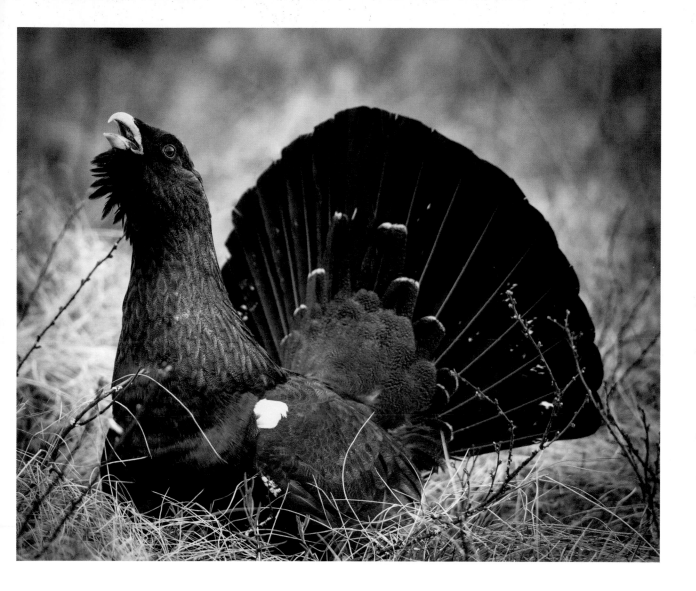

Western Capercaillie
Tetrao urogallus
Kuusamo, Finland
Canon EOS 1D X with 150–600mm
lens, 1/100 sec. at f/5.6, ISO 1250
Juho Salo, @jsalophotography

"A friend of mine works as a professional bird tour guide, and he told me about a 'crazy capercaillie' in the local area. He gave me directions to where the bird could be found, and I found it after about 15 minutes of searching the woods near a swamp. I managed to take a few shots of it before it charged at me and drove me away—a truly crazy bird!"

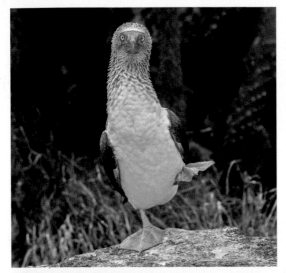

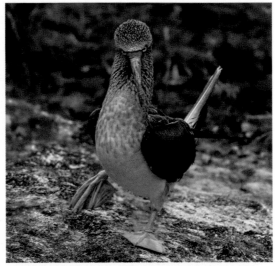

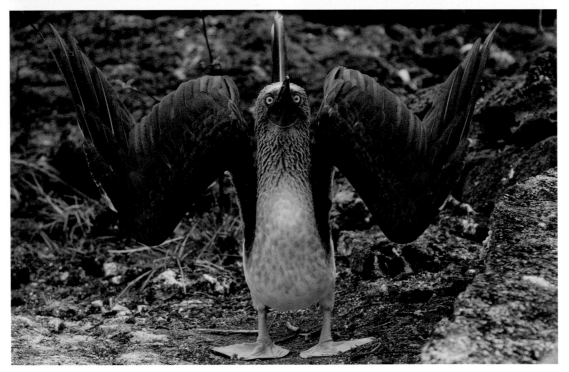

⌃ Blue-footed Booby
Sula nebouxii
Galapagos Islands
Sony α7r IV with 600mm lens,
1/1600 sec. at f/5.6, ISO 3200
Oleg Alexeyev, @oleg_alexeyev_photo

"During breeding season, the male Blue-footed Booby dances to attract a mate. As he struts his stuff, he flashes his feet, finishing up by "sky-pointing" —aiming his bill skyward and spreading his wings."

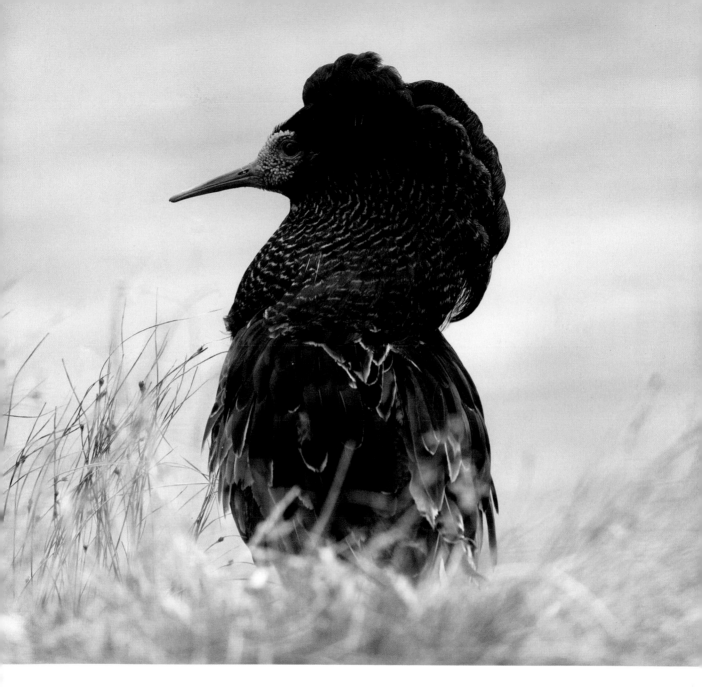

∧ **Ruff**
Calidris pugnax
Vardø, Norway
Canon EOS 1D X with 600mm lens and 1.4x
teleconverter, 1/125 sec. at f/7.1, ISO 1600
Kimmo Lahikainen, @_lahki_birds_

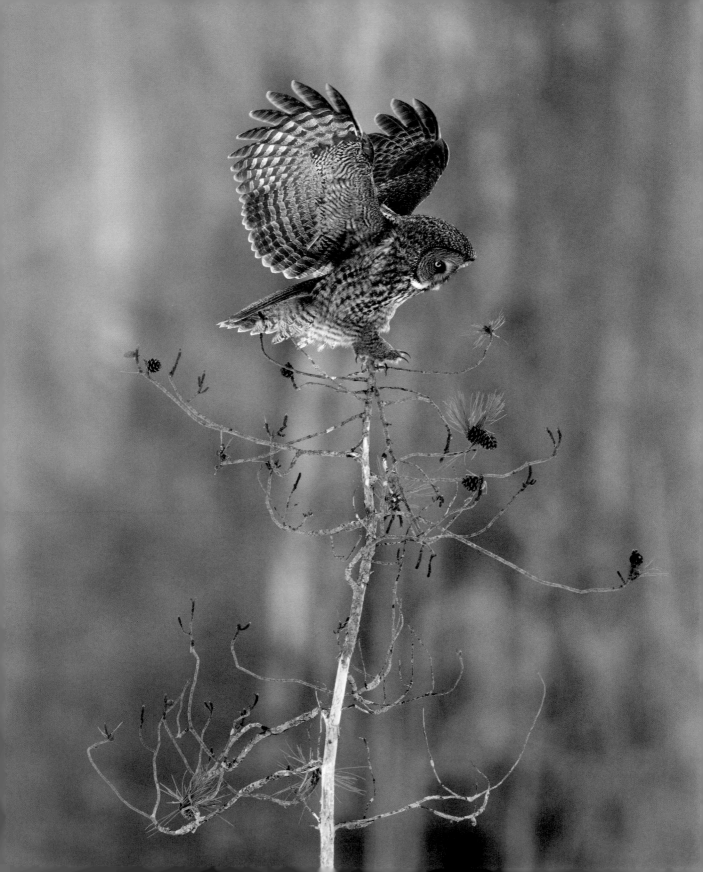

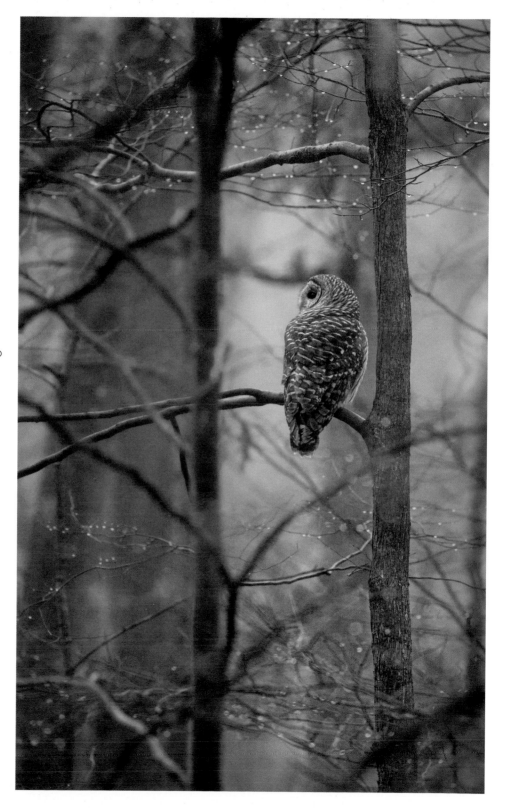

> **Barred Owl**
Strix varia
Westchester County,
New York, USA
*Canon EOS R with 100–
400mm lens, 1/50 sec.
at f/5.6, ISO 500*
Rina Miele, @rinamiele

< **Great Gray Owl**
Strix nebulosa
Northern Minnesota, USA
*Canon EOS 5D MkIV with
600mm lens and 1.4x
teleconverter, 1/800 sec.
at f/5.6, ISO 1000*
Rina Miele, @rinamiele

"This Great Gray Owl
landed on a delicate
pine, from which he
subsequently hunted.
The pine was quite low to
the ground, which made
it easier for him to hear
prey under the snow."

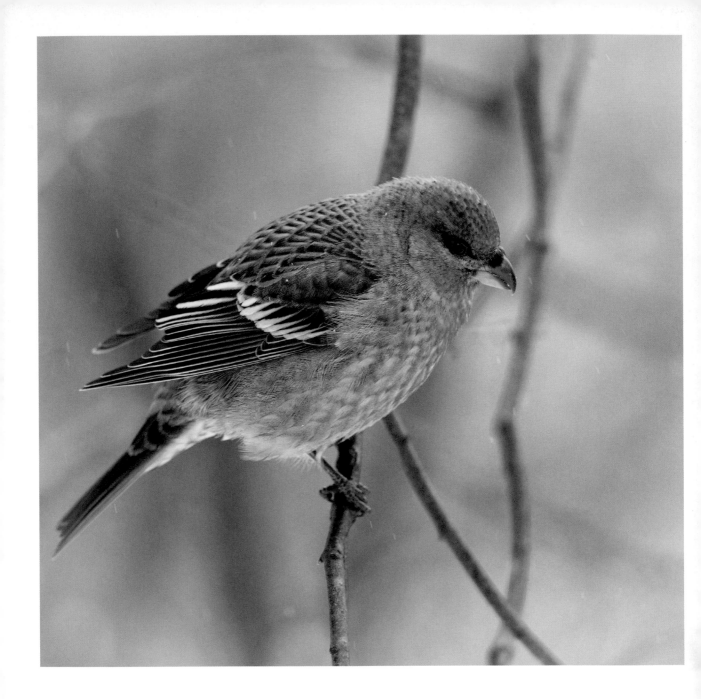

∧ **Pine Grosbeak**
Pinicola enucleator
Kaamanen, Finland
Canon EOS 1D X MkII with 600mm
lens, 1/400 sec. at f/5, ISO 1250
Erik Ruiterman, @erikruiterman

> **Eurasian Jay**
Garrulus glandarius
Southern Finland
Canon EOS 1D X with 150–600mm
lens, 1/160 sec. at f/6.3, ISO 1250
Juho Salo, @jsalophotography

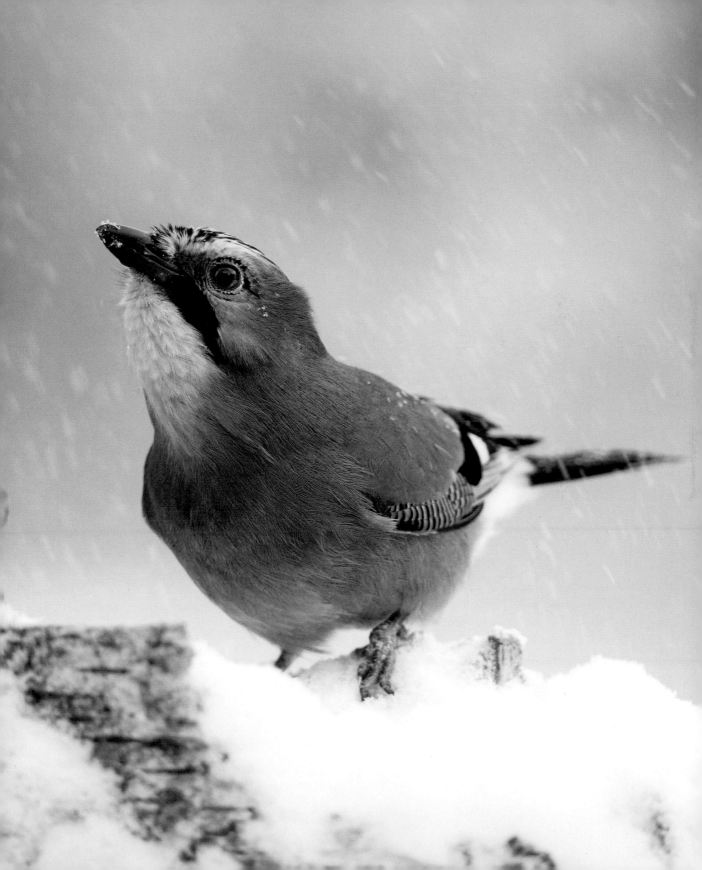

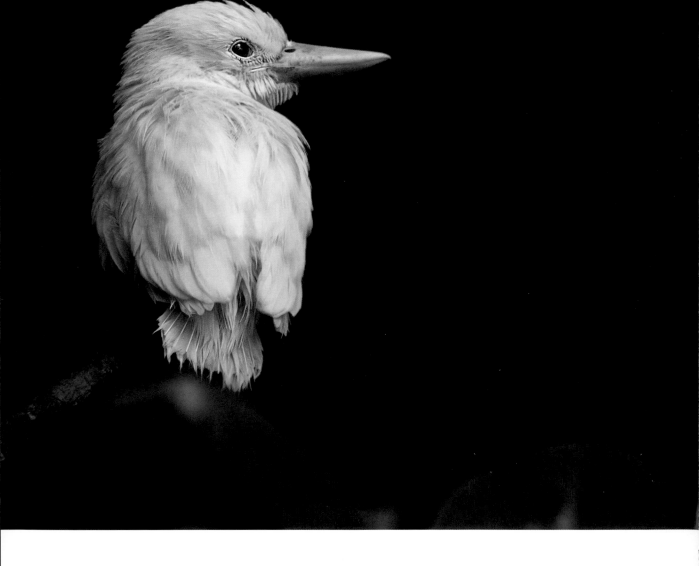

"This albino Collared Kingfisher is believed to be the first on local record. Normal fledglings should be able to forage on their own, but like all albinos, this bird suffers from poor eyesight and has problems landing and hunting."

< Collared Kingfisher
Todiramphus chloris
East Coast Park, Singapore
Nikon D850 with 400mm lens,
1/100 sec. at f/5.6, ISO 400
Vincent Chiang, @vincent_ckx

> Splendid Fairywren
Malurus splendens
Creery Wetlands, Australia
Olympus OM-D E-M1 MkII with 300mm
lens, 1/2500 sec. at f/6.3, ISO 800
Alice Worswick, @alice_worswick

⌐ Gilded Flicker
Colaptes chrysoides
Marana, Arizona, USA
Canon EOS 1D MkIV with 500mm lens and
1.4x teleconverter, 1/320 sec. at f/5.6, ISO 1000
Ben Knoot, @benknoot

"I am very fortunate to have a pair of
these birds in my backyard. One of their
favorite foods is peanuts, so I set up a
little perch with nuts hidden in it and
waited to take a shot."

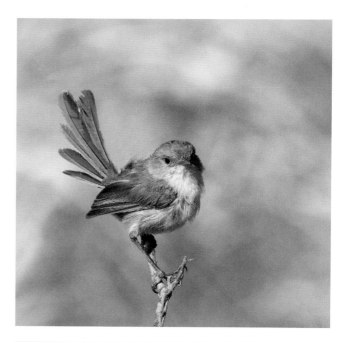

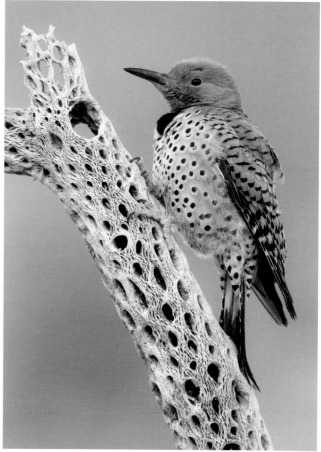

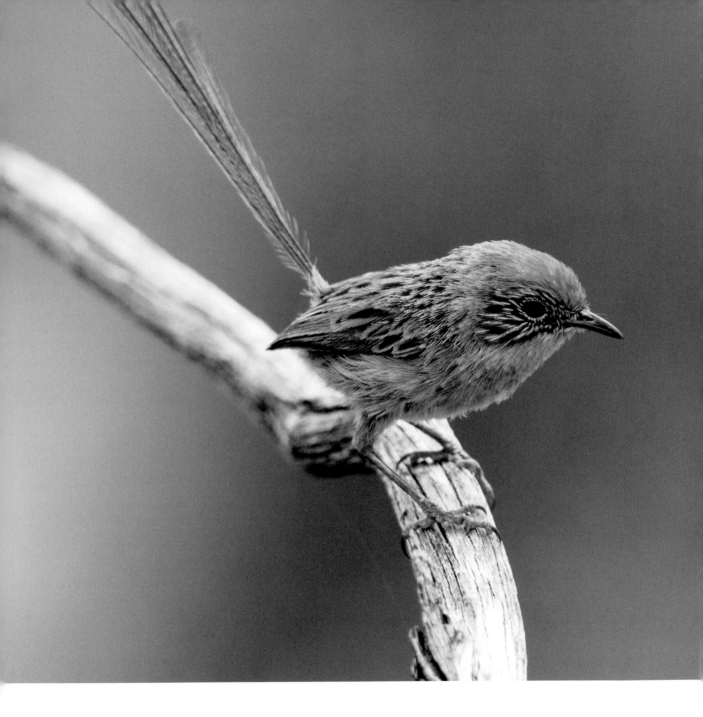

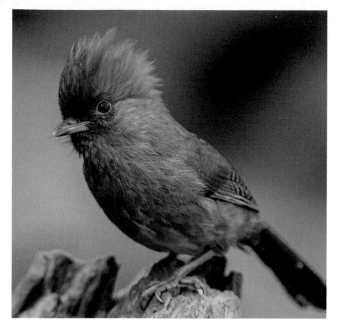

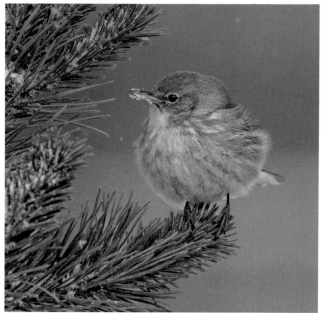

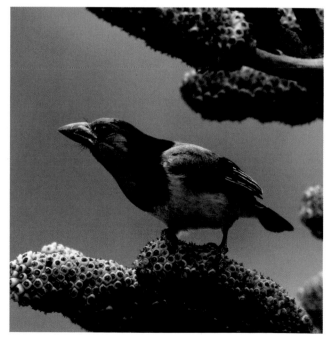

^ **Rusty-fronted Barwing**
Actinodura egertoni
Yunnan province, China
Sony α9 with 400mm lens, 1/2000 sec. at f/5.6, ISO 400
Oleg Alexeyev, @oleg_alexeyev_photo

< **Mallee Emuwren**
Stipiturus mallee
Hattah-Kulkyne National Park,
Victoria, Australia
Nikon D800E with 150–600 lens,
1/800 sec. at f/8, ISO 560
Scott Rolph, @aussiebirdphotography

¬ **Pine Warbler**
Setophaga pinus
Niagara Falls, Ontario, Canada
Nikon D500 with 300mm lens, 1/500 sec. at f/6.3, ISO 640
Robert S. Parker, @robert.s.parker

> **Black-collared Barbet**
Lybius torquatus
Nelspruit, Mpumalanga, South Africa
Nikon D500 with 500mm lens, 1/250 sec. at f/5.6, ISO 400
Heinrich Human, @heinrich_human

"In spring, the birds seem to love our kiepersol tree,
including Speckled Mousebirds, Cape White-eyes,
and Black-collared Barbets."

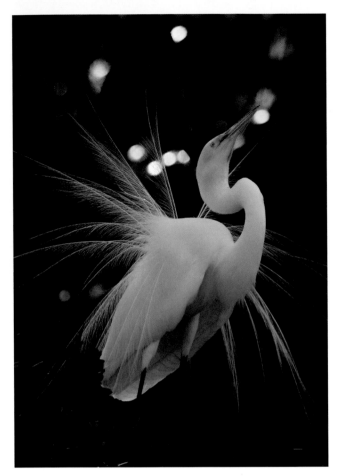

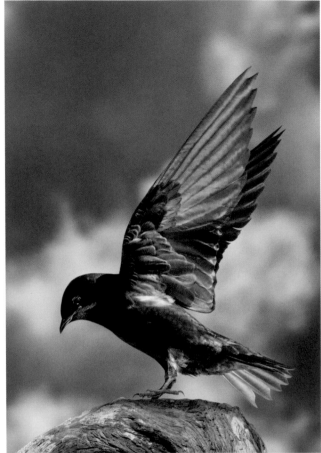

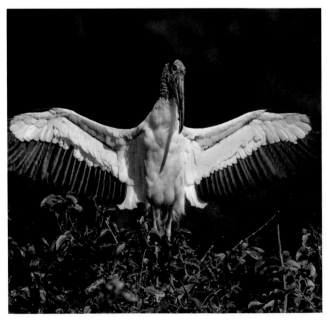

∧ **Great Egret**
Ardea alba
St. Augustine, Florida, USA
Nikon D850 with 500mm lens, 1/2500 sec.
at f/7.1, ISO 900
Greg Christoph, @gregxoph

⌐ **Purple Martin**
Progne subis
Wellington, Florida, USA
Nikon D850 with 500mm lens and 1.4x
teleconverter, 1/2000 sec. at f/7.1, ISO 320
Greg Christoph, @gregxoph

> **Wood Stork**
Mycteria americana
Boynton Beach, Florida, USA
Nikon D850 with 500mm lens, 1/2000 sec.
at f/7.1, ISO 140
Greg Christoph, @gregxoph

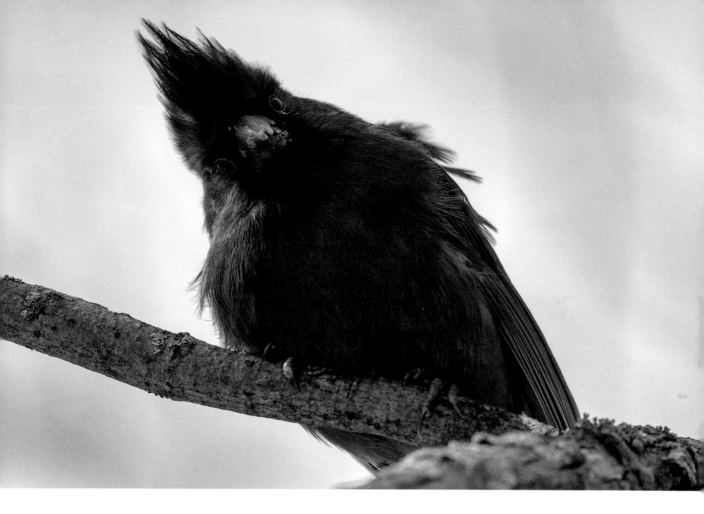

∧ Northern Cardinal
Cardinalis cardinalis
Waterloo, Ontario, Canada
*Olympus OM-D E-M1 with 300mm
lens, 1/1250 sec. at f/5.6, ISO 400*
Kevin Biskaborn, @kevinbiskaborn

"During Ontario's winters, songbirds of different species often travel the forests together, with each bird in the group benefiting when another locates a food source. One day, while photographing a banditry of bold chickadees, I was also greeted by this curious, but more cautious, male cardinal. He perched directly above me and looked down just as I captured the moment."

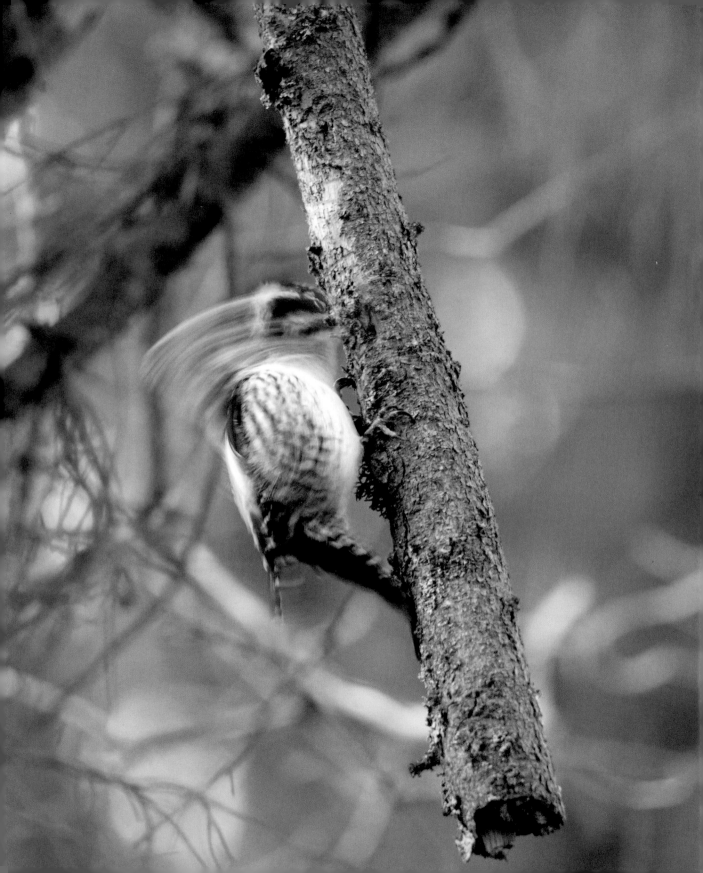

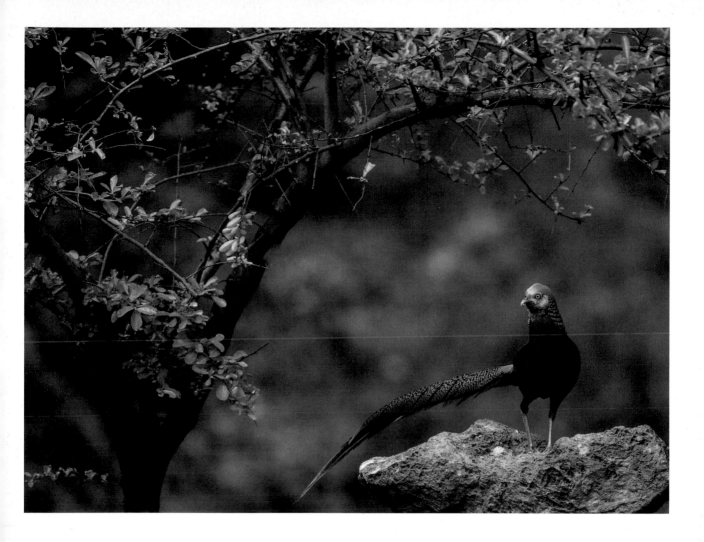

< **Eurasian Three-toed Woodpecker**
Picoides tridactylus
Aulanko, Finland
Canon EOS 1D X with 150–600mm
lens, 1/40 sec. at f/6.3, ISO 1600
Juho Salo, @jsalophotography

∧ **Golden Pheasant**
Chrysolophus pictus
Yunnan province, China
Sony α9 with 400mm lens,
1/2000 sec. at f/4, ISO 4000
Oleg Alexeyev, @oleg_alexeyev_photo

"The Aulanko nature reserve in southern Finland is home to one or two nesting pairs of Eurasian Three-toed Woodpecker, and I have photographed them a number of times. These birds are very rare in the south of the country, as they demand old coniferous forest as their habitat."

> **Eurasian Nuthatch**
Sitta europaea
Wollaton Hall Park, Nottingham, UK
Canon EOS 80D with 100–400mm lens,
1/800 sec. at f/6.3, ISO 160
Jason Ogbourne, @jasonogbourne

"Shooting a subject in shadow against a
bright background is normally a recipe
for disaster, but I could barely contain
my excitement when I saw the potential
for this perfect silhouette!"

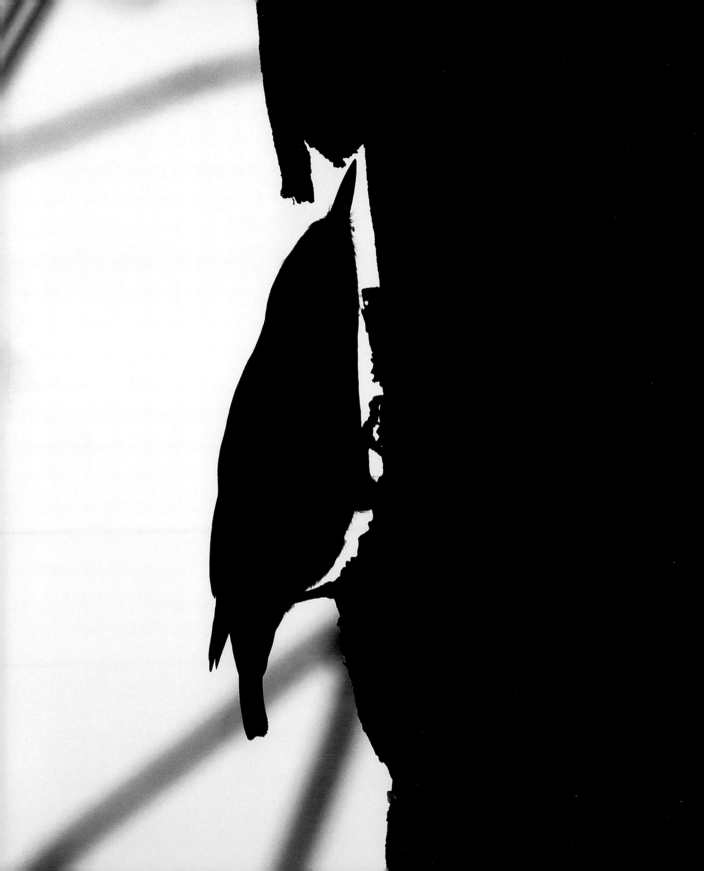

Index

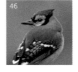 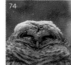 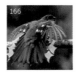 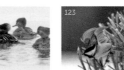
 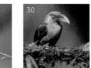 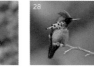
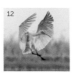 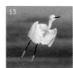 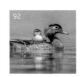 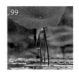

Peter Brannon (cont.)
@peter.brannon

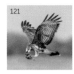 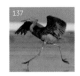 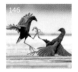 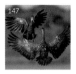 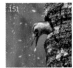

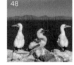 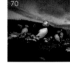

Drew Buckley
@drewbphotography

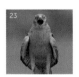 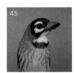 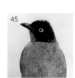 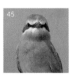 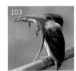

Digvijay Chaugle
@_birdboy_

 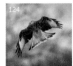

Vincent Chiang
@vincent_ckx

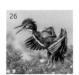 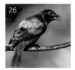

Greg Christoph
@gregxoph

John Crawley
@jc_wings

 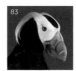 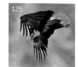

 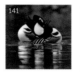 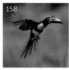 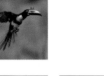

Mark Eastment
@markeastmentphotography

Jess Findlay
@jessfindlay

Elijah Gildea
@elijahs_

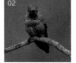 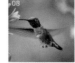

Heinrich Human
@heinrich_human

186

Vishesh Kamboj
@visheshkambojj

 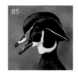

Ben Knoot
@benknoot

Robert Kreinz
@rkreinz

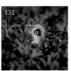 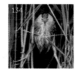 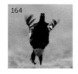

Kimmo Lahikainen
@_lahki_birds_

 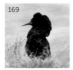

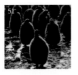 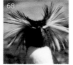 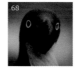

James Lowe
@jameslowe783

 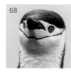 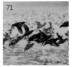 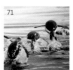

 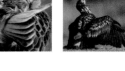

Eli Martinez
@sdmdiving

 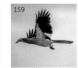

Rina Miele
@rinamiele

 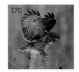

Gururaj Moorching
@gururaj_moorching

Jason Ogbourne
@jasonogbourne

Robert S. Parker
@robert.s.parker

 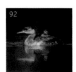 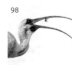 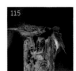 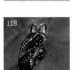

Shelley Pearson
@shelley_pearson_

Pradeep Purushothaman
@pradeep.wildlens

 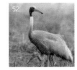 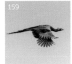 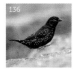 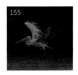

 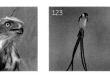

Ananth Ramasamy
@ananth.ramasamy

 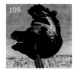

Scott Rolph
@aussiebirdphotography

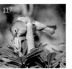 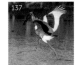 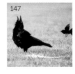 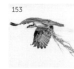 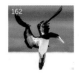

 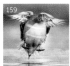

Stefano Ronchi
@stefanoronchi

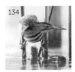 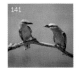 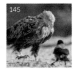 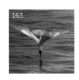 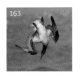 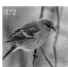

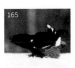

Erik Ruiterman
@erikruiterman

Juho Salo
@aussiebirdphotography

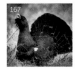 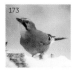 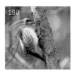

189

Praveen Siddannavar
@praveensiddannavar

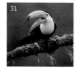 31
 33
 113
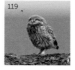 123
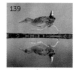 149
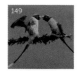 152

Franka Slothouber
@frankaslothouber

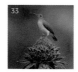 18
 50
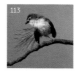 51
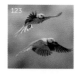 69
 92
 93

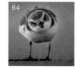 102
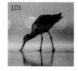 110
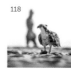 115
 119
 139
 152

Alecia Smith
@alecia_birds

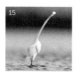 06
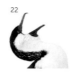 84
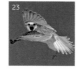 101
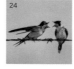 118

Georgina Steytler
@georgina_steytler

 15
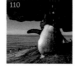 22
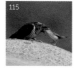 23
 24
 63
72

 73
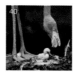 81
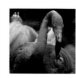 100
 112

Femke van Willigen
@ajoebowan

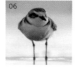 37
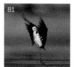 40
 41
 47
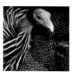 66
57

 67
 111
 134

Alice Worswick
@alice_worswick

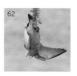 62
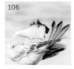 106
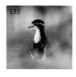 135
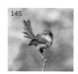 145

190

Acknowledgments

David Allen Sibley and Chris Gatcum would like to thank UniPress Books, in particular Nigel Browning and Kate Shanahan, for commissioning this book in the first instance. To Natalia Price-Cabrera, thank you for your unwavering support and project management. You kept everything on track even in the face of some wobbly moments. To Paul Palmer-Edwards for your beautiful design and layout, we thank you too. And finally, to all the contributors whose work is featured in this book, an enormous thank you. You all gave so generously of your time, images, and knowledge. It has been a pleasure to collaborate with each and every one of you.

> **New Holland Honeyeater**
Phylidonyris novaehollandiae
Baldivis, Australia
Canon EOS 1D X MkII with 500mm lens and 1.4x teleconverter, 1/4000 sec. at f/7.1, ISO 800
Shelley Pearson, @shelley_pearson_

"New Holland Honeyeaters hang around together feeding. They are very noisy and often argue with each other."

191

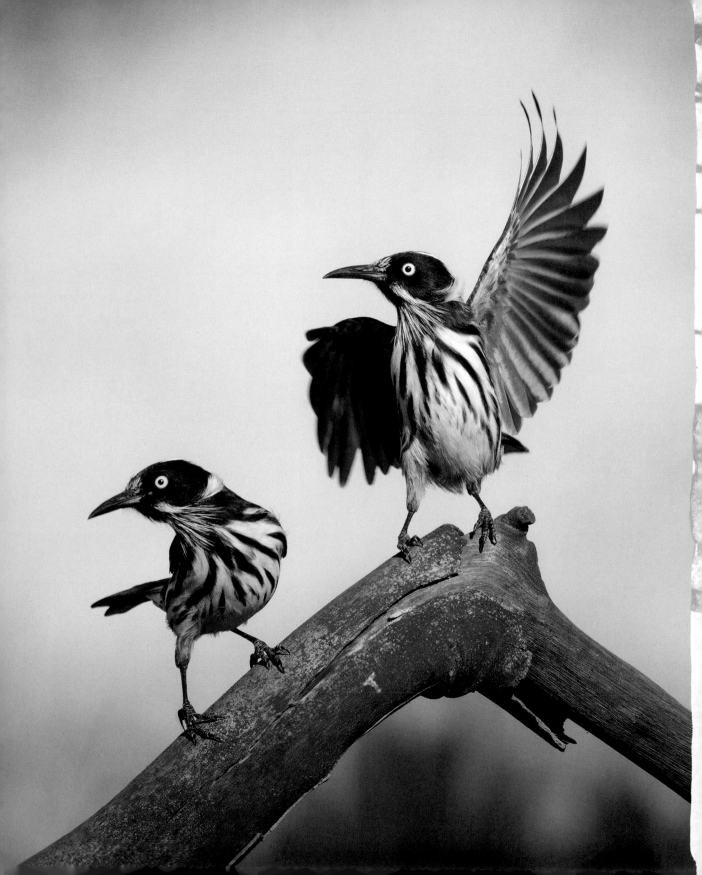